A Concise History of Painting

From Giotto to Cézanne

A Concise History of Painting

From Giotto to Cézanne

MICHAEL LEVEY

549 plates in colour

THAMES AND HUDSON

*Any copy of this book issued by the publisher
as a paperback is sold subject to the condition
that it shall not by way of trade or otherwise
be lent, re-sold, hired out or otherwise
circulated without the publisher's prior consent,
in any form of binding or cover other than that in
which it is published, and without a similar
condition including these words being imposed
on a subsequent purchaser.*

© 1962 AND 1968 THAMES AND HUDSON LTD LONDON

*All Rights Reserved. No part of this publication
may be reproduced or transmitted in any form or
by any means, electronic or mechanical, including
photocopy, recording or any information storage
and retrieval system, without permission in writing
from the publisher.*

REPRINTED 1979

Printed and bound in Singapore by FEP International Pte Ltd.

CONTENTS

On doit toujours s'excuser de parler peinture
PAUL VALÉRY

I
THE EARLY
RENAISSANCE
IN ITALY

GIOTTO'S CONTEMPORARIES would have agreed that a history of painting should begin with him. Cimabue's fame is obscured, says Dante in the 'Purgatorio', and it is now Giotto who is acclaimed: so much for earthly renown. Other Florentines rightly remarked that it was Giotto who had changed the old 'Greek' manner of painting into a modern one.

GIOTTO DI BONDONE (1267?-1337) is thus one of the few great painters recognized and applauded in his lifetime for being a revolutionary. Some later artistic revolutions have been less warmly received; and Giotto was fortunate that his movement was in the direction of a three-dimensional realism welcome after earlier flat Byzantine-style pattern pictures. In fact, he did not so much break with that tradition as evolve from it under the influence of sculpture and mosaic. In 1228, two years after the death of St Francis, the foundations were laid for a great basilica in his honour at his native Assisi. As well as a church, this became a meeting-place and a forcing-house for artistic talent. St Francis, though an inspiration to painters from the first, had actually taught the ungodliness of art and had recommended only buildings in accord with Holy Poverty. So it cannot be said that the basilica of S. Francesco, though it glorifies his achievements, typifies the ideals of St Francis. Indeed, when one of the saint's companions visited the church he commented that the brethren now lacked nothing but wives.

Before Giotto artists were already employed there on schemes of fresco decoration. North from Rome and south from Florence had come painters with their assistants to fresco the basilica built on two levels and consisting of an upper and lower church. What remains of these early fresco schemes, the work of painters very largely unknown, is a palimpsest partly damaged and partly repainted. A few fragments go back to the time of the basilica's founding and are in the style Giotto finally made redundant. Later and very damaged frescoes are traditionally attributed to the Florentine CIMABUE (*c.* 1240?-1302?), traditionally Giotto's master.

Typical of the style in which Cimabue worked, the altarpiece of enthroned *Madonna and Child (pl. 1)* looks old-fashioned and unreal when contrasted with the *Ognissanti Madonna (pl. 2)* attributed to Giotto. Yet the two pictures are possibly separated in time by only some ten years. Different generations help to explain the stylistic differences, yet Cimabue has his own grave monumentality when compared with earlier work, and his achievement was necessary before Giotto could proceed.

Giotto is the first great creative personality of European painting. He was remembered not only as artist but as a personality: his ugly appearance and his witty remarks were duly recorded. Dante was his friend and an early legend mentions Dante's assisting Giotto in painting at Naples; Petrarch treasured a Madonna by Giotto now lost; and to him was attributed a satiric song against Voluntary Poverty. Through him, it was felt, art came to life again. When Lorenzo de' Medici set up a bust on his tomb more than a hundred years after his death, this was the claim Giotto was made to make for himself in Poliziano's verse: 'Ille ego sum, per quam pictura extinta revixit.'

After the papery draperies, the linear two-dimensional throne, and the flat oval faces in Cimabue's picture, Giotto's *Madonna and Child* are solid individualised figures firmly seated on a throne modelled in three dimensions. Both pictures have the gold background of convention; but where Cimabue's figures rise one above the other, seeming to occupy no more space than a handful of playing cards, Giotto's recede in depth. The eye senses weight in the shapes of the foreground kneeling angels, and space as existing between them and the enthroned Madonna. To Cimabue's linear effects, Giotto opposes sculptural ones; both ways of seeing occur throughout Western painting, but for long Giotto's way was acclaimed and followed. The sculptors Nicola and Giovanni Pisano, father and son both older than Giotto, had already created figures dramatically and solidly conceived, human beings in place of

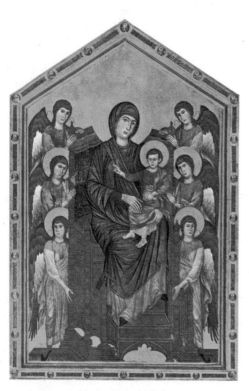

1 CIMABUE *Madonna and Child*

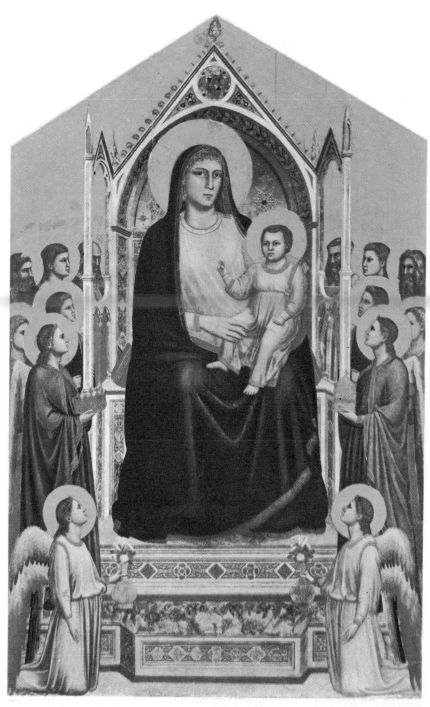

2 Attributed to GIOTTO *Ognissanti Madonna*

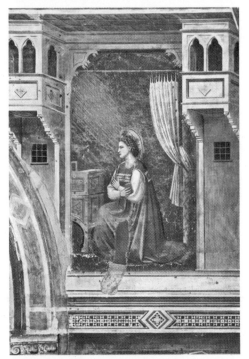

3 GIOTTO *Virgin annunciate*

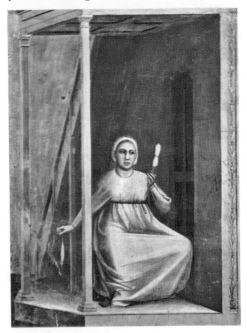

4 GIOTTO *Girl carding wool*

the conventional Byzantine symbols. It is mankind who occupies the central place in Giotto's world. He thus states the whole theme of Italian art down to Tiepolo. The earth, sky and sea surround but do not absorb the painter. There is a tendency to generalise, to monumentalise. Man is at his noblest in Italian art: not cooped up in a room, as so often in Northern pictures, but effortlessly at ease in the natural world.

St Francis himself had responded lyrically to nature, and at Assisi the *Preaching to the birds (pl. 5)*, one of the fresco series from the saint's life traditionally by Giotto, captures this for the first time in art. Naturalism is controlled within a deliberate convention, and the convention is appreciated best today when photography has tired our eyes. Giotto organises a complete spatial world in which detail is subordinated to mass. In the Arena chapel at Padua, where he was probably working about 1306, he has left a large-scale monument to his style more intact than that of almost any other painter. The gaunt exterior of this chapel, built by the son of a Paduan usurer, Reginaldo Scrovegni, whom Dante had placed in Hell, is no preparation for the completely painted interior where the lives of Christ and the Virgin are frescoed in three tiers down the high walls. And the chapel is unusual in having been built to receive frescoes.

All the supposed mysticism of the Middle Ages, with its soaring cathedrals and delight in the intricate and the wayward, is irrelevant and untidy beside Giotto's classic, ordered vision. His people in their plain but subtly coloured clothes inhabit a lucid sphere. The house in which the *Virgin annunciate* kneels *(pl. 3)* is essential, not detailed. In another fresco the girl carding wool in a porch *(pl. 4)* is genre transfigured out of the trivial into dignity. In Giotto's scenes the houses, the rocks and trees are simple enduring forms, as dignified as the people. There is little movement and only the barest scenery; it is an Æschylean world, only here it is the Christian destiny which in various moods is played out before us. The lonely Joachim dreams in an austerely rocky land-

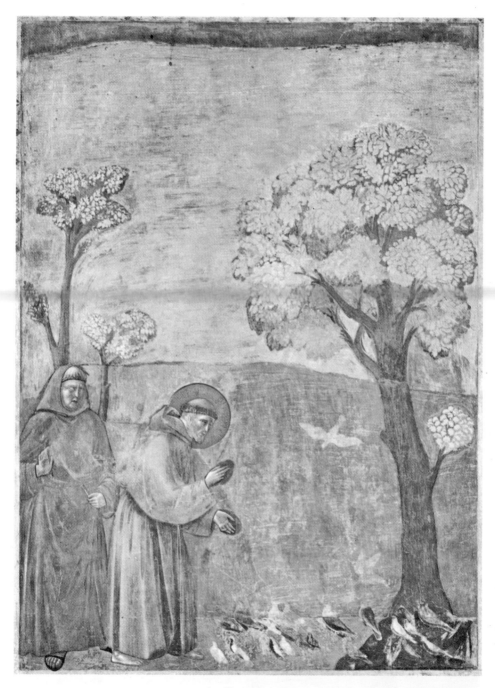

5 Attributed to Giotto *St Francis preaching to the birds*

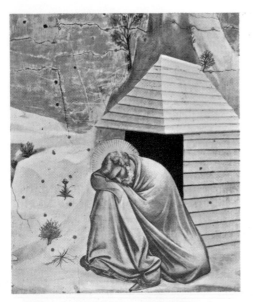

6 GIOTTO *Joachim's dream (detail)*

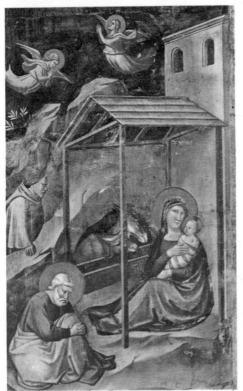

7 TADDEO GADDI *Nativity (detail)*

scape *(pl. 6)*; the *Deposition (pl. 8)* contrasts bulky human mourners, numbed by grief, with angels soaring and plunging in agony like wounded birds.

The elevated tone, the restricted gesture, and monumental grouping, do not inhibit powerful observation of ordinary things. Everywhere are images—like the girl carding wool—as commonplace and as memorable as those in Dante: dogs plagued by flies, a shepherd waiting for the frost to break, a woman fleeing naked with her child at the alarm of fire. Poet and painter share the ability to pare down their images to a compact essence, all the more vivid because of its brevity.

Giotto's ability impressed his contemporaries far beyond Tuscany. As well as at Padua, he worked at Naples and Rome, probably at Bologna, just conceivably at Avignon. And in his native Florence he frescoed some chapels in S. Croce and designed the cathedral campanile, though not exactly in the form it was built.

At Giotto's death, his style was inherited by no great man but was doomed to be duplicated in a weaker prettier way by the Giotteschi, too faithful followers of its externals. TADDEO GADDI (d. 1366) had for long worked directly under Giotto, serving as his chief assistant, and his frescoes at S. Croce *(pl. 7)* reveal his devotion to the master's manner. 'Giotto still holds the field', said a commentator on Dante in 1376. Not until Masaccio *(p. 24)* was Giotto in fact to find a great heir and a worthy rival. Politically, Florence suffered under continually warring factions in the Republic, the sudden failure of two great banking houses, a famine in 1347 and appalling plague the following year.

Geographically close to Giotto's Florence, Siena was contemporaneously to produce a style of painting largely opposed to his ideals and achievements. The Byzantine-Gothic mould from which he had escaped survived in Siena and shaped not only its first great painter DUCCIO (*c.* 1255/60-1318/9) but the course of art in Siena for nearly two hundred years after.

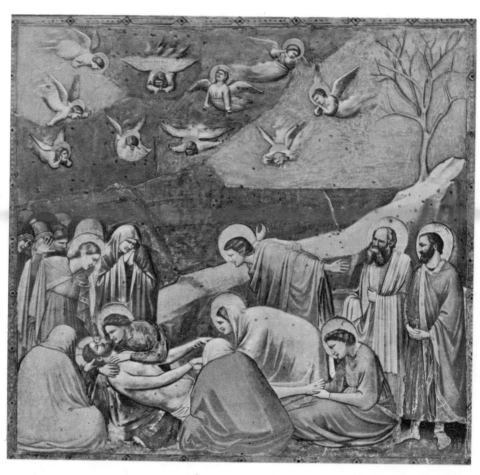

8 GIOTTO *Deposition*

Duccio's *Rucellai Madonna (pl. 9)* comes from a Florentine church and returns one to the ambience of Cimabue. The eye cannot penetrate the picture but must read its brilliantly-coloured intricate pattern, its wrought and inlaid throne with elaborate hangings, placed against a background of pure gold. Only the gilded border of the Madonna's robe curls and clusters into a line serpentine like an advancing wave. In Duccio's later pictures he expands this hint of movement, even while refining in beauty of colour and pattern. The *Franciscan Madonna (pl. 10)*, though composed with the same formal elements as the *Rucellai Madonna*, is animated; the Child gestures across his Mother and the eye travels down the line of the Madonna's arm to the corner where three friars kneel in a quivering ecstasy of piety.

The culmination of Duccio's success came in 1311 when his huge *Maestà* altarpiece for Siena cathedral *(pl. 11)* was carried there in triumph from his studio. On the front of

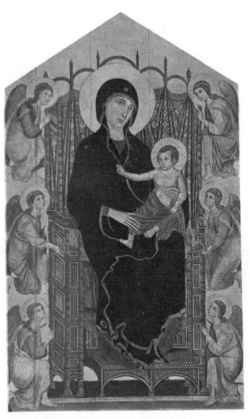

9 DUCCIO *Rucellai Madonna*

10 DUCCIO *Franciscan Madonna*

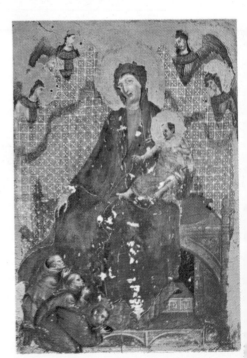

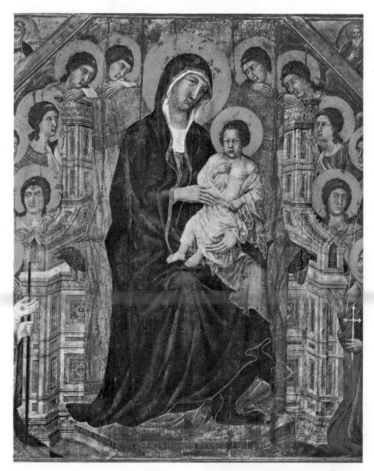

11 DUCCIO *Madonna and Child (from Maestà)*

12 DUCCIO *Three Maries (from Maestà)*

13 DUCCIO *Washing of the feet (from Maestà)*

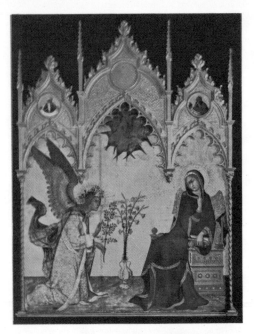

14 SIMONE MARTINI *Annunciation*

15 SIMONE MARTINI *Christ returning to his Parents (detail)*

the altarpiece the *Madonna and Child* are enthroned in conventional majesty. Around them and at the back, some invisible to the worshippers, were small-scale scenes, dramatic narratives, orientally delicate in colour *(pls. 12, 13)*. Every inch of these is enamelled, gilded, burnished; and the Gospel story is related with all the opulent effect of Persian miniatures.

Duccio remained Siena's artist, and his life passed there where he is frequently recorded as fined for petty offences. His fellow-citizen SIMONE MARTINI (1284?-1344) became a figure important far beyond the confines of that isolated city on its hill. Influenced by Duccio, he carried the manner to its courtly extreme and finally settled at the papal court in Avignon where he painted Petrarch's Laura (a portrait now lost). While Giotto was still alive he conceived an *Annunciation (pl. 14)* very different in its strong linear qualities, its shrinking Virgin and the radiant leaf-crowned angel who anticipates Botticelli. Patterns of lilies, leaves, brilliant bird wings, are lyrically fretted against the gold background on which yet more refulgent gold gleams from the angel's halo. Simone's frescoes of the life of St Martin at Assisi *(pl. 17)* are heraldic in their patterned, chequered splendour; and it is as half-person, half-heraldic symbol that *Guidoriccio da Folignano (pl. 16)* proudly rides in the Palazzo Pubblico at Siena—the first equestrian portrait in Western painting. At Avignon barely anything survives of Simone's work, but the *Christ returning to his Parents (pl. 15)*, dated 1342, originates in that period and with Duccio-like ability concentrates in small space a linear, opulently coloured narrative. So highly finished, so glowing, it is almost a jewel rather than a picture.

This decorative ability and feeling for line rather than volume remained the characteristic Sienese response. PIETRO LORENZETTI (*c.* 1280-1348?) in his *Madonna and Child (pl. 18)*, yet another contribution to the basilica of S. Francesco at Assisi, is true to his upbringing despite some awareness of Giotto. His brother AMBROGIO LORENZETTI

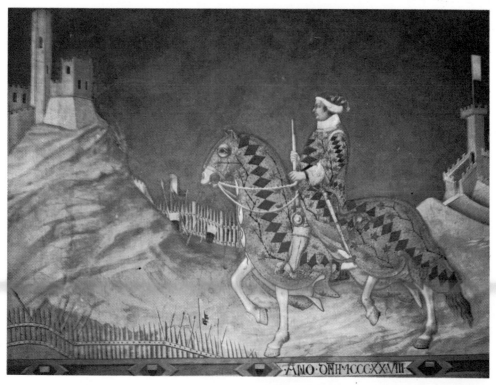

16 SIMONE MARTINI *Guidoriccio da Folignano*

17 SIMONE MARTINI *St Martin's dream*

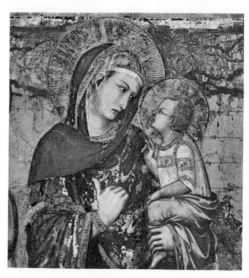

18 PIETRO LORENZETTI *Madonna and Child*

(active 1319-47) pays homage in the enormous fresco of *Good and Bad Government* in the Palazzo Pubblico, Siena, to Simone Martini who might well have imagined the delicate reclining images of *Peace and Fortitude (pl. 19)*. More vividly his own are Ambrogio's observations of life in the Commune, men toiling, nobles hawking, and the fields and buildings of Siena *(pl. 20)*. Good and bad government are not shown by dramatic anecdotes (as Dirk Bouts in Flanders was to paint *(p. 76)*) but through the panorama of a whole society.

Such large decorative schemes seldom came the way of Northern painters, and without the opportunity they lost too the chance of that large public which Italian artists from the first enjoyed. In Italy, where the climate allowed frescoes, the pictures and the building they decorated could be integrated into a whole; and this further freedom encouraged grand concepts, allowing men to paint their own kind on human or even superhuman scale.

Giotto had certainly found a language for expressing such concepts, but it did not penetrate everywhere—as Siena shows. In Lombardy there remained a closer affinity with Northern Europe than with Florence. Milan was ruled by a prince, like the cities of the North, and in the late fourteenth century built a monument to the Northern Gothic link in its cathedral. A courtly decorative style which has been dubbed 'International Gothic' was fused from Northern and Italian elements. Lombardy by its proximity participated in it, and the style reached its Italian perfection in the work of the peripatetic GENTILE DA FABRIANO (*c.* 1370-1427) and his artistic heir ANTONIO PISANELLO (1395-1455/6) working at Verona. Gentile's *Adoration of the Magi (pl. 21)*, set up in a Florentine church in 1423, is a masterpiece crammed with detailed naturalism—yet without the broad naturalism of Giotto, and still more without the new naturalism passionately concentrated on the human figure which the sculptor Donatello and his friend the young painter Masaccio were even then practising *(cf. pl. 32)*.

19 AMBROGIO LORENZETTI *Peace and Fortitude*

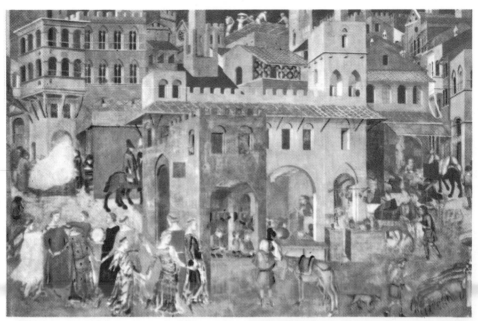

20 AMBROGIO LORENZETTI *Good Government (detail)*

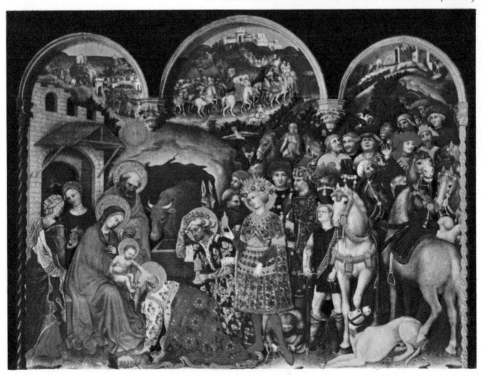

21 GENTILE DA FABRIANO *Adoration of the Magi*

22 ANTONIO PISANELLO *St George and the Princess (detail)*

Patterned fabrics, jewels, birds, dogs and monkeys are all affectionately delineated by Gentile. The effect is like an exotic tapestry, or the enlarged page of an illuminated manuscript: the figures are insubstantial, hardly modelled, without much space around them or beyond. Pisanello's preoccupations seem the same; his *St George and the Princess (pl. 22)* might also be a tapestry, but there is much more incisive line than Gentile ever commanded. Keen observation and superb draughtsmanship give his few profile portraits *(pl. 23)* a psychological power seen more vividly still in his portrait medals. Fantasy and fact are fused in Pisanello: the Madonna and Child burn in a strange halo above a dark wood where stands St George in embossed, gilded and minutely detailed armour *(pl. 24)*. Clothes are like plumage in his paintings and drawings, and his people move with bird-like grace. The *Vision of St Eustace (pl. 25)* seems more an enchanted Arthurian adventure than a religious picture, and illustrated with all the close naturalistic detail to be found in the English poem 'Sir Gawain and the Green Knight' of a hundred years earlier.

Pisanello, succeeding Gentile da Fabriano, painted frescoes (all destroyed) at Venice and Rome, but was not employed at Florence. Even without Gentile's *Adoration*, however, the 'International Gothic' style had a footing in Florence during the early fifteenth century in the studio of Lorenzo Ghiberti, sculptor of the two famous pairs of gilded bronze doors for the Baptistry. Some painters were trained in Ghiberti's workshop and it was a Florentine fifteenth-century conception that the artist should be a craftsman capable of sculpting, designing buildings and jewellery, as well as painting pictures. Under sculpture's influence painting was soon to become preoccupied again with problems of volume and space; but Gothic ideals could still express themselves in the linear brightly-coloured pictures *(pl. 27)* of LORENZO MONACO (*c.* 1370-1425?), a Sienese settled in Florence, and in Sienese art itself. Aware of new Florentine developments, SASSETTA (1392-1450) is yet the

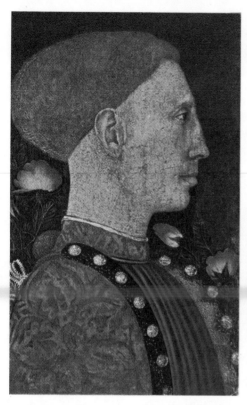

23 ANTONIO PISANELLO *Lionello d'Este*

24 ANTONIO PISANELLO *Virgin and Child with SS. George and Anthony Abbot*

25 ANTONIO PISANELLO
Vision of St Eustace

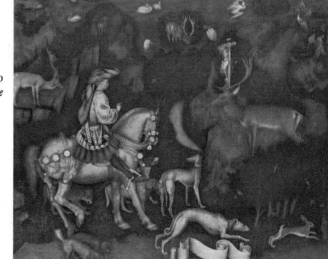

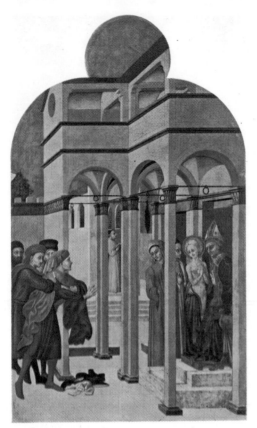

26 SASSETTA *St Francis renouncing his earthly father*

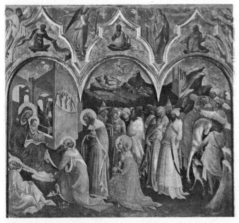

27 LORENZO MONACO *Adoration of the Magi*

quintessence of natural observation meditated on in tranquillity and freshly presented. His Magi setting out *(pl. 28)* might be the sprightly cavalcade of Chaucer's pilgrims, so crisply are people and costumes portrayed. And the flight of birds above the Magi is breathtakingly poetic, an image from real life put down with utter clarity. No problems assail Sassetta, and perhaps piety combined with natural ability (as with Fra Angelico) to present the simple, economical, touching scenes like that in which St Francis renounces earthly things *(pl. 26)*. All is medieval, long after the passing of the Middle Ages; indeed, the manner is quite archaic in the other great fifteenth-century Sienese, GIOVANNI DI PAOLO (1403-82/3), whose *St John in the Wilderness (pl. 29)* has the wild beauty of a lost cause: the last refinement of a style then out of date almost everywhere except in conservative Siena.

In Florence the last of the Gothic painters was MASOLINO *(c. 1383/4-1447?)*, possibly working early under Ghiberti on the first Baptistry doors but later touched into an awareness of new things by MASACCIO (1401-28). Masaccio was almost Giotto born again, into an age of reason. The achievements of the architect Brunelleschi and the sculptor Donatello, both men older than Masaccio, had already created a climate concerned with the two great questions of space perspective and anatomy. Florence itself was enjoying a rare period of calm and prosperity, while the Medici under Cosimo the Elder, grandfather of Lorenzo the Magnificent, were making themselves the first family in Florence, politically and artistically.

Working with Masaccio, Masolino gained a temporary monumentality. The *SS. Jerome and John the Baptist (pl. 30)* has been claimed for both painters, but if by Masolino has unusual weight and solidity. The two saints still remain partly Gothic, emerging from the conventional gold background to stand firmly on that earth which, in Gothic style, is embroidered with minute flowers. The transition to new concepts is not complete, and after Masaccio's premature death

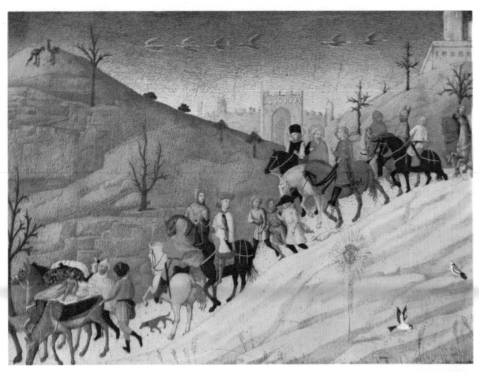

28 SASSETTA *Journey of the Magi*

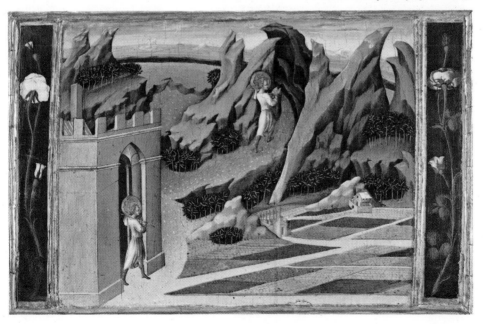

29 GIOVANNI DI PAOLO *St John in the Wilderness*

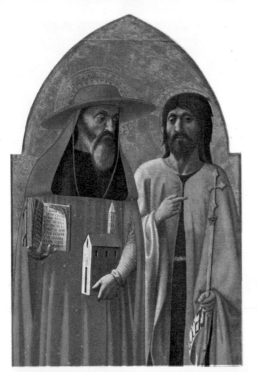

Masolino returned to the decorative style of his youth, apparent in the frescoes of 1435 in the Baptistry at Castiglione d'Olona *(pl. 31)*.

Masaccio's debt to Brunelleschi and Donatello is equalled by what he learnt from the example of Giotto. He went back to this source as if there had never been 'International Gothic'. His reply to Gentile da Fabriano's *Adoration* is the polyptych painted for a church at Pisa when he was twenty-five. Among the dispersed portions of this are the central panel of the *Madonna and Child (pl. 32)*, and the *Crucifixion (pl. 34)*. In comparison with Giotto's *(cf. pl. 2)*, Masaccio's *Madonna and Child enthroned* reveal not only new humanity—almost uncouth in the Child sucking its finger—but new knowledge in the boldly blocked-out throne, Brunelleschan in its classical form, with the cast shadow of the seated group falling across it. In the Brancacci family chapel of the Carmine church, Masaccio had the opportunity to work on an epic scale.

30 MASOLINO (?) *SS. Jerome and John the Baptist (detail)*

31 MASOLINO *Herod's banquet*

32 MASACCIO *Madonna and Child*

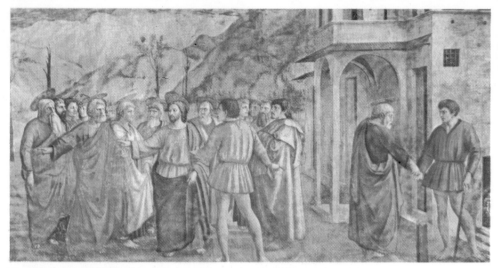

33 MASACCIO *Tribute Money*

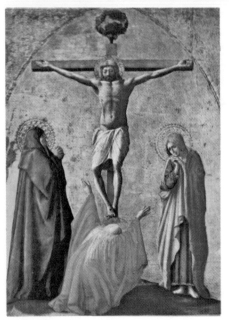

34 MASACCIO *Crucifixion*

Realism is now fully mastered, but remains austerely controlled; and his frescoes are the measured achievement of new thought *(pl. 35)* after meaningless repetition of Gothic forms. The *Tribute Money (pl. 33)* is set in a wintry landscape where the grave group of Christ and his disciples stand like stone figures, weathered but imperishable. Everything trivial and mundane is suppressed. The scene is lifted out of associations of time and place. A classical concentration is concerned with the human figure alone, and the faces are moulded with the massiveness of archaic sculpture. In the *Expulsion from Paradise (pl. 36)* the miserable nakedness of Adam and Eve contrasts with the dignified robed figures of the *Tribute Money* close by. The gateway to Paradise is barely suggested; all concentrates on the half-crazed despair of the slow-moving too human couple, Eve wailing and Adam dumb and blind with grief.

Leaving the Carmine frescoes probably unfinished, Masaccio went to Rome where he died prematurely. He had been little honoured, but Brunelleschi had been his friend and was left in Florence to mourn in his own words 'una gran perdita.' For long the Carmine frescoes served as a school of study for painters, and Leonardo, Raphael and Michelangelo all acknowledged an indebtedness to Masaccio.

35 MASACCIO *St Peter distributing alms*

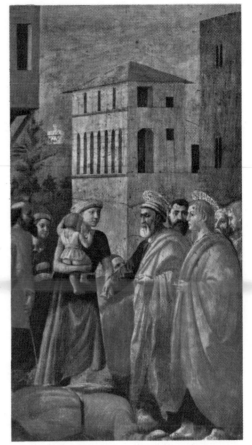

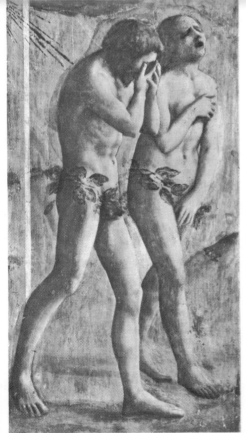

36 MASACCIO *Expulsion from Paradise*

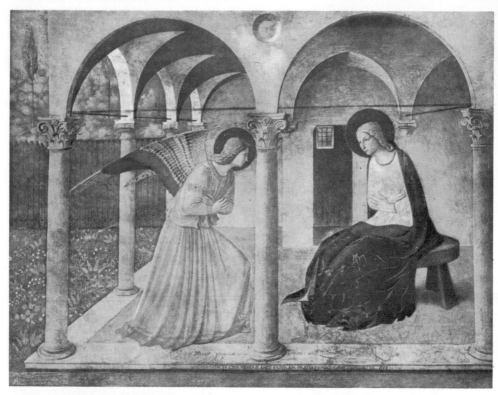

37 Fra Angelico *Annunciation*

The frescoes had an immediate direct effect on painters then in Florence, even on the Dominican Fra Angelico (*c.* 1400-1455) whose conservative training, possibly under Lorenzo Monaco, may have quickened his sense of colour but could never have helped him to the construction of a spatial world. In directness of telling the Christian story he rivalled Giotto, but with more charm, and it is difficult to avoid the word 'sweetness' *(pl. 37)*. His colour is almost heraldic in its intense blues and pinks; and the painter has all the candour of such colours. As well as the strong piety which Vasari records, and which everyone can sense in his work, there is strong confidence. Beyond the foreground *Deposition (pl. 39)*, lies the glowing formalised townscape framed by tall trees, almost cubist in its construction. Towards the end of his life Fra Angelico frescoed a small chapel in the Vatican with scenes from the lives of SS. Stephen and Lawrence *(pl. 38)*. The influence of Masaccio, of Brunelleschi too, is felt more than ever in the careful perspective of the architecture and solid, satisfyingly bulky, figures; while the colour retains a delicate intensity.

So far from being a mystic isolated from contemporary artistic ideas, Fra Angelico understood probably better than any other Florentine how to assimilate, and benefit from, Masaccio's example. Perhaps this was a sort of conservatism, for other painters pushed on more excitingly with researches into problems of space and movement. Absorption in movement gave rise in fact to a neo-Gothic linear interest unrelated to Masaccio's achievements, and culminating in Botticelli; while the great inheritor of Masaccio was to be the Umbrian Piero della Francesca.

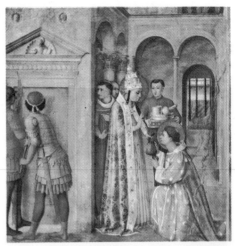

38 FRA ANGELICO *St Lawrence receiving the treasure of the Church*

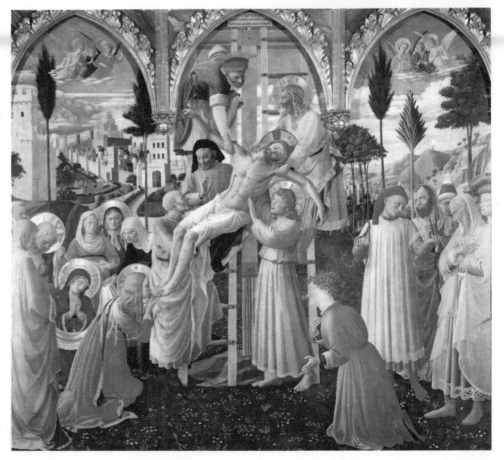

39 FRA ANGELICO *Deposition*

Problems of space certainly obsessed PAOLO UCCELLO (1397-1475), a friend of Donatello, whose careful geometrical structure is at first glance concealed under charming decorative detail. The *Hunt by night (pl. 42)* might seem almost medieval, its coursing dogs like illustrations to some early 'Livre de Chasse'; but the fallen tree trunks, the groups of riders and dogs are planned to lead into the central space, itself demarcated by the verticals of two trees, where the actual hunt takes place. The bloodless pageant battle, the *Rout of San Romano (pl. 41)*, is more elaborate still: dead men, broken lances, pieces of armour, litter the ground to persuade us that what we know to be the flat picture plane is really receding into space. Everything is curiously suspended and not quite real; and the soldiers, dead or alive, are suitable inhabitants of the nursery floor. Pure realism is not Uccello's ambition, but in his damaged fresco of the *Flood (pl. 40)* he seems to adopt a style harsher and more monumental than usual. Perhaps, like Fra Angelico, he returned in later life closer to the ideals of Masaccio.

Less obsessive about spatial problems but interested in effects of light, DOMENICO VENEZIANO (d. 1461) is rather more Brunelleschan than Masaccesque. A cool blonde

40 PAOLO UCCELLO *Flood*

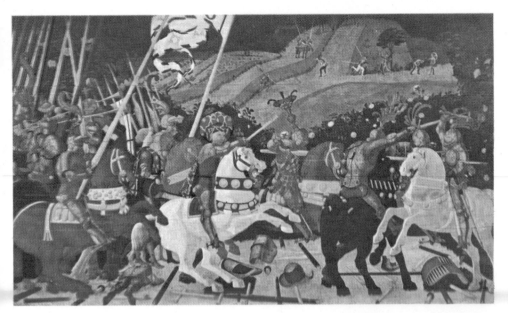

41 PAOLO UCCELLO *Rout of San Romano*

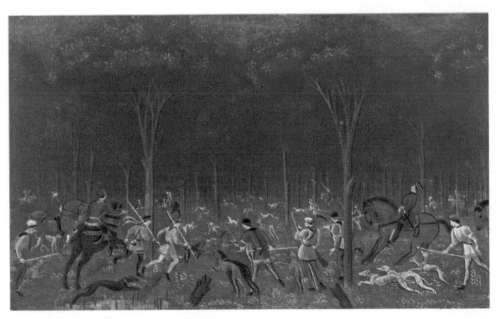

42 PAOLO UCCELLO *Hunt by night (detail)*

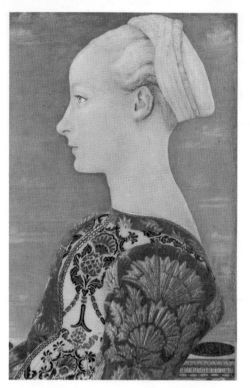

43 DOMENICO VENEZIANO(?) *Portrait of a girl*

light filters over the coloured architecture of the *St Lucy altarpiece (pl. 45)*, one of his only two surviving signed works, where four saints tranquilly meet in conversation with the Madonna and Child. Perhaps because of St Lucy's profile, the blonde and beautiful profile of a girl *(pl. 43)* is also sometimes attributed to Domenico. Its low relief and supple line reveal a positive avoidance of Masaccio's example; it is a masterpiece of Florentine fifteenth-century portraiture in another manner. This manner, in which line predominates lyrically, develops in the work of FRA FILIPPO LIPPI (*c.* 1406-69), an orphan placed in the Carmine monastery and possibly the pupil of Masaccio. His early fresco fragments in the Carmine *(pl. 46)* show that influence, and there is still a solidity and exploration of space in the *Annunciation (pl. 44)*, though already a new gracefulness animates the swaying Madonna. It is as if a just perceptible breeze was blowing; and soon it will rattle through stiff pine trees and set in wavering movement the gauzy draperies of Botticelli's personages. Meanwhile, Fra

44 FRA FILIPPO LIPPI *Annunciation*

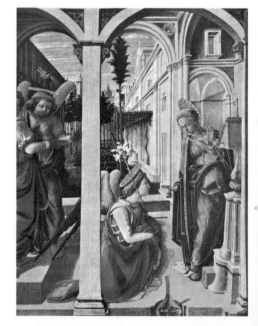

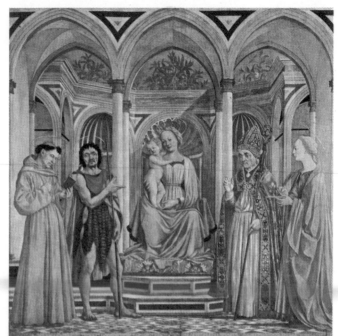

45 Domenico Veneziano
St Lucy altarpiece

46 Fra Filippo Lippi
*Confirmation of the
Carmelite Rule*

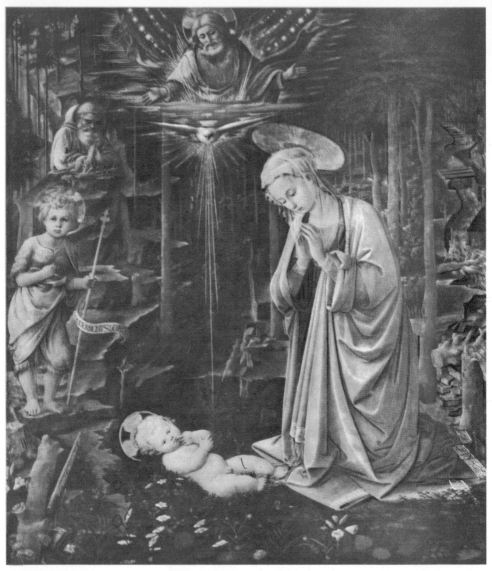

47 Fra Filippo Lippi *Adoration in a wood*

Filippo's own lyricism took on a tender religious note. A charming but almost naive piety is now apparent; and the *Adoration in a wood (pl. 47)* returns to the world not of Masaccio but of Gentile da Fabriano.

The breeze of movement has become a gale in the *David (pl. 49)* of Andrea Castagno (1423-57), with its harsh vigour and emphasis on the body in action. Closer to Donatello than to Masaccio, Castagno sought deliber-

ately statuesque effects in his series of famous men and women, more than life size and set against simulated marble *(pl. 48)*; they too have a wiry nervousness, a sense of energy only temporarily held in check, which runs like fire through the work of a younger man, Antonio Pollaiuolo (c. 1432-98), whose *David (pl. 50)* tensely bestrides Goliath's head. Pollaiuolo, with so many claims to interest, has never quite succeeded in

49 Andrea Castagno *David*

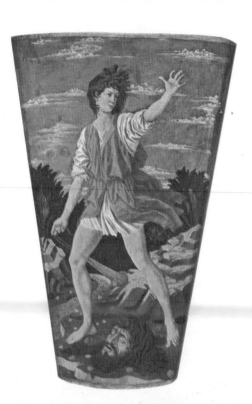

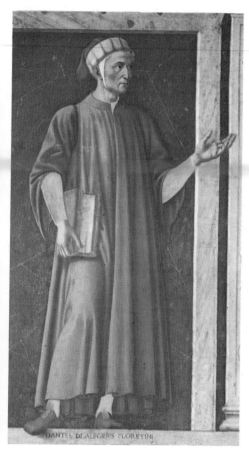

48 Andrea Castagno *Dante*

50 Antonio Pollaiuolo *David*

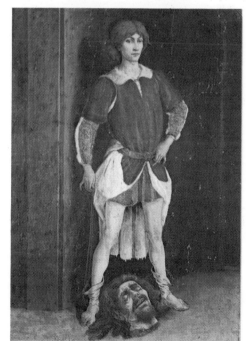

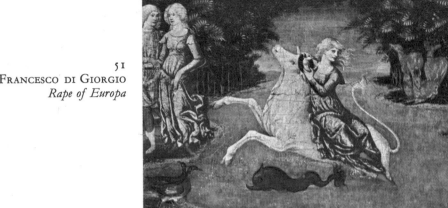

51
FRANCESCO DI GIORGIO
Rape of Europa

arousing it. Sculptor, engraver, goldsmith, as well as painter, he is typical of the all-round Florentine artist. He was one of the first to paint large-scale decorative scenes of pagan subjects. His large *Labours of Hercules* for the Medici palace long ago disappeared, but the fierceness of action in them is specially praised by Vasari. And the archers who ring round the defenceless saint in the *Martyrdom of St Sebastian* altarpiece *(pl. 53)* have a brutal, ferocious power; their muscular actions interest Pollaiuolo much more than does their passive victim. Not only is anatomy studied with scientific precision, but the landscape is recorded with equal exactitude. The poetry of motion in more gentle mood is exquisitely conveyed in the tiny *Apollo and Daphne (pl. 52)*, perhaps originally decorating a piece of furniture. The landscape is a stretch of Tuscan countryside, Apollo is a young Florentine, and there is the same sense of effortless telling of classical story as in the enchanting *Rape of Europa (pl. 51)* by the contemporary Sienese FRANCESCO DI GIORGIO (1439-1501/2).

But a new sophisticated interest in antiquity is expressed at Florence in SANDRO BOTTICELLI (*c.* 1446-1510), a painter largely indifferent to problems of perspective and anatomy. His ostensibly pagan pictures

52 ANTONIO POLLAIUOLO *Apollo and Daphne*

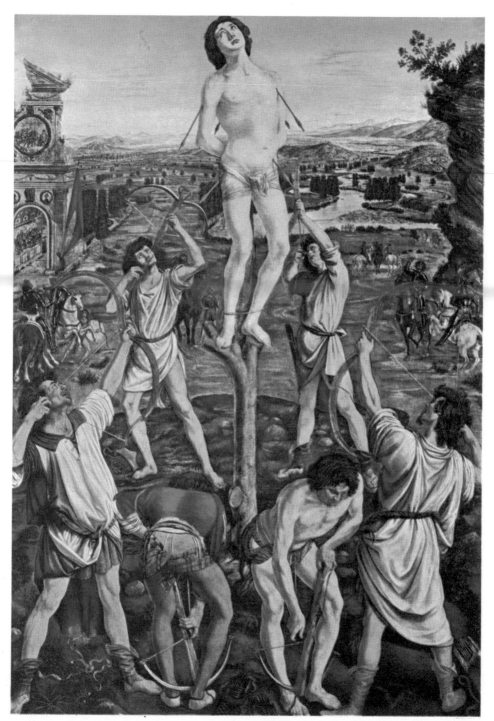

53 ANTONIO POLLAIUOLO *Martyrdom of St Sebastian*

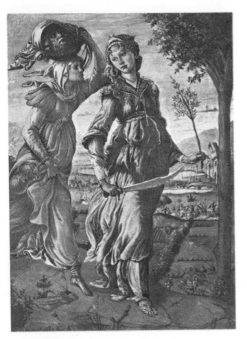

54 SANDRO BOTTICELLI *Judith*

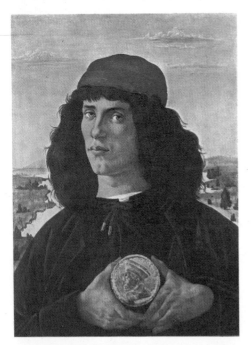

55 SANDRO BOTTICELLI *Man with a medal*

were for a narrow literary and aristocratic circle, fashionably neo-Platonic, while his altarpieces and religious pictures were inevitably easier to appreciate and for a wider audience. From the climate of the period he assimilated what he needed, very much as Fra Angelico earlier had done. Different as the two painters are, they share this ability to adopt the discoveries of others in pursuit of their own uniquely personal vision. That hesitant grace with which Judith returns home *(pl. 54)* is inherited by Botticelli from Lippi; something of Castagno's virility is felt in the *Man with a medal (pl. 55)*. But both pictures have a moody beauty which is Botticelli's alone. He was far from indifferent to realism; the striking portraits of the Medici and their friends make insignificant the Lippi-style Holy Family in the *Adoration of the Kings (pl. 57)*. The theme, so popular with that Medici family of citizen-kings, is treated in a way which at first glance seems little different from Lippi's but a knowledgeable spectator could appreciate it on another level—almost as a group portrait, with three generations of the Medici present.

Obscure layers of philosophical and literary meaning may exist without any diminution of beauty in the *Primavera (pl. 56)*, painted for a young cousin of Lorenzo the Magnificent. Venus appears as goddess of love not just in the conventional sense but as Lucretius apostrophised her: goddess of all generative powers. At the right, at Zephyr's touch, Flora is metamorphosed into the Spring and scatters pink and white roses on the grass; above, blind Cupid shoots a fiery dart at one of the dancing trio of Graces, she who has already pensively turned towards Mercury. And Venus raises a hand as if to bless that union. In a later picture, the *Birth of Venus (pl. 59)*, the now nude goddess is blown half sadly to land, and must lose her divine nakedness now that she comes among men.

If the *Primavera* is like a tapestry, the *Birth of Venus* is a bas-relief where light modelling only emphasises the singing line which traces the air-borne entwined pair of Winds

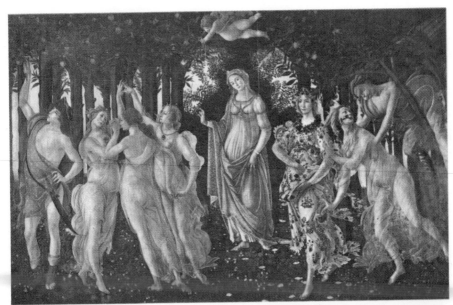

56 SANDRO BOTTICELLI *Primavera*

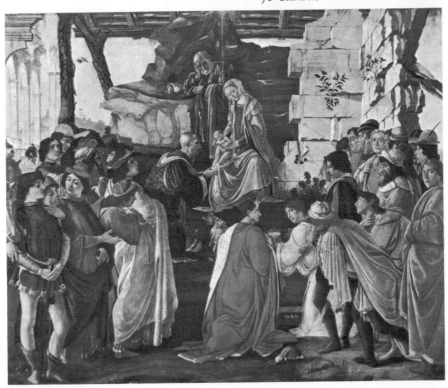

57 SANDRO BOTTICELLI *Adoration of the Kings*

58 BENOZZO GOZZOLI *Journey of the Magi (detail)*

about whom the pink roses fall, and the shrinking arabesque of the lonely Venus poised on her perfectly fluted shell. Botticelli is not mechanically following some learned programme drawn up by a tame humanist; the subject of both these great pictures has sprung his imagination. They are probably the first mythological paintings to breathe an intensity previously reserved for Christian subjects.

Botticelli's very late pictures are shaken by emotion, ecstatic with joy or grief. The *Pietà (pl. 60)* is almost a cry of pain. The black-clad Madonna swoons in the agony of the moment, and the smooth nearly un-

wounded corpse of Christ is collapsed over her knees in ghastly stillness. This mourning over the beardless young god has a pagan note of despair, as if it was Adonis slain rather than Christ.

There could be no inheritor of Botticelli's gifts. His last years seem to have been spent in retirement, and perhaps in religious meditation. Florence was passing chaotically out of stability and prosperity under Lorenzo de' Medici into a new age. The last attempt at a medieval 'city of God' was the gloomy theocracy established at Florence under the Dominican Savonarola, who came from Fra Angelico's monastery of S.

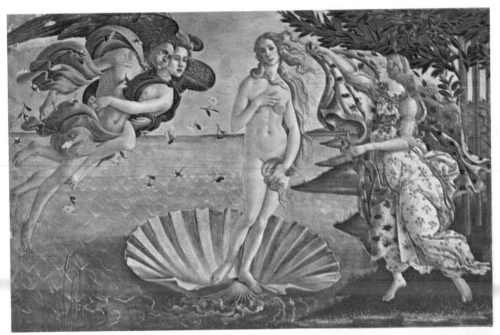

59 SANDRO BOTTICELLI *Birth of Venus*

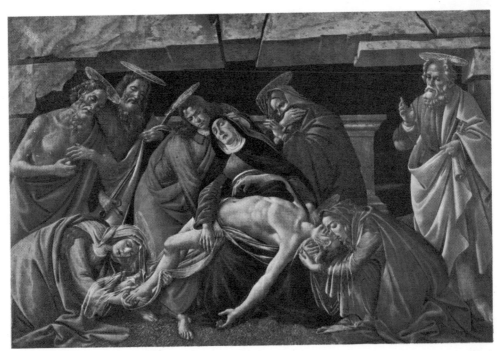

60 SANDRO BOTTICELLI *Pietà*

Marco. His prophetic preachings may have influenced Botticelli's religious opinions; they profoundly impressed the young Michelangelo. Florence seemed to renounce artistic and worldly vanities in the public bonfires of such things, pictures included. But in 1498 it was Savonarola who, at the Pope's request, was publicly burnt.

New artistic standards were soon to make the Florentine fifteenth century appear only the dawn of painting. But within its comparative security a painter like BENOZZO GOZZOLI (c. 1421-97) could contentedly practise a sort of harmless decorative naturalism, seen at its most charming in his frescoes of the *Journey of the Magi (pl. 58)* in the small chapel of Palazzo Medici. Painted during the hot summer of 1459, the frescoes, made brilliant by the gold and azure of which Benozzo could never have enough, are a pageant of Medici portraits under Gentile da Fabriano-style trappings.

More penetrating realism is apparent in the *Birth of St John* fresco *(pl. 63)* by DOMENICO GHIRLANDAIO (1449-94), an illustration of contemporary Florentine life, again with recognizable portraits. Ghirlandaio's realism has a Flemish tinge; not only was he influenced by van der Goes' *Portinari altarpiece (cf. pl. 125)*, but he had a Flemish respect for simple facts; and the unidealised quality of the *Old man and boy (pl. 61)* is part of its tenderness. Ghirlandaio ran an active important studio and was one of the most popular and prolific painters of the day. Based on the discoveries of Giotto and Masaccio, his art conserves rather than pushes forward. His *Adoration of the Magi (pl. 62)*, painted after a stay in Rome, has the novelty of some Roman ruins; but shows no awareness of the new language already apparent in Leonardo's treatment of the theme *(cf. pl. 171)*, of some five years earlier.

Meanwhile, fifteenth-century Italy saw the establishment of great schools of painting outside Florence. Yet these, however they developed, certainly felt the pervasive Florentine influence. Some painters were directly attracted to the city, like the young

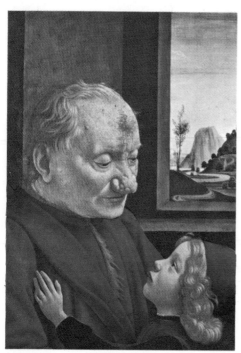

61 DOMENICO GHIRLANDAIO *Old man and boy*

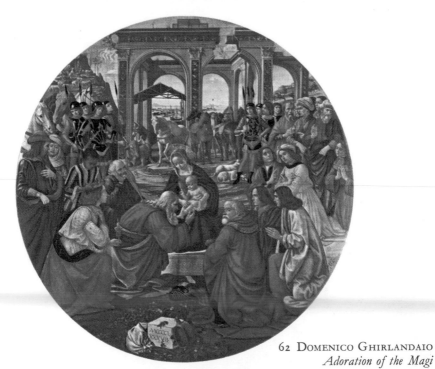

62 DOMENICO GHIRLANDAIO
Adoration of the Magi

63 DOMENICO GHIRLANDAIO *Birth of St John (detail)*

PIERO DELLA FRANCESCA (*c.* 1420-92) who worked under Domenico Veneziano and then returned to his small home town of San Sepolcro in Umbria. Today Piero's is a central name in any history of art. Sixty years ago Wölfflin wrote a still much praised book about the Italian High Renaissance and its antecedents, 'Die Klassische Kunst', and never mentioned Piero della Francesca. Yet some Umbrian sense of balance passed from him to Perugino and thus to Raphael. The lesson of Masaccio was filtered to Piero through Domenico Veneziano's blonde art, but from the first Piero's own pearl-like radiance softly sculpts his grave people. Despite the archaic, flat gold background, the early *Madonna of Mercy (pl. 64)*, with its pale tonality and simple statuesque gravity, gives a sense of space explored. The stillness of the moment again and again in Piero lifts the scene outside time—and it is this fourth dimension that he seems also to explore *(pl. 66)*. Forever the Baptist pours a bright thread of water over the head of that Christ who, seen fully frontally, seems

64 PIERO DELLA FRANCESCA
Madonna of Mercy

65 PIERO DELLA FRANCESCA *Federigo da Montefeltro*

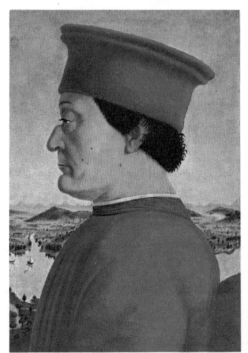

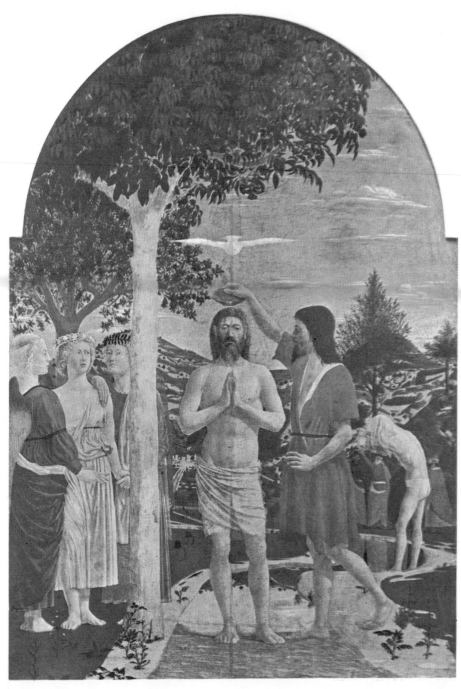

66 Piero della Francesca *Baptism*

67 PIERO DELLA FRANCESCA *Nativity*

to grow from the ground with the natural dignity of a tree; and the dove seems to hover eternally in space. No gesture disturbs the absolute silence.

The zone Piero creates for his people is coolly luminous; light like water washed of all impurities plays about them, fining away everything that is not essential and holding the whole scene from dissolution *(pl. 70)*. Light absorbs rather than reflects; there are no surfaces resistant to it and it falls evenly over the profile of the Renaissance scholar-soldier, *Federigo da Montefeltro (pl. 65)*, and luminously embraces the wide watery stretch of river valley beyond. The cold blues and silver-greys of the *Nativity (pl. 67)*, tones not to be comparably manipulated again until Vermeer, suggest the sunless early morning before colour has finally returned to things, and yet the outlines are clear.

In such a chill world Christ rises in the fresco immediately confronting the spectator on entering the Palazzo Communale at San Sepolcro *(pl. 69)*. Far from any of the great artistic centres, this culmination of Giotto and Masaccio was achieved. Naturalism is subordinated to significance; Uccello-like, trees and the tomb firmly establish a vertical and horizontal frame in which Christ stands sternly majestic, judge rather than saviour. His eyes are fully open, somnambulistically staring; the moment of resurrection is more painful than glorious, and the wound in his side still bleeds.

Piero's is a lonely achievement. He left no school of docile pupils, though Signorelli and Perugino traditionally studied under him. Blind and in retirement at San Sepolcro, he spent his last years not painting but in writing theoretical treatises. His interest in perspective probably influenced MELOZZO DA FORLÌ (1438-94) whose fresco, *Platina appointed Vatican Librarian (pl. 68)*, combines acute portraiture with an architectural perspective setting of virtuoso elaboration.

With LUCA SIGNORELLI (1450-1523) Piero's influence quickly yielded to a passion for the nude inspired rather by the example of

68 MELOZZO DA FORLÌ *Platina appointed Vatican Librarian*

69 PIERO
DELLA FRANCESCA
Resurrection

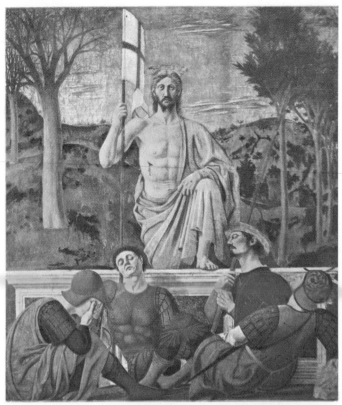

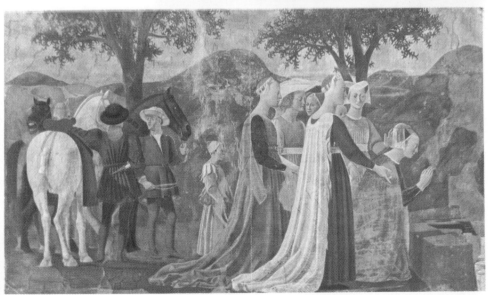

70 PIERO DELLA FRANCESCA *Queen of Sheba adoring the wood of the True Cross*

71 LUCA SIGNORELLI *Holy Family*

72 ANTONIO VIVARINI and GIOVANNI
D'ALEMAGNA *Madonna and Child*

Pollaiuolo. In the background of his harsh
and strange religious pictures where the
Holy Family are sometimes brutish *(pl. 71)*
often occur groups of brooding nudes, fit
denizens of Signorelli's arid landscapes and
the subject of his real interest. His sardonic,
satiric powers spring into genius at Orvieto
cathedral where he frescoed a terrifyingly
dramatic *Last Judgment (pl. 73)*. Angels
blow vast trumpets and out of a sandy desert,
blasted of all vegetation, the dead begin to
stretch and rise. Gloating devils, not
grotesque caricatures but human and mus-
cular, carry off the damned. The living
groan and are smitten by the fire which falls
from the darkened heavens. The whole
scheme anticipates Michelangelo in its
passionate delineation of the nude from
every angle, used to express a gamut of
emotions, and in its apocalyptic fury; while
its sense of desolation is even deeper.

But it was in the North of Italy that a great
school of painting was now to develop, cen-
tering finally in Venice, largely opposed to
Florentine ideals despite debts to Florence.
Uccello and Castagno had both worked
at Venice; and at Padua there were not only
Giotto's frescoes but sculpture by Donatello.
Venice, with its Eastern trade links, had long
remained wrapped in a Byzantine dream.
The heavily gilded, elaborate altarpieces *(pl.
72)* produced by the brothers-in-law AN-
TONIO VIVARINI (*c.* 1405-76/84) and GIO-
VANNI D'ALEMAGNA (*d.* 1450?), are still
Gothic in feeling, oriental in ornament and
relying chiefly on line and pattern for their
effect.

More than elsewhere, the Renaissance of
painting in North Italy was inspired by a
single artist, ANDREA MANTEGNA (*c.* 1431-
1506). He early worked at Padua, in a
chapel of the Eremitani church, close to the
Arena chapel but less fortunate in being
almost totally destroyed by bombing in
1944. Here, where Antonio Vivarini and his
brother-in-law had earlier worked, Mantegna
revealed an intellectual approach to painting
which makes Uccello's work seem child's
play. The *St James martyred (pl. 74)* is
austerely but elaborately conceived, with

73
LUCA
SIGNORELLI
Last Judgment
(detail)

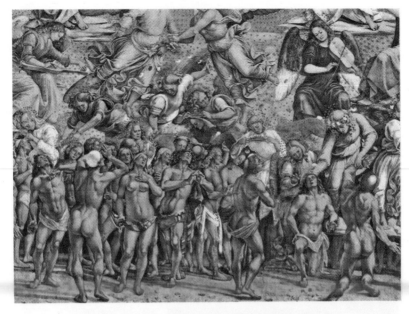

74
ANDREA
MANTEGNA
Martyrdom of
St James

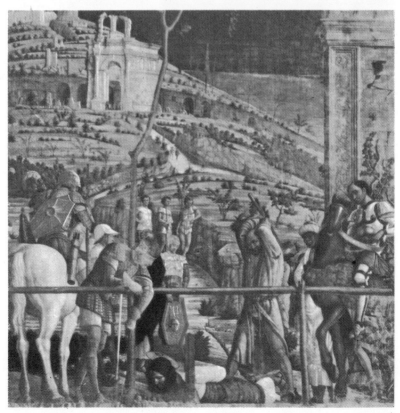

75 ANDREA MANTEGNA *Meeting of Ludovico II with Cardinal Francesco Gonzaga*

76 ANDREA MANTEGNA *Death of the Virgin*

a novel, almost *trompe l'oeil*, effect of the foreground fence, the ground receding steeply out of view and then twisting into terraces of the rising hill behind. St James's martyrdom hardly notices amid these calculated effects. Everything is observed with remorseless clarity, and everything has the grim hard outlines of stone and steel. Mantegna's passionate classicism inspired his archeological detail; but even without Roman antiquity he would still have created this marble world where forms are fossilised into rigidity. Donatello's influence doubtless encouraged his love of feigned stone and twisted metal, but it was Mantegna's nature to expose and then petrify each object, plotting its place in a scheme. The *Crucifixion (pl. 77)* is conceived on a bare stone platform, thrown back from the spectator by the device of the truncated foreground soldier; and the effect is once again theatrical.

Mantegna's grasp on realism is the secret of his formalising powers. He was able to insert into the background of the *Death of the Virgin (pl. 76)* a view of the lakes surrounding Mantua which possesses almost microscopic accuracy. Settled at Mantua as court painter to the Gonzaga family, he combined realism and formalism in the frescoes of the Gonzaga court in the Camera degli Sposi of their palace *(pl. 75)*. It is an achievement similar to Melozzo's *Platina* fresco *(cf. pl. 68)* but on a much larger scale. Within an ingenious simulated framework of painted pilasters, the family and their courtiers, horses, dogs, are placed with penetrating realism. No occasion more solemn is recorded than Ludovico Gonzaga's meeting with his Cardinal son. Life in a petty Renaissance duchy is seen apparently as unidealised as if by Ghirlandaio; but Mantegna's classical tendencies, shared by his patrons, result in backgrounds where grandiose Roman buildings and statues adorn the landscape of fact. Like Poussin after him, Mantegna was naturalised in antiquity. Poussin might have looked with pleasure at the *Parnassus (pl. 78)*, painted in 1497 for Isabella d'Este's Mantuan 'studio',

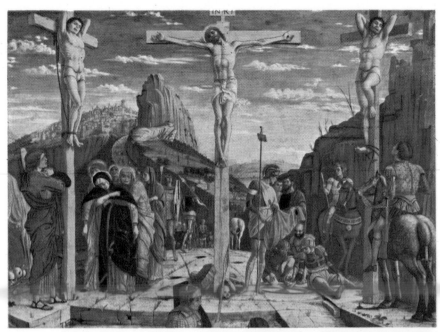

77 ANDREA MANTEGNA *Crucifixion*

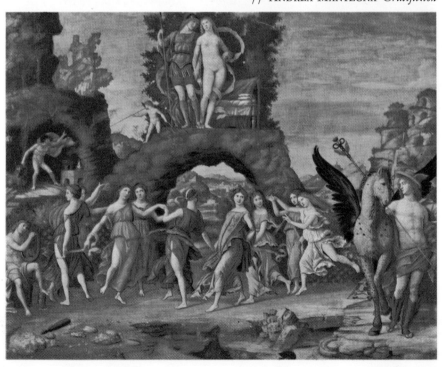

78 ANDREA MANTEGNA *Parnassus*

79 COSIMO TURA *Pietà*

80 FRANCESCO DEL COSSA *April*

which actually arrived in France in 1630. Severe learning is mitigated here by the poetic frieze of decorously dancing Muses and the charming spotted Pegasus against whom Mercury negligently leans.

The stony sculptural side of Mantegna's art had its influence in another small duchy, that of the Este family at Ferrara. In this provincial city COSIMO TURA (before 1431-95) evolved a style more tortured and fantastic than Mantegna's: metallically decorative like the *Allegorical figure (pl. 82)*, perhaps Spring, seated on a polished throne of mummified marine creatures, their eyes jewelled like Fabergé objects, but with a spiny writhing vitality. The draperies are as if damped and then crinkled, wrapped in complex folds about this figure of almost affected sentiment. Less metallic and more crystalline is the air of the *Pietà (pl. 79)* where a monkey crouches up in a sparse orange tree, and the distant figures and landscape have all the delicacy of glass.

In the work of Tura's rival, who was possibly his pupil, FRANCESCO DEL COSSA, (1436-78), a super-clarity illumines the figures *(pl. 83)*; every sinew of St John's arm is visible, and the rocky tunnels and arches behind are painted with hallucinatory effect. It was probably Cossa who also produced the more genre-like and less fantastic *Autumn (pl. 81)*, earthily compacted with something of Piero della Francesca's quality, a reminder that he too had worked at Ferrara. Both Tura and Cossa were employed in decorating Este palaces and in that of Schifanoia (its name, 'Sans Souci', suggesting its purpose as a retreat from care) Cossa was the chief artist of an astrological fresco series of the Months. His *April (pl. 80)* is part courtly pageant and part love-making in rustic surroundings, evoking a considerably more cheerful atmosphere than that of Mantegna's Gonzaga court. Yet it was these small courts which commissioned mirror-like fresco schemes of their activities. There seems to have been no urge towards such secular depictions at Florence, even under the Medici.

Ferrara is an isolated incident in the history of art. Mantegna much more importantly

81 FRANCESCO DEL COSSA *Autumn (detail)*

83 FRANCESCO DEL COSSA *St John the Baptist*

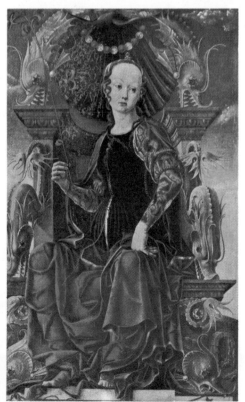

82 COSIMO TURA *Allegorical figure*

84 GIOVANNI BELLINI *Pietà*

85 GIOVANNI BELLINI *Madonna of the Meadow*

affected personally the first of the great Venetians, his brother-in-law, GIOVANNI BELLINI, (*c.* 1430-1516), under whom painting at Venice could soon challenge Florentine supremacy. Alone of Italian states, Venice remained a European power until 1797; and it is the only city with a distinguished school of painting extending from the fifteenth century to the close of the eighteenth century. Throughout that long history it was light and colour which fascinated the Venetians. Bellini's triumph was to release in his pictures such light and colour as had never been seen before. Already in the quite early *Pietà (pl. 84)*, where a Mantegnesque clarity of draughtsmanship delineates the bodies, the rippling stream, and the stony hills, there is a unity of tone which fuses the cold colours of the draperies and the dead flesh with the cool early dawn sky. What is here still tentative becomes warmly glowing in the central part of the *Coronation of the Virgin (pl. 87)*. The Madonna is half bathed in shadow but light catches her bent fingers and falls fully on Christ. The coloured marble throne is cut open to make a frame for the sensuous landscape beyond, where castellated turrets climb the green hill into the liquid sky.

Soon the landscape ceases to be mere background. The *Transfiguration (pl. 86)* shows a completely realised natural landscape in which Moses and Elias appear to Christ. The mountain mentioned in the Gospels becomes this undulating pastoral countryside where a peasant drives his ox and two people stop to talk on a road. There is none of Mantegna's mathematical planning and dry handling. Instead, a quite new feeling in painting for clouds, trees, grass, for all the phenomena of the natural world, is united to an instinctive sympathy for the Christian story in human terms. In his many versions of the theme of Virgin and Child, Bellini conceives them always as a tender group of maternal love. The Child sleeps in the *Madonna of the Meadow (pl. 85)*; the life of the fields goes on unheeding and only the Virgin prays over her Son who is one day to lie dead in her lap. Light and air and water make one elemental

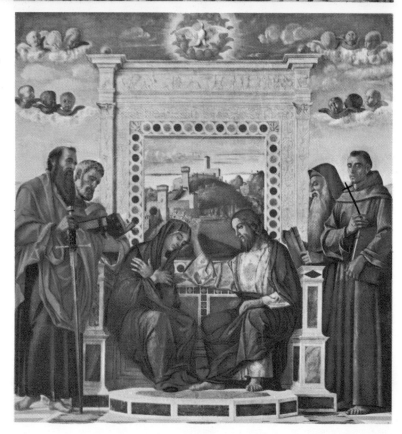

86 GIOVANNI
BELLINI
Transfiguration

87 GIOVANNI
BELLINI
*Coronation of
the Virgin*

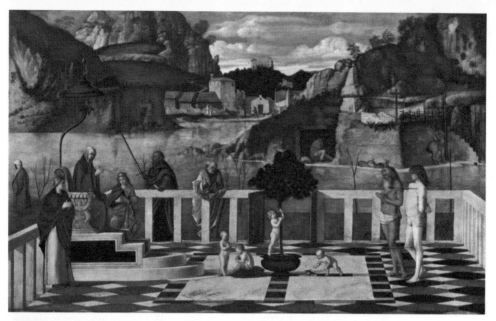

88 GIOVANNI BELLINI *Earthly Paradise*

envelope of the so-called *Earthly Paradise (pl. 88)* with its caressing atmosphere of sunlight. Like the figures, the landscape seems locked in a dream; the clouds drift slowly in the heavy air; only the children have energy enough to shake the apples from the dark-leaved tree, and the other figures move with dream inconsequence. No doubt it is a sacred allegory and certain saints, most obviously St Sebastian, are recognizable. Yet the picture is the first of a new type, to become popular in Venice with Giorgione and his followers, in which subject matters less than mood.

In portraiture also Bellini prepares the way for subsequent developments. His *Doge Leonardo Loredan (pl. 90)* is one of the first of those state portraits in which all the majesty of the Venetian Republic is blended with the individual. Swathed like a mummy in his stiff state robes, the Doge seems to incarnate wisdom and power. Light firmly models the head and shoulders, the folds of white and gold brocade, the gilded nut-like buttons; but none of this dims the forceful

characterisation of the man himself, the exploration of bone structure under the skin, and the pleats in the skin even amid shadow. From an area of only three square feet the whole bust emerges with a sense of largeness of design, confidently turned to meet the impact of falling light.

Part of Bellini's confidence comes through new freedom in the handling of oil paint as a medium. Oil had been often applied tentatively to the dry tempera medium in which powdered colour is mixed with a binder, usually egg. Bellini began only gradually to work in pure oil paint, but with it he achieved glowing luminous effects of flushed skies, polished marble, richly coloured draperies, which became typical of the splendours of the Venetian school.

The technique of oil painting was already practised by a South Italian painter, ANTONELLO DA MESSINA (*c.* 1430-79) who had possibly seen Flemish oil paintings and who arrived in Venice about 1475. His early pictures had more than a tinge of Flemish realism; and the *St Jerome in his study (pl. 89)*

90 GIOVANNI BELLINI
Doge Leonardo Loredan

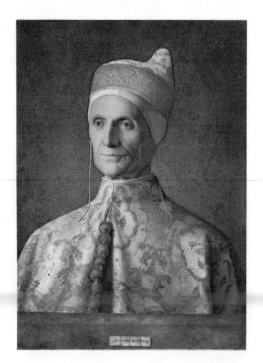

89 ANTONELLO DA MESSINA
St Jerome in his study

91 ANTONELLO DA MESSINA
Portrait of a man

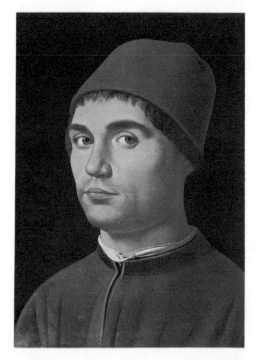

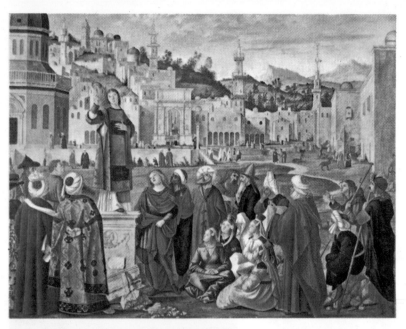

92 VITTORE
CARPACCIO
*Preaching
of St Stephen*

might well, with its complicated interior and
minute detail, be a Northern work. Anton-
ello's portraits probably had some influence
on Bellini. His sitters are bathed in strong
light which accentuates and enamels every
feature, their eyes glassy and bold, and their
costumes of controlled opulence *(pl. 91)*.
Damaged though it is, the *St Sebastian (pl.
94)* remains a triumph of Antonello's
manipulation of light on a much larger scale:
with the saint solidly modelled, and far behind
him the pale shadows and sunny surfaces of
an idealised townscape animated by citizens.
Like a close up of such people is the picture
of the so-called *Courtesans (pl. 93)* by
VITTORE CARPACCIO (active 1490-d. 1525/6),
a Venetian genre scene where two ladies
Colette might have written about enjoy a
breath of fresh air on the balcony, surrounded
by their pets. Antonello's architectural con-
structions probably had their influence on
Carpaccio, and the buildings in the *Preaching
of St Stephen (pl. 92)* form an almost abstract
screen across the picture's background. The
foreground is filled by a variety of exotic
costumes and exemplifies Carpaccio's ten-
dency to turn religious pictures into genre of

93 VITTORE CARPACCIO *Courtesans*

94 ANTONELLO
DA MESSINA
St Sebastian

a pageant kind. Carpaccio remains partly under a Gothic spell, though hardly so far under it as CARLO CRIVELLI (active 1457-d.95) who deserted Venice and settled in the provincial Marches. There his Vivarini-inspired style took on malevolent intensity. His Madonnas, warped by piety, brood like witches over the sickly Child *(pl. 95)*. The mood melts into highly wrought ornamentation in the *Annunciation (pl. 96)* of 1486, a riot of carpets, peacocks, fruit and furniture. Even here, a sharp-eyed little boy peers round the corner with a weird Gothic glance almost cynical. The *Annunciation* is a blazing farewell to the Middle Ages, to the love of linear effects and brilliant patterns, to the passion for adorning every inch of the picture area.

At Venice the achievements of the High Renaissance originate with Bellini. When Dürer met him there in 1506 he found him an old man but, 'still the best painter of them all.' The aged master was capable of a surprising pagan picture as late as 1514 when he produced the *Feast of the Gods (pl. 97)* for Alfonso d'Este at Ferrara. As we see it now, this picture is considerably altered by Titian, traditionally Bellini's pupil; but enough of Bellini's conception remains. Like Shakespeare's late plays it is the result of a new manner given currency by followers of the master and then borrowed back by him.

* * *

Throughout the early Renaissance there had been a growing awareness of Northern art. Some Flemish painters had visited Italy; others came in the person of their paintings. Along with the classical bronzes, gems and manuscripts collected by the Medici at Florence, were Flemish tapestries. From Flanders had come the secret of the new painting in oil. The conditions in the North were very different from those of Italy; but there too great painters were at work.

95 CARLO CRIVELLI *Madonna and Child*

96 CARLO CRIVELLI *Annunciation*

97 GIOVANNI BELLINI *Feast of the Gods*

II
THE RENAISSANCE IN NORTHERN EUROPE

IT IS NOT in sculpture or mosaic that Northern European painting originated but rather in illuminated manuscripts. Meticulous detail remains a typical quality of Northern art until the appearance in the seventeenth century of Rubens. Michelangelo's famous if not totally accurately recorded judgment reveals an Italian artist's awareness of the very different standards existing in the North: 'In Flanders they paint with a view to external exactness...'

To Michelangelo all such work lacked harmony, symmetry, proportion. And it is true that the Northern painters made man no demigod, preferring to record him just as he was, highly conscious of mortality, usually clothed rather than naked, and with careful depiction of the world he lived in. That world can be contrasted with the Mediterranean one of Italian artists, where Greece and Rome were a part of natural inheritance and where a kinder climate made even the imagination warm. The North was dark and cold and damp—no place for frescoes. It is as if lack of light and space had constricted the painters: endless intricate detail serves in place of larger harmonies.

The impact on the North of Sienese art—epitomised by Simone Martini at Avignon—resulted in the blended courtly product called 'International Gothic'; and which indeed crossed the frontiers of most European countries. Just as in Italy, this style, far from being unrealistic, filled the picture with as much realistic detail as possible; it naturally found a home at princes' courts where its exponents were often the craftsmen employed on pageant ceremonies, designing costumes and banners and colouring statues. MELCHIOR BROEDERLAM (active 1381-d. 1409?), painter to Philip the Bold, Duke of Burgundy, completed in 1399 an early example of the style in a pair of shutters for an altarpiece *(pl. 98)* miniaturistic in effect, and somewhat Sienese in style. All Broederlam's secular decorations for the Duke have utterly disappeared: his painting of the mechanical apparatus at one of the Duke's castles which was used as a joke for soaking the guests with water, and

98 MELCHIOR BROEDERLAM
Flight into Egypt (detail)

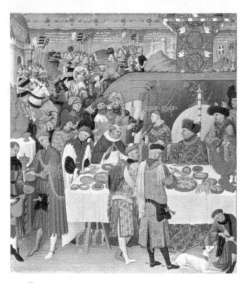

99 LIMBOURG BROTHERS *January*

100 Style of JAN VAN EYCK
Finding of the Crosses

the ships which he painted blue and gold. Something of the splendour of this world is preserved, however, in the Book of Hours which the three brothers LIMBOURG (all dead by 1416) painted for the Duke of Burgundy's brother, the Duc de Berry, one of the great French collectors and patrons. He ransacked Europe and the East for rarities, managing to acquire among them St Joseph's wedding ring. The page of *January (pl. 99)* from the 'Très Riches Heures' shows the Duke feasting, and its sumptuous colour and decorative detail are the quintessence of the courtly style which in fact a new type of realism was about to replace.

France itself was gradually ceasing to be the leading power of Europe, while the Low Countries under a new Duke of Burgundy, Philip the Good, grandson of the other Philip, rose in power and importance. In 1435 Philip the Good concluded the treaty of Arras, humiliating for France while confirming the freedom of Flanders from French control. Two years earlier the Duke had had occasion to reprove his accountants for their failure to verify his letters patent for his well-beloved equerry and painter, the like of whom for 'art et science' could not be found, JAN VAN EYCK (active 1422-d.1441).

In Jan van Eyck the Duke had obtained the services of a painter very different from the International Gothic practitioners. Van Eyck's new realistic art was, like Bellini's, based on awareness of light and made possible by his use of oil paint. Nor did the Duke have a monopoly of his services; employed by Italians settled in the Low Countries as well as by personages at the Burgundian court, van Eyck was a few years after his death renowned in Italy, Spain and Germany. The extraordinary verisimilitude of his work is praised by the fifteenth-century Italian humanist, Fazio, who knew pictures by him now lost, and whose words breathe admiration of their minuteness of detail and control of light. Van Eyck may have begun as a miniaturist, but the few miniatures *(pl. 100)* associated with him are probably echoes of his mature work rather than actually by him – as used to be supposed. His firmly spatial,

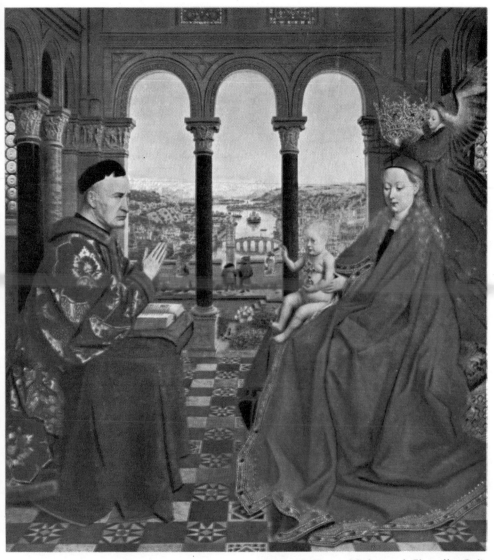

101 JAN VAN EYCK *Madonna of Chancellor Rolin*

atmospheric achievement is beautifully con-
veyed by the *Madonna of Chancellor Rolin* (*pl.
101*), with its virtuoso grasp of interior and
exterior. The eye follows the perspective
patterned tiles, pierces the pillared arches and
gazes over the battlements to the river
winding away in sunlight beyond. Through-
out the picture's small area everything glows
with the intensity of a jewel; the texture of
metal, velvet, stone, is conveyed with pre-

cision. There is an almost medieval feeling
for the quality of each object, and for its
symbolic meaning; the Madonna and Child
are as solidly realistic as Nicolas Rolin,
kneeling suspicious and tight-lipped before
them. Like Rolin himself, the picture stresses
wealth; it is a private vision to the Chancellor
alone and by special arrangement the Christ
Child blesses him who in life seemed to con-
temporaries so regardless of spiritual things.

Van Eyck's pursuit of flawless reality and his dispassionate recording created also the unique masterpiece of *Giovanni Arnolfini and Giovanna Cenami (pl. 104)*, dated 1434, a purely bourgeois commission. Probably it is the solemn moment of the betrothal of these two Italians living in Flanders which is shown; but the picture remains a piece of genre which to the casual eye seems unceremonial. It is an interior to compare with the Dutch interiors of the seventeenth century. Chancellor Rolin knelt in an elaborate palace of marble and glass, but the bedroom where this couple plight their troth is plain and ordinary with cast-off shoes on the floor, oranges on a chest, a rosary on the wall. Fixed within this perspective cube, between the converging planes of ceiling and floor, the two people take on a solemn air, befitting the ancestors of group portraiture. Only the legal-style lettering of the signature prominent above the mirror 'Johannes de Eyck fuit hic' is unrealistic.

The *Adoration of the Lamb polyptych (pls. 102, 103)* dedicated in 1432, in the church of St Bavon at Ghent, is full of literal depiction of the imagery in Revelation. There is a certain lack of coherence in this

102 JAN VAN EYCK *Music-making Angels (from Adoration of the Lamb polyptych)*

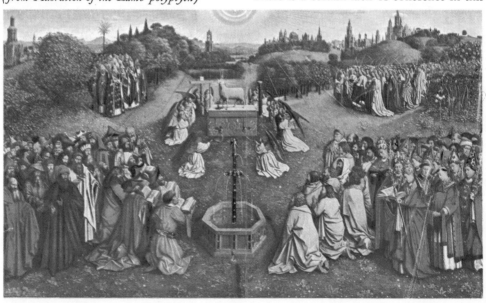

103 JAN VAN EYCK *Adoration of the Lamb (detail)*

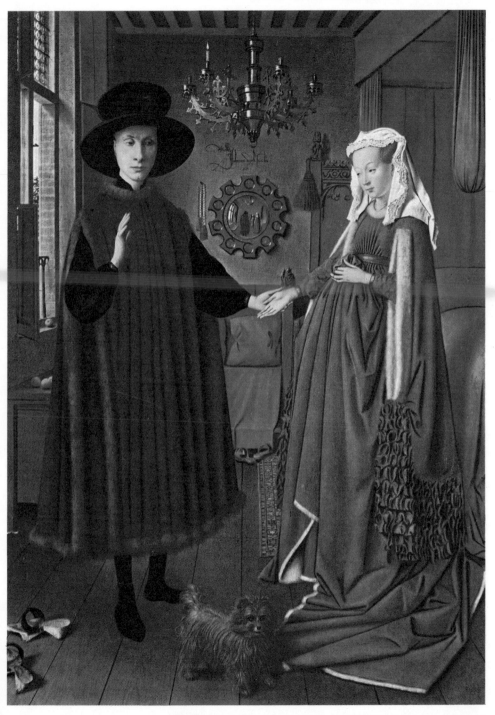

104 JAN VAN EYCK *Giovanni Arnolfini and Giovanna Cenami*

105 Petrus Christus *Portrait of a Carthusian*

106 Ascribed to Campin *Portrait of a man*

elaborate altarpiece as it stands; and this may reasonably be connected with the fact that according to an inscription on it Jan van Eyck carried through a task begun by his brother Hubert. Virtually nothing is known of this brother, and most of what is now visible in the Ghent altarpiece is probably by Jan or modified by him.

With Jan van Eyck, the first Fleming to sign his work, the individual quality and the chief direction of Northern European painting during the Renaissance was declared. His marvellous manipulation of oil paint was imitated as far as possible, and reality was pursued with as much as possible of his spirit. His probable pupil Petrus Christus (d. 1472/3) brought something of his ability especially to portraits *(pl. 105)* which have less austerity than van Eyck's, and a clear affinity with those of Antonello da Messina. *(cf. pl. 91)*.

But there already existed a rather different style of 'realism' practised by the Master of Flémalle who is conceivably the same person as the painter Robert Campin (1378/9-1444) working at Tournai. There was nothing courtly in this art but from the first a sort of clumsy forcefulness lacking elsewhere in the Low Countries. As much detail as in van Eyck can be seen in the altar wing of *St Barbara (pl. 107)* painted for Heinrich von Werl of Cologne in 1438; the setting is a thoroughly bourgeois interior of the period, and St Barbara sits comfortably reading with her back to the fire in homely fashion. St Joseph in the so-called *Mérode altar (pl. 109)* is more carpenter than saint, as he sits working away at a mouse trap (itself a symbol of the way the Devil traps souls); and his slightly absurd appearance is perhaps no accident at a time when he was often mocked in literature. There is a bold air to the *Portrait of a man (pl. 106)*, attributed to the same painter, and a particular vigour in the folds of his strong red turban. Campin's feeling for individual colour is shown in the mauve-white dress the Virgin wears as she nurses the Child in a town interior *(pl. 108)*; and it is almost a humorously realistic touch to make her halo not of the con-

108 ROBERT CAMPIN *Virgin and Child before a firescreen*

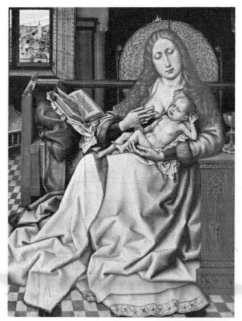

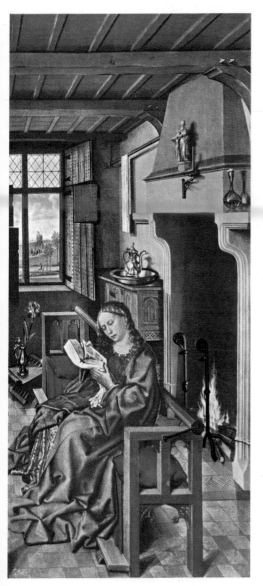

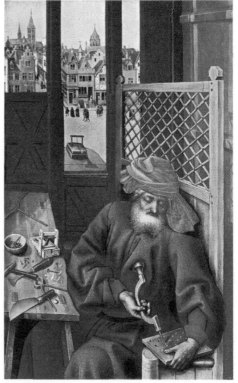

107 ROBERT CAMPIN *St Barbara*

109 ROBERT CAMPIN *St Joseph (from Mérode altar)*

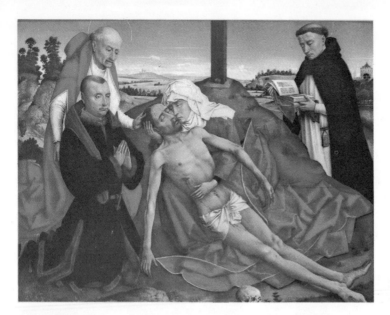

110 ROGIER VAN
DER WEYDEN
Pietà

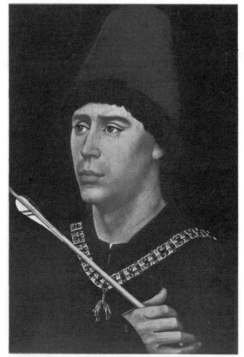

111 ROGIER VAN DER WEYDEN
Antoine de Bourgogne

ventional gilded kind but from what is in
fact the wicker-work firescreen.

In Campin's studio ROGIER VAN DER WEYDEN
(1399/1400-64) was trained. He settled in
Brussels where he became city painter, and
though holding no court appointment he was
much patronised by leading members of the
Burgundian court, Chancellor Rolin among
them. What had been plebeian and uncouth
in Campin remains in Rogier's work still
human but has become poignant. In place
of van Eyck's cold prismatic effect which
held reality embedded as if in a glass paper-
weight, there is a warmer, more sympathetic
atmosphere and less insistence on recession
in space. Rogier's technical gifts, great as
they are, are subordinated to the mood of the
picture. The *Pietà (pl. 110)* juxtaposes the
vivid portrait of the donor to the tragically
lifeless corpse of Christ, and delicacy in the
actual paint gives a tender poetry to the
whole. In the large-scale *Deposition (pl. 112)*
Rogier reveals his ability to organise without
awkwardness a monumental composition,
moulded like a sculptured group and standing
out in relief against a deliberately plain back-
ground. Combined with pathos—expressed
almost hysterically in the Magdalen wringing
her hands at the right—is once again power-

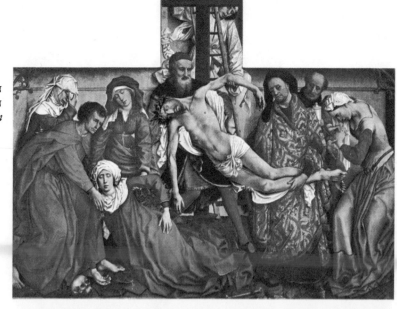

112 ROGIER VAN
DER WEYDEN
Deposition

113 ROGIER VAN
DER WEYDEN
*St Columba
altarpiece*

114 AVIGNON SCHOOL *Pietà*

ful characterisation, especially of Nicodemus and Joseph of Arimathea. Rogier's men have all the vigour of Campin's but a new sensibility: calmly proud, usually melancholy, profoundly moving likenesses in which the personality asserts itself over any religious pretext *(pl. 111)*.

Rogier's influence was perhaps more powerful even than van Eyck's; the humanity of his style and its emotional reality were immediately appealing. Campinesque realism had been refined by Rogier, examples of whose work could be seen in Italy (where he had travelled in 1450) and in Germany, where the *St Columba altarpiece (pl. 113)*, for a church at Cologne, profoundly affected painters. At Bâle Konrad Witz *(p. 82)* painted with almost Pre-Raphaelite clarity. In France a new feeling for realism produced the stark poignancy of the *Pietà (pl. 114)* from Villeneuve-les-Avignon, by an unknown fifteenth-century artist. The tooled gold background is a Gothic hangover, but the broken body of Christ, supported by St John, and the head of the kneeling donor are observed in a new manner with strongly articulated bone structure. The leading French painter of the time, JEHAN FOUQUET, (*c.* 1420-81?), created the bizarre diptych of Etienne Chevalier, treasurer to the King, kneeling with his patron St Stephen *(pl. 115)* before a fashionable Madonna (possibly his mistress) surrounded by blue and red cherubim *(pl. 116)*. The Madonna and Child panel is wooden and awkward; but the spare sinewy quality of Chevalier, and the sculpted face of St Stephen, whose single stone is wonderfully hard and quartz-like, reveal a grasp on reality confirmed in Fouquet's incisive single portraits.

The Flemings did not escape Rogier's influence. HANS MEMLINC (d. 1494) was traditionally his pupil and suffers from the proximity. His quietistic vein of piety results in

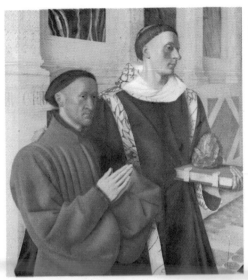

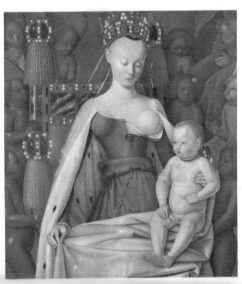

115 JEHAN FOUQUET *Etienne Chevalier* 116 JEHAN FOUQUET *Madonna and Child*

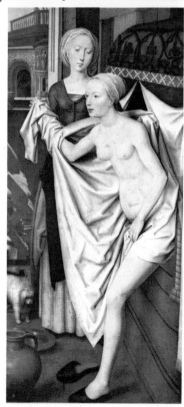

117 HANS MEMLINC *St John* 118 *St Lawrence* 119 HANS MEMLINC *Bathsheba*

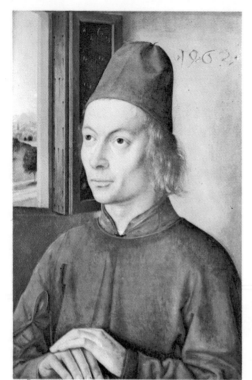

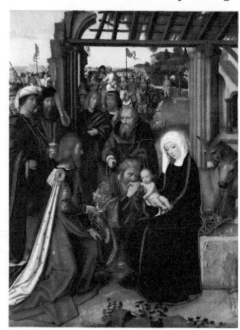

pleasing pictures, delicately painted *(SS. John and Lawrence, pls. 117, 118)* and, once in the unexpected nude *Bathsheba (pl. 119)* who, though undernourished, is a welcome change from the near insipidity of much of Memlinc's work. Memlinc settled at Bruges, and the city where Jan van Eyck had lived grew increasingly conservative as the century progressed. Bruges was retiring commercially and artistically into the placidity it still retains, while Antwerp, where a new style of painting was soon to be practised, rose in importance. Well into the sixteenth century the tradition was preserved at Bruges by GERARD DAVID (d. 1523) whose *Adoration of the Kings (pl. 121)* is a re-stating of old themes, competently but unexcitingly handled.

A much more considerable personality coming under Rogier's influence was DIERIC BOUTS (c. 1415-75) a native of Haarlem who settled at Louvain. Even in the mid-eighteenth century when the Primitives were quite out of fashion, indeed little known, Mozart's father praised Bouts' pictures at Louvain. For the town hall there Bouts painted the *Justice of the Emperor Otto (pl. 122)*, one of his few certain works, and its restrainedly rich colour and grave realism is a homage to Rogier. Like so much Flemish art, it hardly succeeds in conveying the drama of this scene when a woman clasped without harm a bar of red-hot metal and thus proved her veracity. The slender elegant witnesses express only mild surprise at the event, which might indeed as painted by Bouts pass for a piece of everyday genre. A more intimate side of his talent is seen in the perceptive *Portrait of a man (pl. 120)*, once thought to be the artist in hospital clothes recovering from illness, and the legend pays tribute to the frail beauty of the portrait, with creased plum-coloured hat and gown setting off the pale features.

Amid so much withdrawn and imperturbable art, the pictures of HUGO VAN DER GOES (d.

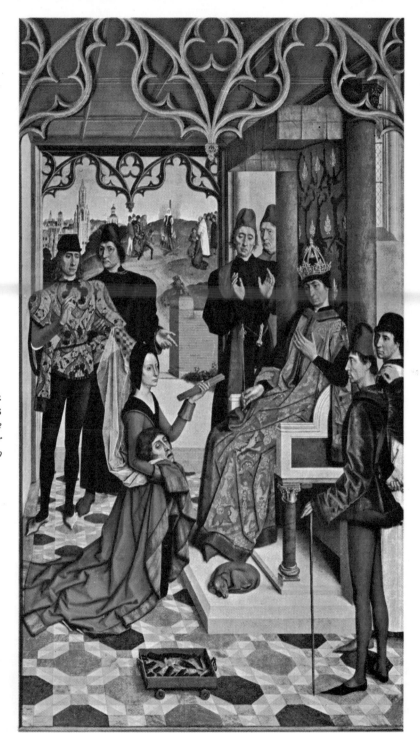

122
DIERIC BOUTS
*Justice of the
Emperor
Otto*

1482) are disturbed and almost 'expression-ist' in their forcefulness. And very different from the calm existence of, for example, Memlinc, van der Goes became a victim of religious melancholia and died mad. He is not afraid of grotesqueness; around the Madonna's deathbed the Apostles gape and gesticulate *(pl. 124)*; and the shepherds peer with peasant curiosity at the new-born Child, in the *Portinari altarpiece (pl. 125)*. A rougher and more personal touch replaces the velvet finish of Eyckian tradition, and the concepts are on a bold scale. This altarpiece of about 1475, painted for Tommaso Portinari, has nearly lifesize saints, firmly characterised donors, and in the right wing *(pl. 126)* a landscape where bare trees rise into a winter sky, anticipating Bruegel's *Dark day (cf. pl. 166)*. But it was hardly seen in Flanders, being quickly despatched to Florence where it certainly impressed Ghirlandaio.

The North Netherlands produced at Haarlem not only Bouts but also a painter who remained active there about the same time, ALBERT VAN OUWATER (*c.* 1450). In Ouwater's sole surviving certain composition, the *Raising of Lazarus (pl. 123)*, the restriction of space, and figures within it, results in a mild explosion of drama which centres on

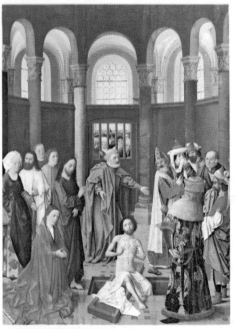

123 ALBERT VAN OUWATER
Raising of Lazarus

124 HUGO VAN DER GOES
Death of the Virgin

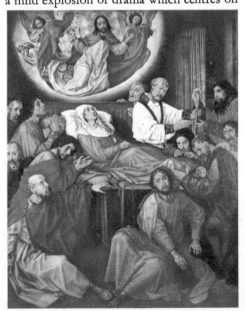

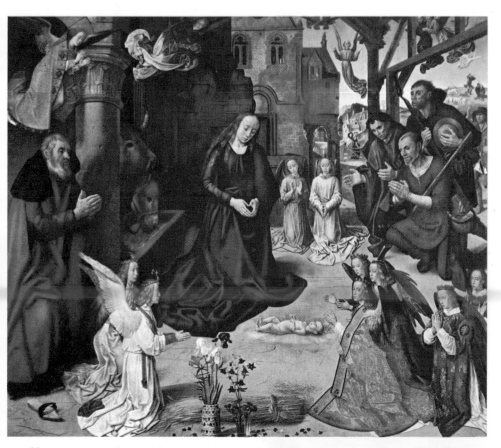

125 HUGO VAN DER GOES *Adoration of the Shepherds (from the Portinari altarpiece)*

126 HUGO VAN DER GOES
*Female saints and donors
(from the Portinari altarpiece)*

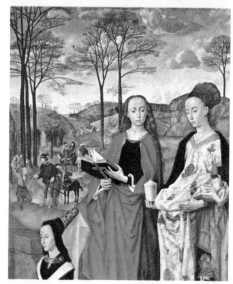

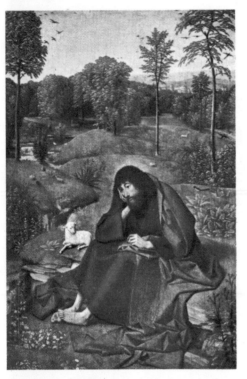

127 GEERTGEN TOT SINT JANS
St John the Baptist

the newly-risen Lazarus. To emphasise depth, the foreground man at the right is daringly turned away completely from the spectator, and only his back is visible. Ouwater was early praised for his landscapes, and perhaps some echo of these is present in the *St John the Baptist (pl. 127)* by his pupil GEERTGEN TOT SINT JANS (died late fifteenth century). The wilderness is more like an earthly paradise, with its stream and birds, rabbits, deer; only the melancholy St John, literally twiddling his toes, is isolated from this natural beauty and subordinated to it. Landscape becomes the picture's subject. Geertgen died in his late twenties, but his few pictures are all highly personal, with almost orientally impassive figures, unusual light effects and this new development of landscape.

Beyond the North Netherlands and Flanders lay the enormous expanse of Germany where lack of a real central power resulted in different artistic centres being established in petty kingdoms and free cities. Stimulated by Flemish and Italian example, regional schools of painting grew up, often in isolation from each other, and the great achievements of German painting are lonely personal achievements by one or two artists.

During the fourteenth century the Holy Roman Emperor, Charles IV, created prosperous stability, and his court at Prague encouraged the most exotic 'International Gothic' style, seen at its luxurious peak in the *Glatz Madonna (pl. 130)*. This is half courtly, half pious, with its archbishop-donor a tiny humble figure before the imperial enthroned Virgin who holds a sceptre and is presented with an orb.

The hegemony of Prague collapsed, artistically and politically, after Charles' death. And the last refinements of this style passed to Cologne. The Gothic linear *Madonna of the Sweet Pea (pl. 129)*, by an unknown early fifteenth-century artist, has a soft grace and feeling for pattern which remain typical. The sentiment and the means of expression are little altered in the charming *Rose-garden Madonna (pl. 128)* by STEPHAN LOCHNER (d. 1451). This calmly sweet style, still

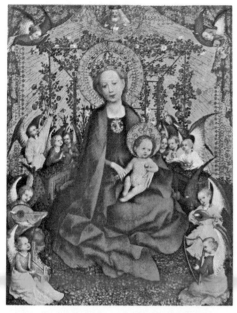

128 STEPHAN LOCHNER *Rose-garden Madonna*

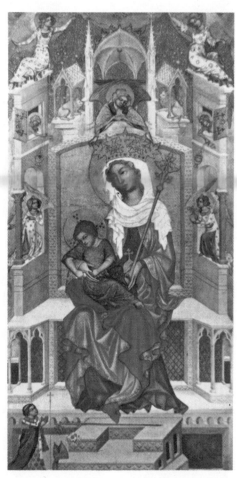

130 BOHEMIAN MASTER *Glatz Madonna*

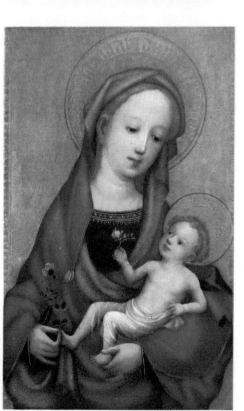

129 COLOGNE MASTER
Madonna of the Sweet Pea

131 MARTIN SCHONGAUER *Madonna (detail)*

132 MASTER OF THE LIFE OF THE VIRGIN
Conversion of St Hubert

Gothic in effect, resisted disturbance. The influence of Bouts and Rogier is certainly strong in the MASTER OF THE LIFE OF THE VIRGIN (active late fifteenth century) whose *Conversion of St Hubert (pl. 132)* might be taken for provincial Flemish work. It remains Gothic and tapestry-like in the landscape background, but St Hubert's cast shadow reminds one that it is later work. Yet outside Germany this picture would have seemed archaic and out of date.

Indeed, while Lochner was still alive KONRAD WITZ (1400/10-44/6) at Bâle had already assimilated the lesson of Campin and in the *Miraculous Draught of Fishes (pl. 133)*, dated 1444, turned the lake of Galilee into a recognizable view of the lake of Geneva. Witz's handling, which looks so smooth in reproduction, is in fact surprisingly rough. But the hallucinatory clarity which sees the depths of rippling water with reflections in it, the dotted trees on the abrupt slopes of the shore, is a naturalistic vision of a revolutionary kind—as bold as the bulky scarlet-clad Christ who glides over the glassy lake. Such similar angular sculptural effect appears again in German painting only with the pictures of the Tyrolean painter-sculptor MICHAEL PACHER (*c.* 1435-98) who seems to have known the work of Mantegna and the Ferrarese, and conceivably Witz. His *SS. Gregory and Ambrose (pls. 134, 135)* are like polychromed sculpture, themselves virile and fully realised but enthroned under elaborate Gothic canopies.

They are still prisoners of their environment; and it was to release art from such bonds that ALBRECHT DÜRER (1471-1528) worked and wrote. He meant to study under MARTIN SCHONGAUER (*c.* 1435?-91), a painter much influenced by Netherlandish art, as his *Madonna (pl. 131)* shows, and important also as an engraver. Schongauer's Madonna is conceived in tragic terms, with Rogier-like pathos, as she looks at the thorny rose of sorrow she must pluck. This emotional realism probably impressed Dürer, but Schongauer himself died before Dürer could meet him. Italian art also profoundly affected Dürer, not only in his work but in

133 KONRAD
WITZ
*Miraculous
Draught
of Fishes*

134 MICHAEL PACHER
St Gregory
135 *St Ambrose*

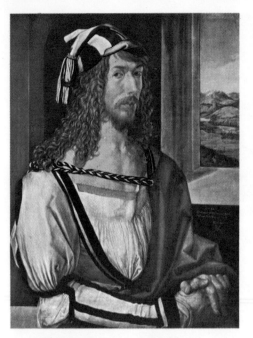

136 ALBRECHT DÜRER *Self portrait*

his high conception of the artist. He visited Italy twice and his life was one long journey towards new conceptions, new scientific facts: towards a profound synthesis of life and art. Though court painter to the Emperor Maximilian, and later to the young Charles V, he received little active encouragement in the self-imposed task which he carried out in provincial Gothic Nuremberg. His paintings give small indication of his range of interests, but already in the youthful *Self portrait (pl. 136)*, of 1498, he presents himself not as humble craftsman but elegant, fashionable, even vain—the ideal painter as Leonardo da Vinci wrote of him, at ease and 'dressed in the clothes he fancies.' Leonardo was the prototype for Dürer but Mantegna was a greater artistic influence; while personal contact with Bellini at Venice gave him more fluent, less crabbed, handling of paint.

Already in the *Adoration of the Magi (pl. 138)*, of 1504, his figures move with new freedom in the elaborate setting of ruined arches. The *Apostles (pls. 137, 139)*, presented by him to

137 ALBRECHT DÜRER
Apostles SS. John and Peter (detail)

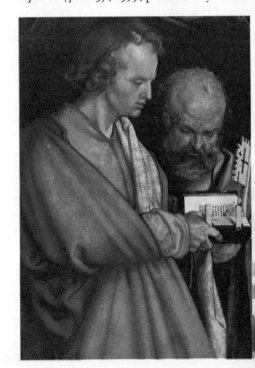

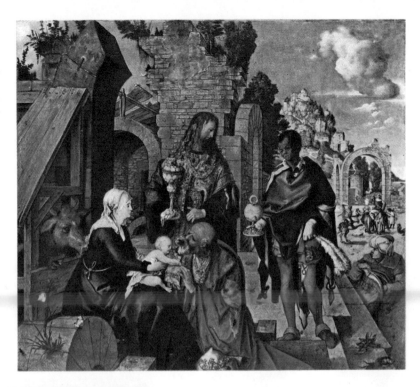

138 ALBRECHT
DÜRER
*Adoration
of the Magi*

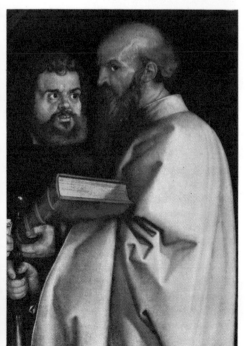

139 ALBRECHT DÜRER
Apostles SS. Paul and Mark (detail)

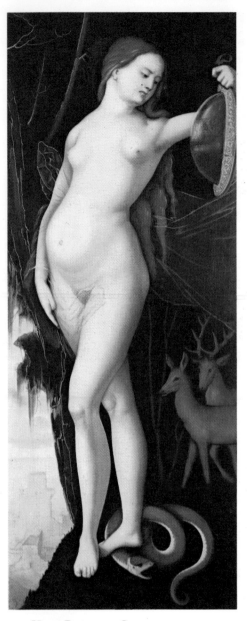

140 HANS BALDUNG GRIEN
Allegorical figure

Nuremberg in 1526, grandly and effortlessly
fill the whole picture area: a largeness of form
has simplified the voluminous robes, focus-
ing attention on their physiognomies in
which Dürer depicted types of temperament.
As a result of the Reformation he turned
what had been intended as saints in a 'con-
versation' with the Madonna into the Apos-
tles on their own. Perhaps accidentally, the
result is the most classic and restrained
painting of the German Renaissance.

Through his woodcuts and engravings,
Dürer's influence was colossal in Germany,
and it extended to Italy. His compositions
and his imagery inspired direct copies, vague
derivations or helped other artists to discover
their own talent. Very close to Dürer was
HANS SÜSS VON KULMBACH (*c.* 1480-1522).
His portrait of the *Margrave Casimir of Bran-
denburg (pl. 143)* has a zany intensity and a
psychological penetration typical of German
portraiture which seems always to be probing
the sitter—in marked contrast to the calm
acceptance of outward appearances in
Netherlandish pictures. The *Portrait of a man
(pl. 142)* by HANS BALDUNG GRIEN (1484/5-
1545), who possibly studied under Dürer,
has the same neurotic tenseness, with pale
staring eyes, and hair and beard like tingling
tangled wire. Such portraits have that sense
of unease which so much German art con-
veys. Baldung's enamelled paint makes de-
corative his white nudes *(pl. 140)* who pose
as allegories, often against jet black pine
trees; and like the allegories they seem to
belong in a Gothic environment, somewhat
bloodless for all their attempted elegance,
sophisticated and yet naive.

This Gothic environment was really one
with which German painters were instinc-
tively in sympathy. Elements of fantasy and
intricacy, and the emphasis upon line, never
far below the surface in Baldung, break out
more exuberantly in other artists. Hardly
recognizable as a classical scene is the
Judgment of Paris (pl. 141) by the Swiss
NIKOLAUS MANUEL DEUTSCH (*c.* 1484-1530)
which is as amusing as charming, and effort-
lessly fantastic as for instance in Venus's
winged headdress. In the pictures of LUCAS

142 HANS BALDUNG GRIEN
Portrait of a man

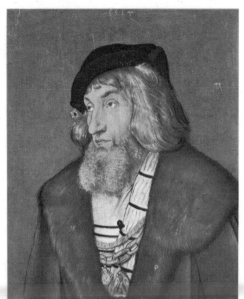

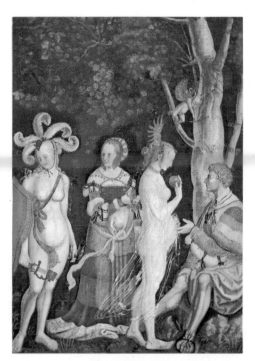

141 NIKOLAUS MANUEL DEUTSCH
Judgment of Paris

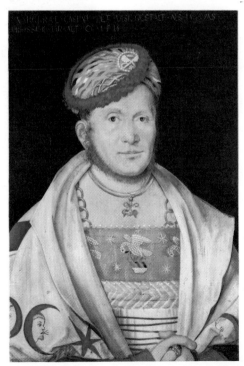

143 HANS SÜSS VON KULMBACH
Margrave Casimir of Brandenburg

CRANACH (1472-1553) a courtly fantasy refines both religious and classical subjects into etiolated nudes like the *Venus and Cupid (pl. 144)* where line serves to suggest volume. Cranach early became court painter to the Electors of Saxony at Wittenberg, and to some extent his position and his concomitant factory production of pictures dried up the natural observation on which his style was based. The *Rest on the Flight (pl. 145)*, dated 1504, is set in a wild Danubian landscape where tall trees struggle into the intense blue sky. But the mood is tranquil. Nature alone fashioned this deep green world which almost smells of pine woods, where baby angels play around the Holy Family who no longer need the protection of a garden. The feeling for the Gothic quality in nature—patterns of pine trees against sky and luxuriant foliage—deepens in the work of ALBRECHT ALTDORFER (*c.* 1480-1538) until nature becomes the sole subject. In the depths of a forest St George encounters the dragon *(pl. 146)*, but the eye has to seek these figures amid the thick trees. The

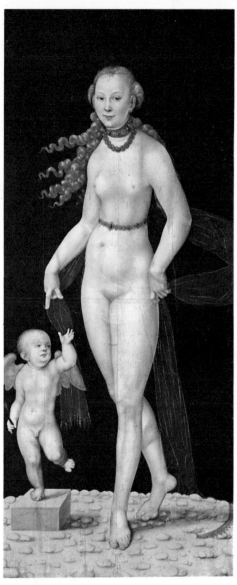

144 LUCAS CRANACH *Venus and Cupid*

145 LUCAS CRANACH *Rest on the Flight*

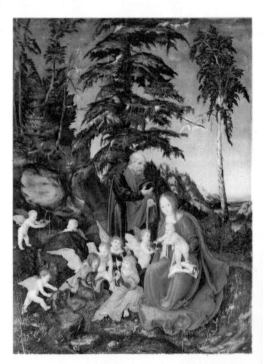

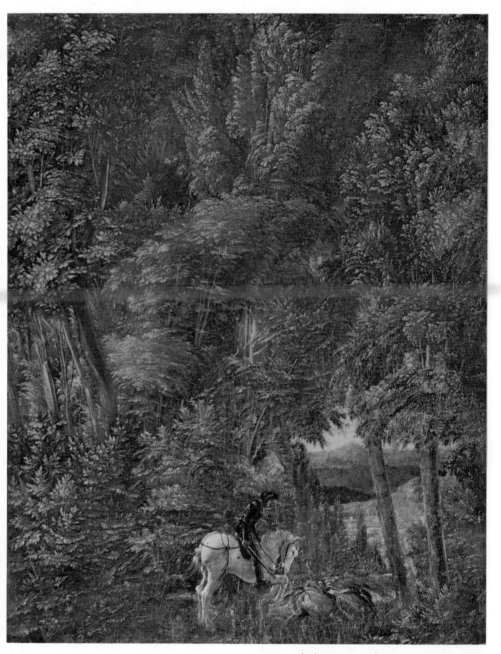

146 ALBRECHT ALTDORFER *St George*

147 ALBRECHT ALTDORFER
Danube landscape

148 GRÜNEWALD *SS. Maurice and Erasmus*

Danube landscape (pl. 147) is perhaps the first picture simply of scenery; and Altdorfer responds equally to the sky, painted with a marvellous aerial delicacy which captures the faint wreaths of cloud and the soft glow above the blue mountains. The picture possesses an immediacy which makes irrelevant the facts of Altdorfer's life as architect and councillor at Regensburg.

But the real force of German Gothic fantasy exploded in Dürer's contemporary MATHIS NEITHARDT GOTHARDT, called GRÜNEWALD, (*c.* 1470/80-1528), about whom little is known. A lost picture of his showed a nightmare scene of a blind hermit helped by a boy to cross a frozen river, and suddenly falling murdered on the screaming child. That ability to wring the nerves is already apparent in the brutal *Mocking of Christ (pl. 150)* where a bully raises his fist in a spasm of rage to beat Christ's blindfolded bleeding head. On the outside of the Isenheim altarpiece, painted for that Alsatian village but now in the tranquil museum at Colmar, the lacerated Christ expires in agony on the Cross and his hands turn up convulsively as if about to tear away from the rough wood *(pl. 149)*. Though it needs no emphasis, his body is made larger than those of his mourners; and at his feet the Magdalen almost insane with grief twists up to share the agony. In a panel visible only when the altarpiece was finally opened, the landscape of Cranach and Altdorfer has rotted away into wet moss-grown desolation where the hermit saints Anthony and Paul are seated *(pl. 151)*. There even the bird bringing food seems a scavenger, first of a flock of ragged-winged vultures.

This art is too passionate to bother with harmony. Everything is extreme and nearly everything is macabre. Even when less intense, as in a later work, *SS. Maurice and Erasmus (pl. 148)*, Grünewald gives an eerie quality to St Maurice's armour and his jewelled headdress proliferates as if alive. Grünewald betrays here his knowledge of Renaissance ideas of solidity and space—especially in the firm placing of St Maurice—but his violent imagery needed the emotional freedom of Gothic line. Ultimately he is

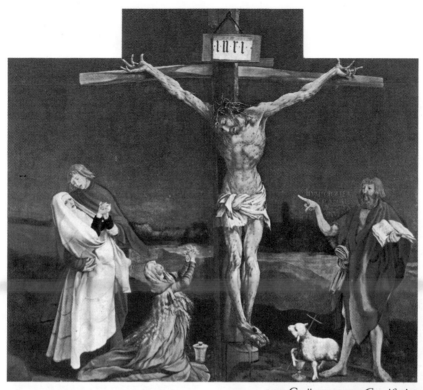

149 GRÜNEWALD *Crucifixion*

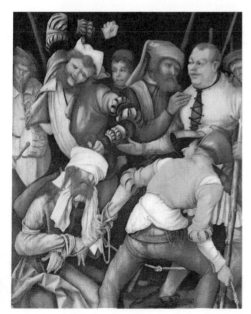

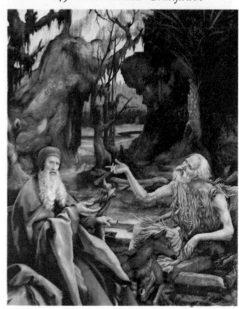

150 GRÜNEWALD *Mocking of Christ (detail)*

151 GRÜNEWALD *SS. Anthony and Paul (detail)*

concerned not with the real world but with states of mind. All that he shares with Dürer is loneliness of achievement.

Without Dürer's intellectual ambitions and utterly without Grünewald's religious intensity, HANS HOLBEIN (1497/8-1543) is the last of the great German painters. His triumphs, however, took place in Bâle and in London where he became painter to Henry VIII, whose appearance in posterity's eyes is Holbein's creation. For all the Italian influences in his pictures, fresco decorations and goldsmith's designs, the extraordinary and imperturbable realism of his portraits seems entirely his own creation. The *Madonna of Burgomaster Meyer (pl. 152)*, of 1525/6, is herself an insipid image, made the more so by the vivid flanking portraits of the burgomaster and his family. Yet reality is translated into linear terms, most obviously in the kneeling girl in white; she is all line and pattern, an only lightly shadowed silhouette who faces the much more Italianate and Raphaelesque boy kneeling opposite. Technical virtuosity gives place to a rare moment of personal intimacy in the *Artist's wife and children (pl. 155)*, of two or three years later. Its moving realistic portrayal of a sad-faced woman and two ugly children is more profound than Holbein cared to be with important or aristocratic sitters. He maps people's faces as impassively as he records the litter of their daily life—never more successfully fusing sitter and environment than in *Georg Gisze (pl. 153)* where the enamelled ball of string, the thick rug, the carnations in the glass vase, are painted with flawless grasp of shape and surface. These forms surround but do not overwhelm the Hanseatic merchant fixed forever in his London office with that timeless quality shared by van Eyck's Arnolfini pair. In his drawings Holbein's dexterity matched his feeling for character, but a court portrait like *Jane Seymour (pl. 157)* is as decorative and detailed as the queen on a playing card—and with no more personality. Despite his ability to probe, the painter prefers to return to linear pattern-making.

It was not only in Germany that the Italian

152 HANS HOLBEIN *Madonna of Burgomaster Meyer*

153 HANS HOLBEIN *Georg Gisze*

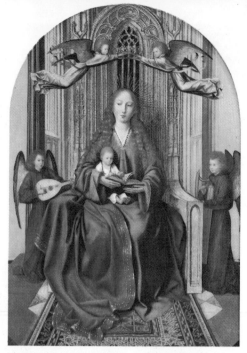

154 QUENTIN MASSYS *Virgin and Child with Angels*

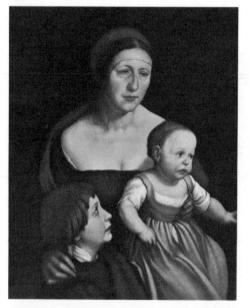

155 HANS HOLBEIN *Artist's wife and children*

Renaissance was having a powerful effect on painters. In the Netherlands too artists were discovering their great Italian contemporaries, Leonardo da Vinci and Raphael above all. Antwerp was now the commercial centre of the Netherlands and when Dürer visited it in 1520 it was also an artistic centre. Dürer was warmly received by the local painters but he did not manage to meet QUENTIN MASSYS (1464/5-1530), though he saw his Italianate house. Even in Massys's early *Virgin and Child with Angels (pl. 154)* there is a new broadness of effect in the Virgin's polished robes, painted so fluently. Northern and Italian influences blend in the impressive commanding court portraits of the Utrecht-born ANTHONIS MOR (*c.* 1517/21-76/7), whose *Queen Anna of Spain (pl. 158)* is almost as if a drawing of Holbein's had been copied by Titian. Mor represents a courtly version of realism, but already genre was being practised by PIETER AERTSEN (1508-75) who worked in Antwerp and Amsterdam, anticipating in his vigorous scenes of humble daily life *(pl. 156)* a type of picture which became enormously popular in seventeenth-century Flanders and Holland.

157 Hans Holbein *Jane Seymour*

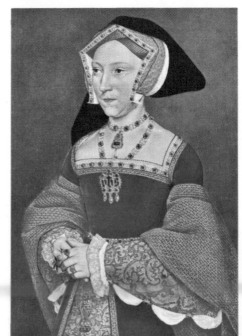

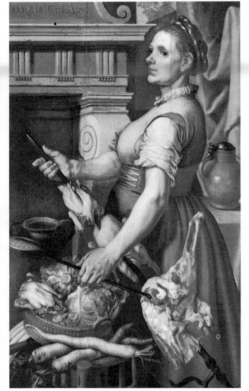

156 Pieter Aertsen *Cook*

158 Anthonis Mor *Queen Anna of Spain*

But before Mor and Aertsen, and quite unconnected with the Antwerp Italianizers, the fag-end of the Middle Ages produced in the Netherlands HIERONYMUS BOSCH (*c.* 1450-1516), the most creative painter of fantasy who has ever lived. Even when he seems incomprehensible in his allusive or nightmarish moments, Bosch handles paint with an instinctive delicacy; and evil deformed creatures of his imagination are painted with exquisite refinement and ravishing colour which make them beautiful. His inventiveness is far removed from the merely grotesque. He is capable of the medieval allegory picture, as in the *Ship of Fools (pl. 161)*, animating such a concept as man's sinful mortality with effortlessly fresh imagery. While a picture like *Hell (pl. 160)* represents the complex extreme of these images, weird, obscure and sexual, the *Adoration of the Kings (pl. 159)* is pure fantasy without fish monsters or giant birds. The marvellous magical presents brought by the Magi are almost alive; and that helmet-crown with single jewelled eye placed beside the kneeling King might scuttle away. The Moorish King, in his white robes fringed and cut as if with scissors out of stiff paper, bears the most marvellous present of all, the gold bird on a silver-white globe. And behind the King stands his negro attendant for whose headdress lyrical fantasy creates a curling sprig of green leaves and a single scarlet fruit.

In the *Pedlar (pl. 162)* fantasy gives way to observation, and the whole scene is touched by the cool grey tonality. Low life, indeed poverty, is painted not as a joke but with tender attention. The pedlar with his basket, a spoon, his one slipper and one shoe, turns back to that wretched inn with its broken windows and gaping roof; and that is sufficient subject for Bosch's picture.

The landscape here, and the landscape especially in the *Adoration of the Kings*, show how Bosch could respond to and set down the countryside of fact, luminously and sensitively, and quite without any 'Gothic' horror. Based on fact but freely fantastic, the landscapes of JOACHIM PATINIR (d.*c.*

159 HIERONYMUS BOSCH
Adoration of the Kings

160 HIERONYMUS BOSCH *Hell* 161 HIERONYMUS BOSCH *Ship of Fools*

1524), an Antwerp painter portrayed by Dürer, are among the first pictures in which landscape is the protagonist. Patinir could not achieve the direct romantic beauty of Altdorfer *(cf. pl. 147)* but his *Charon crossing the Styx (pl. 163)* though Bosch-like in its machinery, is full of natural observation and feeling for light and water.

To unite fact and fantasy in landscape was reserved for the last and greatest of Antwerp painters in the sixteenth century, PIETER BRUEGEL *(c.* 1525/30-69). Bruegel visited Italy, but Italian art seems to have left him largely unaffected. Like Bosch, but with more satire than fantasy, Bruegel could evoke a surrealist-allegorical scene as in the *Land of Cockaigne (pl. 165)* where gluttony has surfeited the men sprawled under the table.

But it was in a series of paintings of the Months, commissioned by a rich Antwerp citizen, that Bruegel achieved atmospheric landscapes which remain unique. The *Hunters in the snow (pl. 164)* is not purely naturalistic—there is a hint of archaism in the dark shapes of the hunters and hounds plodding through the snow. Feeling for the

162 HIERONYMUS BOSCH *Pedlar*

163 JOACHIM PATINIR *Charon crossing the Styx*

164 PIETER BRUEGEL *Hunters in the snow*

165 PIETER BRUEGEL *Land of Cockaigne*

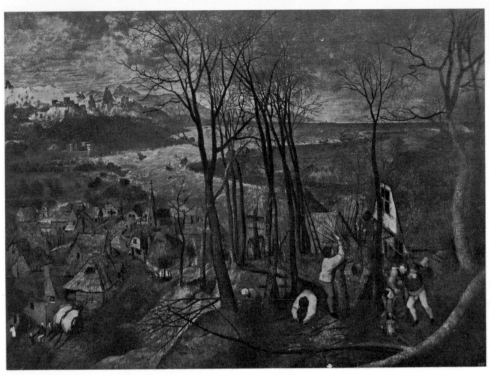

166 PIETER BRUEGEL *Dark day*

pattern of this white and black world is combined with a stinging sense of iron coldness. Winter's bleakness extends across the plain and the frozen lakes to the jagged teeth of the mountains against the sombre sky—a distance made more remote by the device of the flying bird large enough to seem near at hand. After the icy calm of this picture, the *Dark day (pl. 166)* is even more striking in its louring gloom and agitated water. The day closing in with promise of a storm, the huddled village, the matted bare twigs, are painted with an affection for natural phenomena almost overwhelming. In both pictures detail is multifarious but subordinated to mood and to the broadly planned composition. While snow scenes were not quite new (one had long before been painted by the Limbourg brothers in the 'Très Riches Heures') nothing like the *Dark day* has perhaps ever been painted. There is no specific drama, no contrast of light and dark: only a group of peasants pollarding trees in bitter February weather. Nobody before Bruegel had responded so sensitively to weather. All the raw bleakness of Northern winter is in the *Dark day*; in it a painter comes completely to terms with his environment and achieves his masterpiece in that way.

III
THE LATER RENAISSANCE IN EUROPE

THE GREAT ARTISTS of sixteenth-century Italy enjoyed during their lifetimes a prestige they have never lost. Not only were Leonardo, Raphael, Michelangelo and Titian great painters; their social status was great too, and Northern artists might well look wistfully across the Alps to the country where genius was treated as an equal by popes and kings.

Before the first ten years of the sixteenth century had elapsed, these great painters had given proof not only of genius but of their revolutionary natures. The achievements of the previous century were virtually forgotten in the superb achievements of the 'High Renaissance' style. The oldest of the creators of this style was LEONARDO DA VINCI (1452-1519), trained in the studio of ANDREA DEL VERROCCHIO (c. 1435-88), itself a typical Florentine workshop where pictures were painted and goldsmiths' work and statues executed. The sort of picture coming from his workshop is well represented by *Tobias and the Angel (pl. 167)* with its charming polished competence, its elegant sense of movement, and attention to detail of landscape, embroideries, brooches and so on. From this workshop issued too the *Baptism of Christ (pl. 168)* where the left hand angel is traditionally by the young Leonardo; and some of the melting landscape background is probably by him too. Verrocchio's studio no doubt encouraged thorough knowledge of perspective, anatomy, even botany. With Leonardo scientific and biological interests were eventually to swamp his interest in painting. He was to prefer enquiry to exposition and to come to look on painting as a poor method of conveying his discoveries —as indeed it was for someone who conceived flying machines and submarines, and nearly discovered the circulation of the blood.

But the few pictures Leonardo did paint, or at least began, conveyed new grace and mastery. Already the angel of the *Baptism* is a harmoniously realistic figure, clothed in draperies broadly conceived though carefully painted fold by fold. Vasari says that when Verrocchio saw Leonardo's angel *(pl.*

167 ANDREA DEL VERROCCHIO studio
Tobias and the Angel

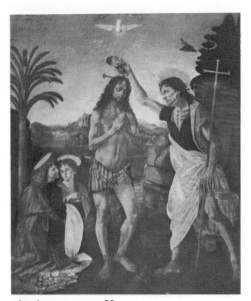

168 ANDREA DEL VERROCCHIO
Baptism of Christ

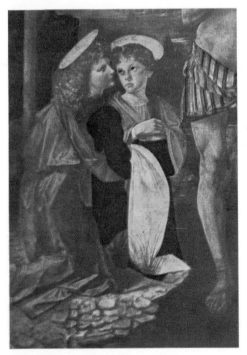

169 LEONARDO DA VINCI and
ANDREA DEL VERROCCHIO
Baptism of Christ (detail)

169) he gave up painting, in chagrin, and
though this is a typical Vasari story it
expresses a psychological truth. In place of
detailed but isolated studies of figures,
buildings, landscape, Leonardo soon fuses
all these into one organic composition, even
while his own studies are more vigorous
and searching than any undertaken before.
For his new effects he needed a suaver
medium and under his brush oil paint begins
to take on atmospheric hues pale as water-
colour. Between the dark somewhat Gothic
trees in the *Annunciation (pl. 170)*, a picture
probably his at least in part, one glimpses a
misty seascape with steep mountains rising
into a luminous sky.

Ambitious and restless, Leonardo was not
likely to remain long content with Florence.
Before he left the city he started on the large
altarpiece of the *Adoration of the Magi (pl.
171)*, commissioned in 1481 but never
finished. Leonardo's favourite motifs are
present, with something of the tantalising
mystery so often possessed by his drawings.
The picture is a unity; out of the shadows of
a great ruined palace where trees now grow
but where the unshattered double staircase
still stands, rise brooding figures and noble
horses encircling the graceful seated Ma-
donna, whose pose is one of Leonardo's
discoveries and is repeated in St Anne of the
Holy Family (pl. 173) more than twenty-five
years later.

Leonardo drifted away to Milan, leaving the
Adoration unfinished, and took service with
the Duke Ludovico Sforza to whom he had
drafted a letter of self-recommendation.
Nine 'secrets' of war are known to him, he
claims, but he believes he can give satisfaction
also in times of peace. In painting he can
achieve at least the equal of any other artist;
and he proved his point in painting the *Last
Supper (pl. 172)* in the refectory of S. Maria
delle Grazie at Milan. For another Milanese
church he painted the *Madonna of the Rocks
(pl. 174)* where the popular Florentine
group of Madonna and Child with the youth-
ful Baptist is set in a strange grotto, amid
high primeval rocks between which flows a
sunken river. Chiaroscuro modelling gives

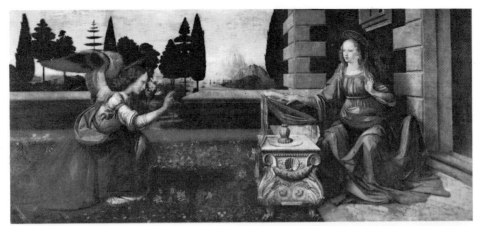

170 Leonardo da Vinci *Annunciation*

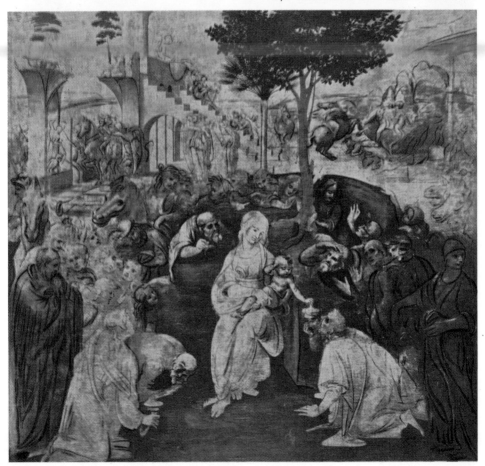

171 Leonardo da Vinci *Adoration of the Magi*

172 LEONARDO DA VINCI *Last Supper*

173 LEONARDO DA VINCI
Holy Family with St Anne

the illusion of real flesh to the faces, the eyes are luminous under heavy lids, and the hair curls electrically as if just brushed.

All such marvels of handling long ago disappeared from the *Last Supper* which Leonardo chose to paint in oil not fresco, and which deteriorated on the wall within his lifetime. But the composition, occupying the whole end of a low plain room, still asserts its power: opening out like a window in the wall to the equally plain room where the static drama takes place and which itself has windows on to open air and countryside beyond. The composition is crowded but balanced; on each side the Apostles draw back, leaving in a poignant isolation, emphasised by the framework of door behind, Christ who has just said 'one of you shall betray me.'

When the French occupied Milan Leonardo left for Florence, and the rest of his life passed in wanderings and frustrated exploits. In 1516 he settled in France. At his death his faithful pupil Melzi inherited not only the *Holy Family with St Anne* but those sketchbooks where Leonardo dealt with anatomy, hydraulics, geology, the structure of plants and the action of water. 'It is not in the power of nature', Melzi wrote 'to reproduce such another man.'

But nature was more fecund than Melzi in his

174 LEONARDO DA VINCI *Madonna of the Rocks*

175 MICHELANGELO
BUONARROTI
Holy Family

grief could realise. When Leonardo reached Florence in 1503 the Republic which had replaced the Medici commissioned from him a large wall painting, the *Battle of Anghiari*, for its Council Chamber. For the same room a *Battle of Cascina* was to be painted by a much younger man, MICHELANGELO BUONARROTI (1475-1564). The bold idea of cooping up these two rivals in one room was unfortunately not rewarded. Leonardo dabbled at his work; Michelangelo was summoned to Rome by the Pope before he could begin. It was left to the mediocre Giorgio Vasari, invaluable as the biographer of Italian Renaissance artists, to cover the walls with his frescoes.

No more than Leonardo did Michelangelo think of himself primarily as a painter. A universal man of a different kind, he was above all a sculptor, an architect also and a poet. He had worked in Ghirlandaio's studio, but the epic humanity of Masaccio's Carmine frescoes is more significant for his development as a painter. The greater part of his long life was passed in Rome, during a period while Italy dwindled politically and the papacy steadied itself after the shock of Luther by establishing the Society of Jesus

and the Holy Inquisition. Leonardo had given allegiance only to his own genius; Michelangelo was preoccupied by the state of the world and the Catholic church.

About 1505 he painted his only certain easel picture, the *Holy Family (pl. 175)* for a certain Agnolo Doni whom Raphael portrayed (*cf. pl. 183*). Leonardo's mysterious twilight is dissipated by bright sun, and everything is wrought like highly-polished marble. The Holy Family is a tightly-knit heroic group, a balanced triangle of movement and repose which might have been sculpted from a single block of stone. Though seated on the ground, the Virgin is no Madonna of Humility but a classical goddess-mother; and in this Greek atmosphere angels become nude youths who lounge and tease each other in the rocky defile behind.

Like Masaccio, and like Giotto, Michelangelo clears the stage of all inessentials, concentrating on the human body alone. Clothes are an impediment in appreciation of it; only naked can it express his most sublime concepts. The task of frescoing the huge ceiling of the Sistine chapel in the Vatican, a task Michelangelo did not want, gave him in fact

176 MICHELANGELO BUONARROTI *Creation of Adam (from Sistine ceiling)*

177 MICHELANGELO BUONARROTI
Libyan Sibyl (from Sistine ceiling)

178 MICHELANGELO BUONARROTI
Prophet Jeremiah (from Sistine ceiling)

the opportunity to turn the chapel into a temple to his own ideals—despite the Old Testament themes he painted. His imagination moved with colossal ease in an era of creation; he was there from the beginning and it is he who has summoned into existence that *Adam (pl. 176)* stirring under the first impulse of energy. There is a brooding energy in his figures even in repose: the prophet *Jeremiah (pl. 178)*, a giant plunged in dejection, might yet uncross his powerful legs and rise in this pantheon of the dynamic. Above the niches where sit the prophets and sibyls *(pl. 177)* nude athletes flank the central scenes: the pictures as it were which so much simulated statuary supports. The mood is Olympian and supremely confident. Technique, concept, everything makes it nearly incredible that the painter was Grünewald's contemporary. When the impatient Pope opened the chapel in 1509 the ceiling was still unfinished, but its success was immediately apparent and applauded.

As an old man, in very different mood, Michelangelo returned to the Sistine chapel to fresco the *Last Judgment* above the altar, unveiled in 1541. The ceiling had unfolded the events which led to Christ being born our saviour; it is now as judge that he appears, beautiful and terrible like Apollo, the dealer of destruction *(pl. 179)*, while the Virgin shrinks away impotently and the saints goad Christ on to smite down to Hell his victims *(pl. 181)*. The dead wake to this nightmare vision *(pl. 180)*, less cosmically desolate than that imagined by Signorelli but almost more hysterical in its horror and pandemonium.

Before calmness fled in this restless desperate counter-Reformation scene, Rome had witnessed the triumphs of synthesising genius in RAPHAEL (1483-1520) whose art was indebted to Michelangelo and to Leonardo. And the Rome of Raphael was a confident, cultivated city, unaware that shortly after his death it would be sacked by foreign troops.

Raphael's early years were spent in the workshop of PIETRO PERUGINO (*c.* 1445/50-1523) who had himself probably been in

MICHELANGELO
BUONARROTI
Details from
the Last Judgment
179 *Christ*

180 *Dead coming to life*

181 *The damned*

182 PIETRO PERUGINO *Virgin and Child*

Verrocchio's studio about the time Leonardo was there. Perugino painted chiefly religious pictures with charming colouring and softly diffused light, and their own vein of poetic piety. In a peaceful liquid atmosphere the Virgin prays tranquilly over her solemn Child *(pl. 182)*. Nothing much disturbs the Umbrian placidity of these compositions; but Perugino seeks throughout them for a harmony which was more intellectually to be attained by his pupil.

When Raphael completed the *Betrothal of the Virgin (pl. 184)* in 1504, he had absorbed and exceeded the teaching of Perugino. The space is wonderfully ordered and luminously holds within it the compact structure of the temple, closer to Piero della Francesca than to Perugino. About the time it was painted Raphael left provincial Umbria and arrived in Florence where Michelangelo and Leonardo were engaged on the abortive Hall of Grand Council scheme. He copied Masaccio's frescoes in the Carmine; and the *Agnolo Doni (pl. 183)*, with its almost Flemish realism, suggests that he had looked too at Ghirlandaio.

183 RAPHAEL *Agnolo Doni*

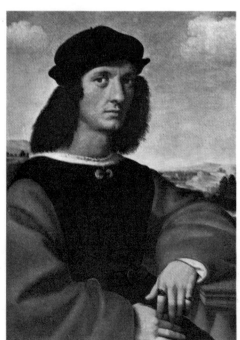

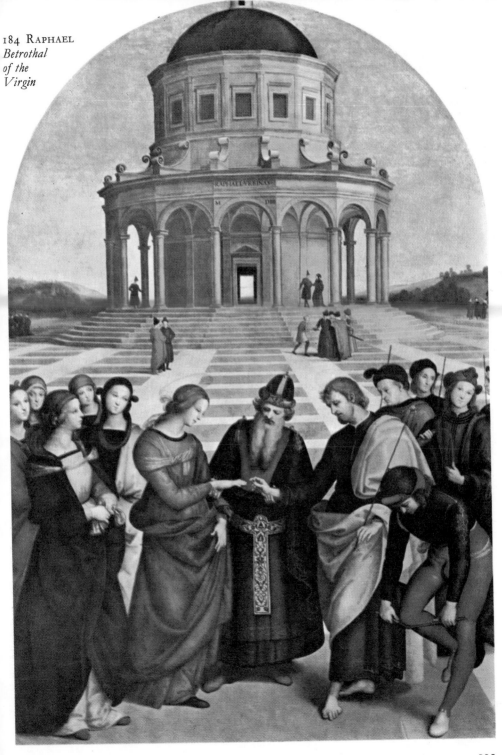

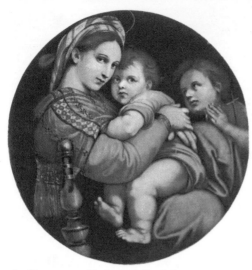

185 RAPHAEL *Madonna della Sedia*

Beyond Florence lay Rome where Julius II, Michelangelo's imperious patron, soon summoned him. The rest of Raphael's short life was spent in activity and fame, organising a large studio and creating on the walls of the Vatican frescoes like the *School of Athens (pl. 187)*, compositions grander and more superbly composed than anything yet seen. Plato and Aristotle find themselves holding court in the very centre of the papacy; ancient philosophy faces on an opposite wall modern theology, not in opposition but as two aspects of Truth. The philosophers in the *School of Athens* are Michelangelesque in stature but serene in mood; and serenity comes partly from the intervals between the groups of figures, partly from the spacious vaulting which curves high above them, framing without constricting, and conceived as grandly as they are.

The Sistine ceiling and Raphael's first Vatican frescoes were painted in that brief period of apparent prosperity before the Reformation and the sack of Rome. The warlike and masterful Julius II was succeeded by the indolent luxury-loving Leo X whom Raphael depicted enjoying the papacy *(pl. 186)*. Such a group portrait had not been painted before. Its truth to character is the more remarkable in a portrait of one of St Peter's successors, shown in a leisurely moment, fleshy, short-sighted, toying with a magnifying glass as he examines an illuminated book. The machinery of government is represented by the cardinals flanking him, his secretary at the right and at the left his cousin Giulio, already *papabile* and soon to become Clement VII.

In his Madonnas Raphael can move from the intimate conception of a family group like the *Madonna della Sedia (pl. 185)*, where so many soft curves are fitted finally into the curved picture shape, to the upright stately vision of the *Sistine Madonna (pl. 188)*, where the combination of grandeur and humanity is unique. The curtains are drawn back, the Pope and St Barbara sink into the clouds, and an almost uncertain Madonna is revealed, clasping to her the staring Child not yet assured enough to raise his hand in blessing.

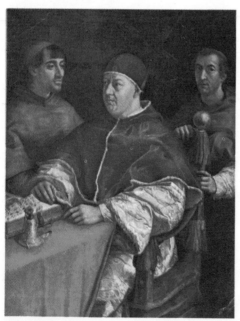

186 RAPHAEL *Leo X and two cardinals*

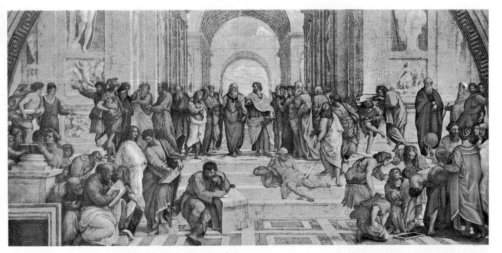

187 RAPHAEL *School of Athens*

188 RAPHAEL *Sistine Madonna*

189 FRA BARTOLOMMEO *Pietà*

There is no mystery, no action; and in the suffused glow from behind the Madonna all forms are simplified, like the Pope's tiara, and the few sweeping folds of his cope. The golden equilibrium was lost in Raphael's own late work, and the frenzied whirlwind energy of Michelangelo swept many painters before it. In Florence the originality of Leonardo and Michelangelo left an awkward situation for young artists growing up. The language of broad accomplished naturalism was accepted by members of the first generation like FRA BARTOLOMMEO (1475-1517) who simplifies detail to emphasise large forms, at their best restrained and noble *(pl. 189)* but liable to topple into empty rhetoric. The pressure of influence was dangerously high, and more successful was the eccentric PIERO DI COSIMO *(c. 1462-1521?)* whose *Mythological subject (pl. 190)* is a masterpiece of personal interpretation. Piero shared with Leonardo a sympathy for wild creatures. His affinity was with misfits and outcasts, and his dying nymph (or whoever she is) mourned by the helpless satyr and dog on a lonely seashore, is like a symbol of isolation. No doubt it too would have seemed, as the painter did, ridiculous in the eyes of that man of the High Renaissance, Vasari, himself type of the artist more at home broadcasting than painting.

One of Piero's few pupils was ANDREA DEL SARTO (1486-1531), a brilliant draughtsman whose grand manner style conceals nervous tensions. The *Madonna of the Harpies (pl. 191)* is a monumental composition, at first seeming static but built up out of almost exaggeratedly precarious moments of balance. The Madonna herself on the small harpy pedestal is literally supported by *putti*, yet manages with one hand to hold in position the wildly leaping Child; at the right St John wrestles with a book on which even his finely articulated long-fingered hand barely retains a grasp. All the figures turn out towards the spectator, the Child with

190 PIERO DI COSIMO *Mythological subject*

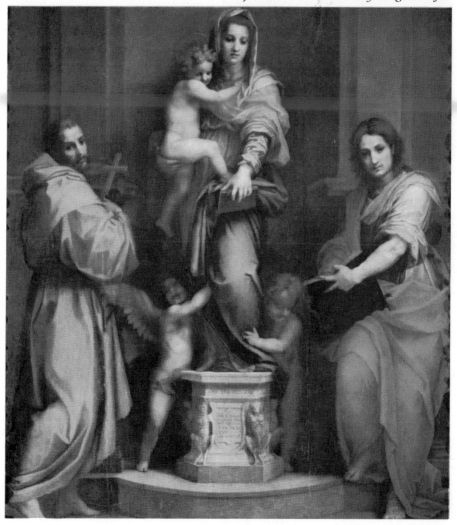

191 ANDREA DEL SARTO *Madonna of the Harpies*

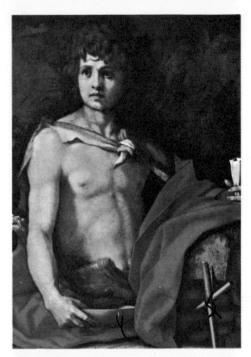

192 ANDREA DEL SARTO *St John the Baptist*

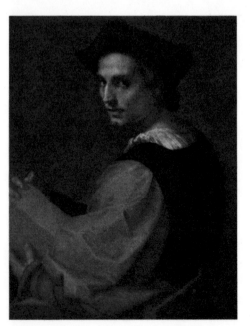

193 ANDREA DEL SARTO *A Young Man*

positively inveigling glance. And there is a challenging air in the youthful *St John the Baptist (pl. 192)*, who could be mistaken for a David were there not the ostentatious display of the Baptist's properties.

The melancholy intensity in the gaze of the so-called *Sculptor (pl. 193)* has something of Piero di Cosimo's sentiment, though the picture's silver-grey harmony is nearly Venetian. The disasters in sixteenth-century Florence might well increase melancholy; and the long doomed Republic, oscillating under various Medici rulers, finally became a despotic state under Duke Cosimo I. In religious pictures the participants now tend more and more to seek the spectator's attention: raising their cloudy eyes, questioning yet veiled. In romantic portraits black-clad young students pose Hamlet-like. Classical equilibrium, already slipping in del Sarto's work, was entirely replaced in the work of some Florentines trained partly under him. Instead of his smoky colour schemes, vibrantly brilliant colours were to shoot across the picture and the composition forgets space construction under more emotional needs. The nude in action fills the whole area in the *Moses and Jethro's daughters (pl. 194)* of ROSSO (1495-1540), with overwhelming and unexpected effect. The master of this new manner of assault was JACOPO PONTORMO (1494-1556) whose daringly dramatic masterpieces mingle poignancy with fantasy. The *Visitation (pl. 195)* is as novel as if the subject had never been treated before. Again the figures swell to occupy almost all the area, leaving only a patch of thundery sky and glimpses of an empty street. The ovoid forms of the two pregnant holy women touch briefly at their widest and then sway apart—and the picture is electric from this momentary contact. The draperies play like ectoplasm about the figures, fluorescent in colour and heightening the dramatic tension of the scene. In the *Deposition (pl. 196)* grief grows crazed, and the clothes are dyed metallic red and flamingo pink as if lit by some monstrous aurora borealis.

Pontormo retains this highly personal style

195 Jacopo Pontormo *Visitation*

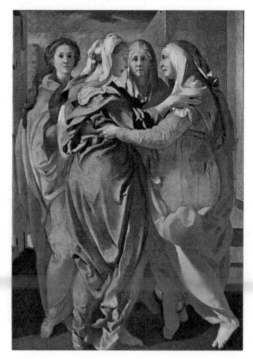

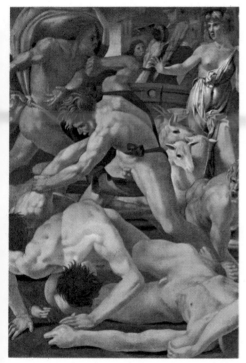

194 Rosso *Moses and Jethro's daughters*

196 Jacopo Pontormo
Deposition (detail)

197 JACOPO PONTORMO *Lady in red*

in his tense, proud and attractive portraits, like the *Lady in red (pl. 197)* which has a sort of quivering authority. The sitter's personality is accentuated even while the whole picture is imbued with Pontormo's manner. One feels it to be a 'speaking likeness'—very different from the cold and silent personages who were to be depicted by Pontormo's pupil and adopted son, ANGELO BRONZINO (1503-72) whose portrait Pontormo put with great tenderness into *Joseph in Egypt (pl. 199)* as the child huddled on the steps. With Bronzino a Florentine court portrait style was established; and he has fixed in enamelled paint Cosimo I, his family and entourage. Likeness to each other goes beyond heredity or environment: all these people wear smooth reptilian masks, at times slipping to reveal real character, at others worn with an insolent disdain *(pl. 198)*. The flawless surface of Bronzino's pictures is part of their icy fascination, that and their opulent but tightly controlled colouristic effects: no other painter has made such a marvellous use of black, suddenly broken by a single brilliantly blue book or a raspberry-pink statue. His draughtsmanship is tightly controlled too, able to map with Ingres-like ability all the intricate pattern of Eleanora di Toledo's dress without loss of the overall pattern of his picture *(pl. 200)*. Cosimo's wife, impassive and as stony-eyed as is the boy at her knee, triumphs even over the sumptuous dress in which a few years later she was buried.

The quintessence of Bronzino's court style is not a portrait but the *Venus, Cupid, Folly and Time (pl. 203)* where a complicated but hardly profound allegory provides the pretext for elongated bodies pale as pearl to pose before blue silk hangings. The picture breathes an almost Indian refinement and decadence, steeped in the luxury it purports to expose, and with some elusive air of obscenity which its superb technical dexterity only enhances. Suitably enough it went off to François I, the flashy lover of jewels and women, who was fostering a renaissance of the arts in sixteenth-century France.

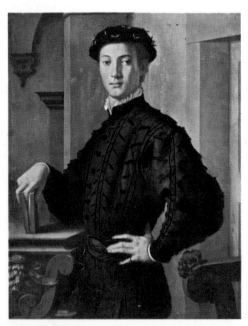

198 ANGELO BRONZINO
Portrait of a young man

199 JACOPO PONTORMO *Joseph in Egypt*

200 ANGELO BRONZINO
Eleanora di Toledo and her son

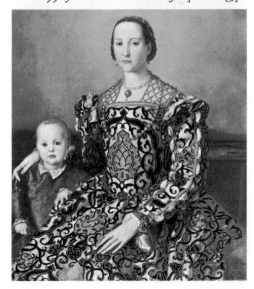

A more sensuous elegance, without even the pretence of intellectuality, appeared quite unheralded in the work of ANTONIO ALLEGRI DA CORREGGIO (1489?-1534), born at the small town of Correggio but chiefly active in Parma. The eighteenth century loved his pictures, and a rococo grace animates his alluring nudes, painted with a caressing feeling for flesh which makes them timeless. After Bronzino's nudes, Correggio's *Mercury instructing Cupid (pl. 201)* seems modern, at least eighteenth-century, in its atmosphere— though painted long before Bronzino; and his Venus, rightly conscious of her allure, seems blended out of reminiscences of Leonardo and anticipations of Boucher.

There are no problems in Correggio's pictures. Everything is dissolved into misty veils of paint—but not in mystery. There seems almost no art in the *Holy Night (pl. 202)*, so effortless is the concept of light radiating out from the Child and illuminating his mother's watching face, and so instinctive

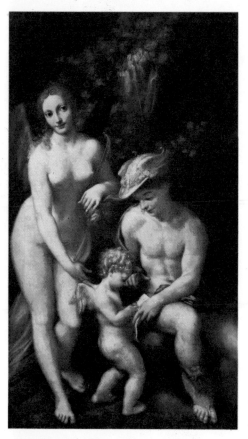

201 ANTONIO ALLEGRI DA CORREGGIO
Mercury instructing Cupid

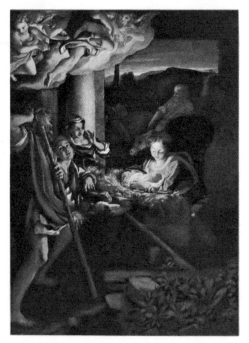

202 ANTONIO ALLEGRI DA CORREGGIO
Holy Night

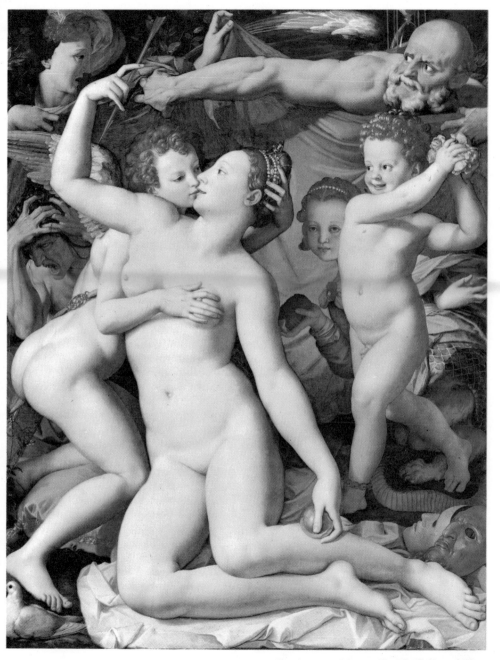

203 ANGELO BRONZINO *Venus, Cupid, Folly and Time*

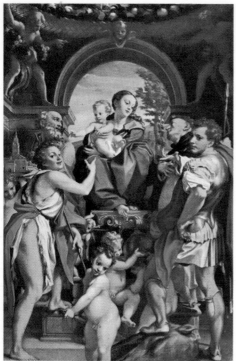

204 ANTONIO ALLEGRI DA CORREGGIO
St George altar

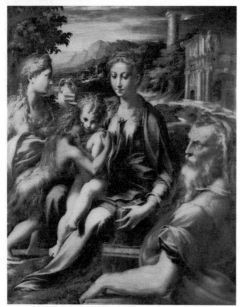

205 PARMIGIANINO *Madonna with St Zachary*

the tangle of bright angels who float in above. In the *St George altar (pl. 204)* nearly perfect preservation gives the surface the bloom of a peach, and the spectator is drawn into this delightful conversation, of unanalysable charm, where *putti* play with St George's armour. The paint has a porcelain quality, or rather, pastel, as if blown on to the surface, translucent, warm, and of almost palpitating texture. Correggio cannot help making every detail luminously decorative and his few surviving frescoes, like the ceiling of S. Giovanni Evangelista at Parma *(pl. 206)*, dissolve solid space into soft, cloudy recession, a heaven of graceful forms. And in this too he heralds the airy light-filled ceilings of eighteenth-century decorative painters.

Despite a strong influence of Correggio on him, the Parmese FRANCESCO MAZZOLA, called PARMIGIANINO, (1503-40) was the creator of a more tensely imaginative and elegantly fantastic art, which through his etchings and through engravings became widely known. Like Correggio he visited Rome; like Pontormo he knew Dürer's engravings and woodcuts. His personal harmonies are very different from Raphael's but his pictures are full of subtle intervals and restrained movement, as well as occasional hallucinatory effects like the gaunt prophet and the row of surrealist columns which occupy the background of the *Madonna dal collo lungo (pl. 207)*, and which are much more remarkable than the Madonna's long neck. Faced with the problem of the 'sacred conversation', Parmigianino refined away at reality until the personages were like those in the *Madonna with St Zachary (pl. 205)* with flowing draperies, long fluent hands, and with everything sharpened into elongated grace out of ordinary proportions. The old man at the right is metamorphosed—into a marine god, with a beard like foam of the sea, crested and curled. And at the same time Parmigianino was capable of painting direct portraits, liking often to place the sitter full face *(pl. 208)* in absolute but highly effective simplicity.

The mannered grace of Parmigianino, Pon-

206 ANTONIO ALLEGRI
DA CORREGGIO
S. Giovanni Evangelista ceiling

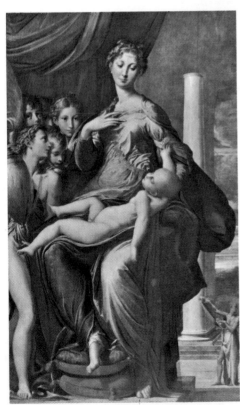

207 PARMIGIANINO *Madonna dal collo lungo*

208 PARMIGIANINO *Antea*

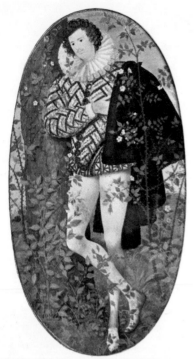

209 NICHOLAS HILLIARD *Young man*

tormo, Bronzino, became a style for lesser men to imitate. It was naturally adapted to courtly decorative uses, and under François I the work of both Italian and French artists in his palace at Fontainebleau created a positive Fontainebleau style of shadowless nudes, linear, tall and lithe, like the *Diana as huntress (pl. 212)* by an unknown painter. In portraiture too the effect is of a tinted drawing, and the bejewelled but pale *Elizabeth of Austria (pl. 213)*, perhaps by FRANÇOIS CLOUET (d. 1572), is like a Bronzino painted in watercolours. With NICCOLÒ DELL' ABBATE (*c.* 1512-71), a Modenese who spent his last twenty years in France, it is landscape which becomes mannerist, suitably enough for the nudes who pose there *(pl. 211)*. Foliage foams silvery-green in a sinuous expanse of landscape twisting and winding to the crystalline pale mountains of pure fantasy; and the countryside is as chic as if 'done up' by an interior decorator.

In England also, despite Holbein's activity, the tendency was towards a more intricate allusive type of picture, the international mannerism of for example *Sir John Luttrell (pl. 210)*, of 1550, by HANS EWORTH, an Antwerp painter working in London (*c.* 1545-74). Queen Elizabeth and NICHOLAS HILLIARD (*c.* 1547-1619) agreed that portraits were best done 'in plaine lines without shadowing'; and Hilliard's *Young Man (pl. 209)*, mooning amid briar roses, is a charming last reminiscence of Italian mannerist portraiture.

But in Italy one city, Venice, had remained aloof from that style. Giorgione and Titian did not break with the tradition of Venetian painting but evolve from Giovanni Bellini, himself living long—outliving Giorgione— and always evolving. GIORGIONE (*c.* 1476/8-1510) was probably trained in Bellini's studio and the quite early *Madonna and Saints (pl. 215)*, for his native Castelfranco, shows a rapt Bellini-style Madonna enthroned high above the more conventional saints. So far above them is she that there can be little conversation; she melts into the suave landscape behind, and each of the three isolated figures is lost in its own dream. There are no

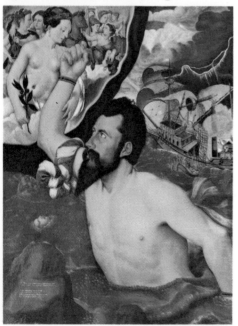

210 HANS EWORTH *Sir John Luttrell*

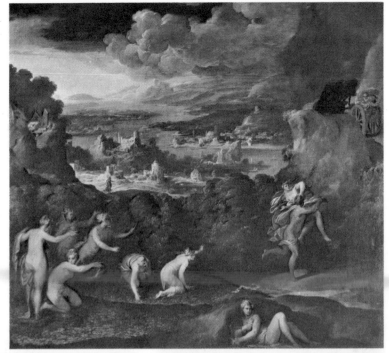

211
NICCOLO DELL'
ABBATE *Rape
of Proserpine*

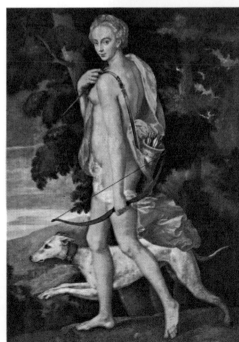

212 FONTAINEBLEAU SCHOOL *Diana*

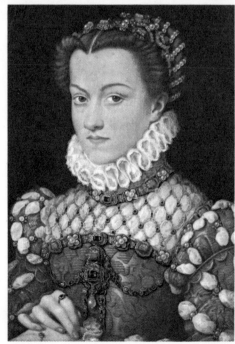

213 FRANÇOIS CLOUET *Elizabeth of Austria*

shocks of composition or colour, but a calm twilit air and sensuous glowing effects like that of the creased white drapery which rhythmically divides the Madonna's deep green dress from her warm red robe. Perhaps the mood is more secular than would be Bellini's, more romantically passive and nearly languorous: as if St Liberale could hardly any longer support the tall shaft of his banner.

In the so-called *Tempest (pl. 214)* atmospheric landscape is the subject. The figures have a casual accidental air; the eye dodges them as it follows the river deep into the composition to meet the thundery sky. It is the elements which battle, and the woman suckling her child and the gallant regarding her are detached from all that is happening. Such a picture is a poem without ostensible subject matter, and the Venetians soon began to call pictures like this 'poesie'. In the *Concert champêtre (pl. 218)* a few people are enjoying a day in the country. Only Pater has been able to convey its sleepy afternoon air when it is too hot for the lutanist to more than idly pluck the strings and when the bubble of glass which the woman dips in the cistern evokes almost painful coolness. It is sometimes supposed that this picture is not by Giorgione, but at least it is Venetian and typically so in its glowing textures of flesh and silk, its sense of enjoying beautiful bodies, fine clothes, and the deep peace of the countryside with its heavy, summer-foliaged trees. Nothing so sensuous and un-intellectual was produced in Florence; in the North of Europe the nude remained still awkward and unlovely, and the weather was too cold. Giorgione's *Sleeping Venus (pl. 219)* rests in country surroundings, and no classical properties distract from this sleeping naked woman whose very relaxation is a tribute to the harmony found in nature. The landscape sleeps too, even though it was probably finished after Giorgione's death by Titian.

It is easy to contrast with Giorgione's quiet poetry the forceful vigorous temperament of TITIAN (*c.* 1490-1576), left potentially the greatest painter in Venice after the premature

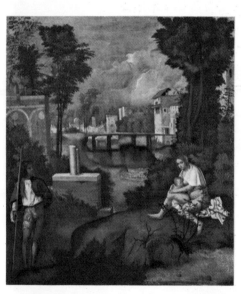

214 GIORGIONE *Tempest*

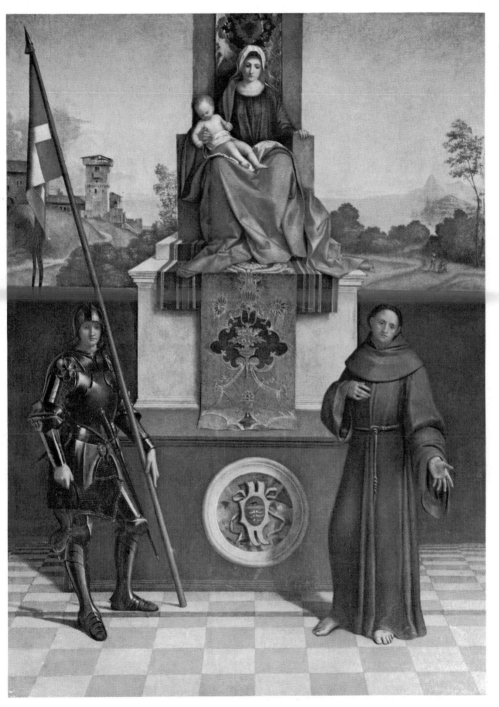

215 GIORGIONE *Madonna and Saints*

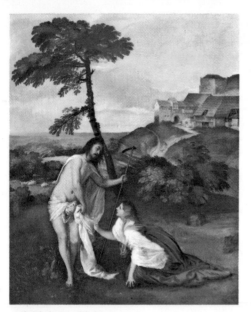

216 TITIAN *Noli me tangere*

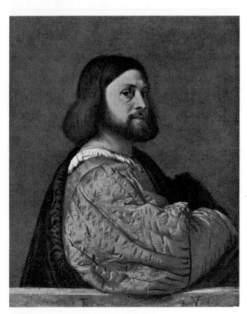

217 TITIAN *Portrait of a man*

death of Giorgione. But in the first years of the sixteenth century the two painters seem to have worked closely together, and between them they created that specifically Venetian mood perfectly exemplified in the *Concert champêtre*. Titian's style was always evolving, growing bolder and freer throughout the course of his long life. As Picasso was to grow out of his 'Rose' period, so Titian discarded the Giorgionesque style; and both painters doubtless needed courage to break with a manner proved so popular.

Titian's evolution carried him to the heights of being arguably the greatest painter yet produced, while good health brought him some seventy years of activity. He had none of Leonardo's scientific interests or Michelangelo's religious and poetic ones; he was simply a painter, not an architect or a sculptor. Titian's early *Noli me tangere (pl. 216)* already has a strong rhythm in the eager Magdalen and withdrawing Christ; they play out their drama disassociated from the landscape which is at the right a duplication of that in the *Sleeping Venus*. Recent cleaning has revealed the bulky shape of the Magdalen's skirt and emphasised the masterly handling of oil paint, as in the folds of Christ's white drapery, thinly painted with scratchy brush strokes and shadowed with the blueish tone of watery milk. The fluid virtuosity of the medium has become a joy to the artist and under Titian's brush there was no limit to what it could convey.

There are few drawings by him. His work was done on the actual canvas itself, and he modified, altered, suppressed, as he painted. Already in the early *Portrait of a man (pl. 217)*, paint works the miracle of the swollen silk sleeve, a shimmering blue-purple surface creased and slashed; and with more vivacity than the sitter himself. The rather faint impression made by the man is perhaps one indication of the portrait's early date, for Europe discovered in Titian the supreme painter of portraits. All the flashy splendour of Titian's friend Pietro Aretino is conveyed in his portrait, with its dazzling touch on the gown and almost cruel observation of the man who was said to have a bad word for

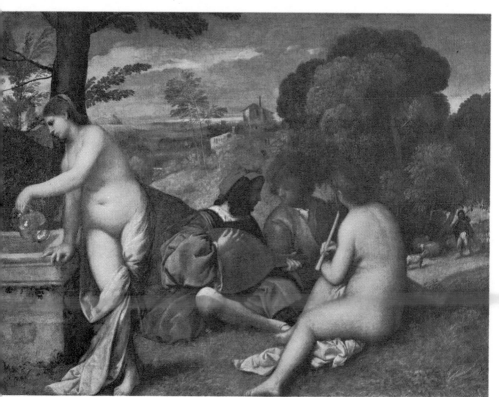

218 GIORGIONE (?) *Concert champêtre*

219 GIORGIONE *Sleeping Venus*

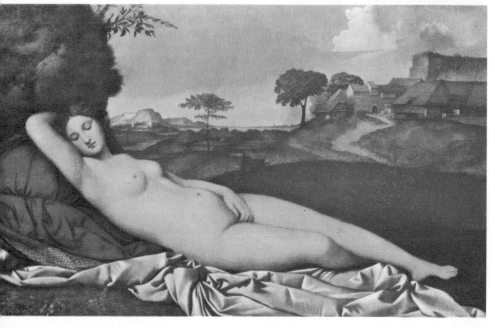

everyone except God—and that only because they were not acquainted. This portrait *(pl. 222)* is probably of about 1545 when Titian's mastery of oil paint seemed complete but in fact he was soon to develop even greater impressionist handling.

In court portraiture Titian retained all his overpowering feeling for personality, offering no flattery, for example, to Philip II of Spain *(pl. 220)* whom he painted at Augsburg in 1550 when the King was about to succeed his prematurely aged father Charles V, one of Titian's patrons. Philip succeeded his father also in that. Philip's sickly arrogant bearing, which had such a bad effect on his future subjects, is not concealed; but superb damascened armour carapaces his weak figure, and the white silk breeches and hose, set off by the crimson tablecloth, are painted with sheer joy in their texture. Titian responds to everything he sees: everything is to be translated into paint. Gradually he absorbed detail into the general tonal effect, but his response remained as strong as ever. His pagan pictures are truly pagan with something of the word's Latin sense of countrified. Bellini's *Feast of the Gods (cf. pl. 97)* was still a peaceful scene, even when altered by Titian. But Titian's own *Bacchanal (pl. 221)*, painted not long after Bellini's death, is exuberantly noisy, a riot of dancing drinkers and drunken dancers. The subject is the Andrians, inhabitants of the island of Andros where a great river of wine burst out of the earth: and the story is a fit symbol of Titian's own ebullience. For all its riotousness, the picture is full of marvellously painted passages; and the crumpled shirt of the man dancing at the right is as delicately painted as if by Watteau. The nude sleeping woman in the foreground is considerably more abandoned than Giorgione's chaste *Venus (cf. pl. 219)*. Titian's nudes were much appreciated, gloated over no doubt by Philip II who certainly received the best Titian ever painted. The *Venus and Adonis* design originated as the King's commission and exists in numerous versions— though only in one, a studio piece, does Adonis wear a ravishingly absurd hat *(pl.*

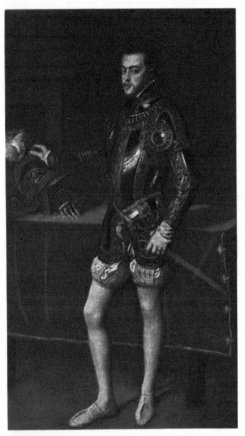

220 TITIAN *Philip II of Spain*

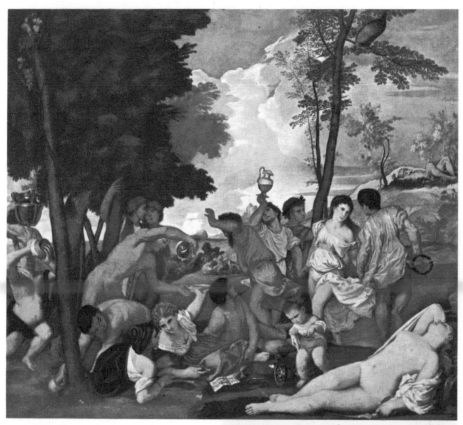

221 TITIAN *Bacchanal*

222 TITIAN *Pietro Aretino*

223 TITIAN studio *Venus and Adonis*

224 TITIAN *Mocking of Christ*

223). The goddess grabs almost clumsily at her reluctant mortal lover, so unconsciously eager for death. It is a new virile type of 'poesia', with its sense of urgency enhanced by the noble panting dogs. For Philip the *Danae (pl. 225)* was painted in 1554, she also a repetition of a composition conceived some ten years before. Danae is a Michelangelesque nude but bathed in light and shadow, sinking onto her bed in a pose frankly inviting to the lover in the shower of gold. The old woman tries to catch the falling gold, but Danae melts and dissolves amid her bedclothes; and the paint ceases to be paint, dissolves too into atmosphere. Looked at closely there seem to be nothing but rapidly applied marks and scratches on the canvas. Only as one draws away does the play of light and shadow assert itself and focus into being this body of voluptuous flesh appreciatively shifting under the ray of sun which pierces the clouds and falls across the upturned face.

Titian's religious pictures show the same progression towards tonal dramas of ever deepening intensity. In the *Entombment (pl. 226)*, painted in the early 1520s, the light is thundery, glowing on patches of dress, by-passing whole areas which are wrapped in deep shadow. The romantic poignancy of this becomes brutal reality in the *Mocking of Christ (pl. 224)* of some twenty years later. And another twenty years later he took up the subject again and painted it with startling freedom. To some of his contemporaries this freedom seemed a sign of failing powers, but in fact Titian had always been working towards a personal handling of the paint, and now could dispense even with brushes and really handle it. A pupil who had watched the aged master at work recorded that he finished the pictures 'more with his fingers than his brush.'

A classical subject like *Tarquin and Lucretia (pl. 227)* is in his very last years given no particular setting or costumes. It becomes a violent struggle between any man and woman, and violence is reflected by the dash of the paint itself which suggests without stating: streaks of roughly applied colour

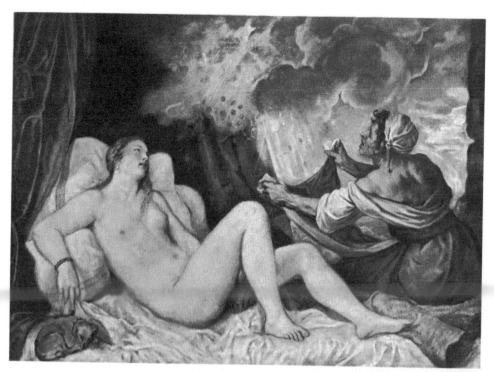

225 TITIAN *Danae*

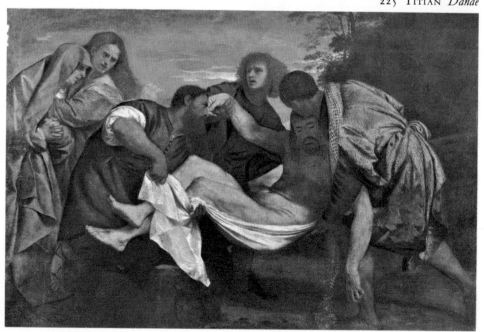

226 TITIAN *Entombment*

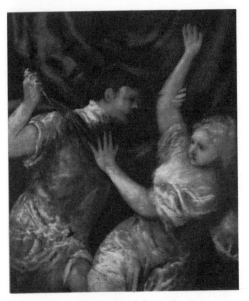

227 TITIAN *Tarquin and Lucretia*

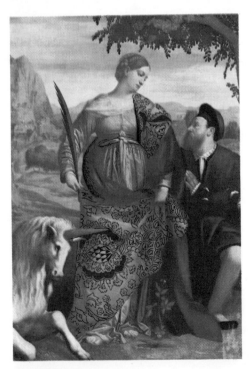

228 MORETTO
St Justina with a donor

rapidly establish Tarquin's attack, the wild gesture of Lucretia, slipping—it seems—as she twists away. The spectator is thrust into intimate contact with the scene; it flashes before him as if the impression of a moment, and no more is realised in the picture than the eye can absorb in a moment. One has only to turn back to the early *Noli me tangere (cf. pl. 216)* itself the drama of a man and woman, to see Titian's tremendous development. He had painted nearly every kind of picture; he had mastered and almost exhausted the capacities of oil paint. Portraits, religious and mythological pictures, could hardly again be painted without some hint of his colossal influence. But his real inheritors were not Italian, nor of the sixteenth century. It was the great painters of the following century to whom he was an inspiration and an ideal: Velazquez, Poussin, Rembrandt, and Rubens.

In Northern Italy Titian's influence and that of Giorgione was naturally especially strong. There were, however, pockets not so much of resistance but where a local style of painting was already established. At Brescia a particular type of realistic portrait of ordinary people was produced with emphasis on sober colour. MORETTO (*c.* 1498-1554) was probably the creator of the full-length portrait in Italy, used not for grand personages but for petty nobles, lawyers and so on. His *St Justina with a donor (pl. 228)* has a tranquil everyday air, despite the saint's unicorn, and hardly seems a religious picture. A more pungent portraitist was his pupil, GIOVANNI BATTISTA MORONI (*c.* 1525-78) whose *Tailor (pl. 230)* is an early genre-portrait of a professional man not posing but simply engaged at his trade. The absence of panache in these Lombard pictures is a reminder that sixteenth-century Italy was not peopled entirely with characters from Webster's plays.

More directly inspired by Titian was another Brescian, GIOVANNI GIROLAMO SAVOLDO (*c.* 1480-1548). He too had a homely respect for facts and the texture of materials, as well as for unusual but realistic lighting effects. Thickly painted draperies in the *Transfigura-*

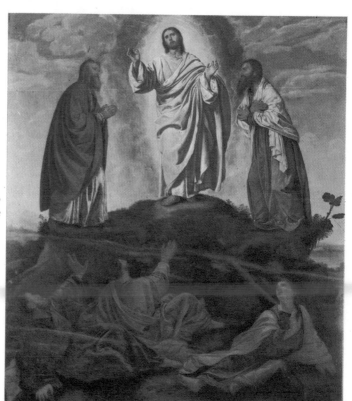

229 GIOVANNI GIROLAMO
SAVOLDO *Transfiguration*

230 GIOVANNI BATTISTA MORONI *Tailor*

231 LORENZO LOTTO
Portrait of a man (detail)

232 LORENZO LOTTO *Susanna*

tion (pl. 229) have a feeling of heaviness and weight which anticipate Caravaggio and are very similar to the draperies in pictures by the young Velazquez *(cf. pl. 323)*. Much more eccentric—literally—and on the fringe was a much greater painter LORENZO LOTTO *(c.* 1480-1556), a Venetian who spent most of his life outside Venice.

The strange disturbed intensity of his work contradicts any view of the 'balanced' nature of Venetian art. His colour schemes have a stinging memorable individuality, and there is a tense feeling for personality in his penetrating portraits *(pl. 231)*. *Laura da Pola (pl. 234)* is at once ostentatious and complex; and gives some sense of complicated Renaissance character. The small *Susanna (pl. 232)*, dated 1517, has figures who might be derived from Northern engravings and a very Flemish-looking landscape. The Elders gesticulate with mannered passion and two men almost tumble through the door into the walled bathing pool. Lotto is full of idiosyncracies, and even his *Madonna and Child with Saints (pl. 233)* is a curiously uneasy conversation, with its sullen Madonna and somewhat contorted angel who seems already weary of holding the crown of flowers over the Madonna's head. In some ways Lotto is like a latter-day Crivelli, bolder no doubt, but full of a wayward 'expressionism' which perhaps increased in isolation from any great artistic centre.

It was not easy to assert individuality in the shadow of the High Renaissance giants; many painters oscillated between the two forces of Michelangelo and Titian who, as the century progressed, were seen to be the exponents of two distinct styles: drawing and colour. The two men had met only once in their long lives, at Rome in 1545 when Michelangelo had admired some of Titian's pictures and Titian had conceived his Michelangelesque *Danae*.

SEBASTIANO DEL PIOMBO *(c.* 1485-1547) was a Venetian who began under the strong influence of Giorgione but settled at Rome and came under the spell of Michelangelo. His *Pietà (pl. 236)* in fact was based on a cartoon by Michelangelo, according to Vasari; and

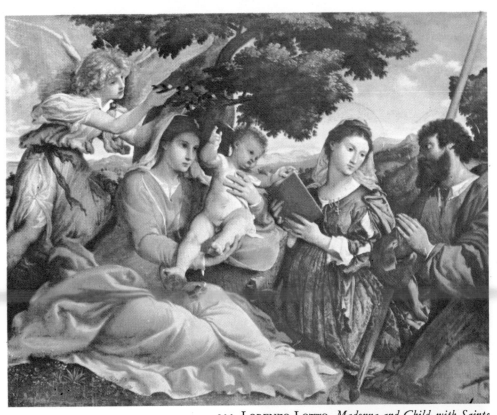

233 LORENZO LOTTO *Madonna and Child with Saints*

234 LORENZO LOTTO *Laura da Pola*

the Madonna has a largeness of form and statuesque air which is like his, while the moonlit landscape with its clump of dark trees silhouetted against night sky is pure Venetian poetry. A dusky splendour of colouring remains typical of Sebastiano; and a grandeur in portraiture *(pl. 235)* which Vasari rightly emphasised.

Those artists who remained at Venice were inevitably overshadowed—or at least are so in the eyes of posterity. The mood of late summer afternoon seems to haunt the work of JACOPO PALMA the elder *(c.*1480-1528) whose placid pictures say nothing very new but say it with great feeling for blonde flesh and sumptuous clothes. His *Meeting of Jacob and Rachel (pl. 237)* is quite unreligious; it is a scene in the Venetian countryside, as it were an enlargement from the background of Giorgione's *Concert champêtre (cf. pl. 218)*, where the rustic couple of Jacob and Rachel embrace with touching simplicity. There is no straining for intellectual problems; Palma disposes his sacred persons in a pleasant landscape where they accommodate themselves agreeably, forming a pleasing group.

To solve the dilemma of Michelangelo versus Titian a way more daring than Sebastiano del Piombo's was proclaimed in Venice by JACOPO TINTORETTO (1518-94) who openly expressed his intention to synthesise Titian's colouring and Michelangelo's drawing. The resulting pictures are a triumph of mannerism —but of a Venetian kind. They are also the triumph of a new concept of painting where the instant process of imagination is preferred to that of intellect, and the resulting pictures bear all the marks of speedy execution. All Tintoretto's best work approximates to sketches—however colossal the scale. The dynamism introduced by Tintoretto probably had its effect on the old Titian but it did not fully return in Venetian painting until Tiepolo two centuries later. Tintoretto's portraits are restrained and intimate; in the portrait of *Sansovino (pl. 238)* the paint is thinly applied and the canvas texture plays its part in suggesting dry tight skin. In his classical pictures Tintoretto modulates his dynamism

235 SEBASTIANO DEL PIOMBO
Portrait of a cardinal

236 Sebastiano del Piombo
Pietà

237 Jacopo Palma *Meeting of Jacob and Rachel*

238 JACOPO TINTORETTO *Jacopo Sansovino*

to more flowing graceful lines, coming very near Titian in the *Origin of the Milky Way (pl. 240)* though Jupiter plummets down dramatically with the infant Hercules. The *Bacchus and Ariadne (pl. 241)* is a perfect 'poesia', and the god rises from the sea with Giorgionesque grace to crown his bride.

But Tintoretto's revolutionary effects are hardly glimpsed in these pictures. His audacity consisted in a new type of painting, as personal as handwriting, in which light is the protagonist and where reality is admitted only in so far as it acts as a light conductor. His creamy crouching *Susanna (pl. 239)* has little in common with Titian's nudes, with its blonde incandescence as if lit by the slow flush of summer lightning; and all around Susanna light flickers and spirals, shaping the tree trunks, spraying out into bunches of

239 JACOPO TINTORETTO *Susanna*

240
JACOPO
TINTORETTO
*Origin of the
Milky Way*

241
JACOPO
TINTORETTO
*Bacchus
and Ariadne*

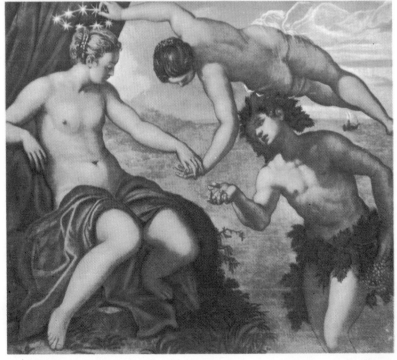

242 JACOPO TINTORETTO *Christ in the house of Mary and Martha*

243 JACOPO TINTORETTO *Flight into Egypt*

leaves or curling up to become the clothes of the Elders.

In this heightened world objects recede steeply in space. Christ talks in the house of Martha and Mary *(pl. 242)* and the floor is tilted abruptly, running towards the doorway which frames tall luminous figures beyond. A crackling vivacity animates everything—the folds of Mary's transparent veil are like cellophane paper—and Tintoretto's brush seems to be dipped in light.

In 1564 Tintoretto began his association with the Scuola di S. Rocco, where he later worked for twelve years decorating the entire building with large canvases illustrating the life of the Virgin and of Christ. In these *(pls. 243, 244)* Tintoretto's vision is even bolder; the compositions positively explode, and yet the significance of each scene is illuminated by the explosion. Working fast, working with assistants, the painter responds unfailingly to the deepening drama of the story, reaching a culmination in the large overwhelming *Crucifixion*. Tintoretto was, like Titian, working up to the end of his life. The *Last Supper (pl. 245)*, for the church of S. Giorgio Maggiore, is one of his last pictures. Two sources of light are contrasted in the steep room; natural torches burn, but brighter shines the supernatural aura around the nearly transparent angels. The equilibrium so carefully established by Leonardo's famous composition has been sent spinning, and probably to him Tintoretto's picture would have seemed incomprehensible. Vasari of course disapproved but could not quite rid himself of the effect made by Tintoretto's work. And in fact Tintoretto had broken most of the Renaissance concepts; the development beyond him lay with El Greco.

Contemporary with Tintoretto Venice was offered the very different art of PAOLO VERONESE (*c.* 1528-88) in which High Renaissance concepts made their last appearance. Veronese, born at Verona but working throughout most of his life at Venice, is in some respects a North Italian Raphael: gifted with the same ability to reduce a huge crowded composition to harmony. If he

244 Jacopo
Tintoretto
Crucifixion
(detail)

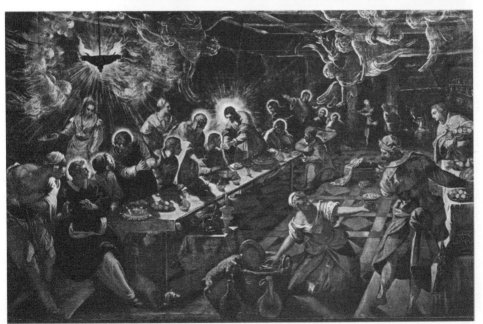

245 Jacopo Tintoretto *Last Supper*

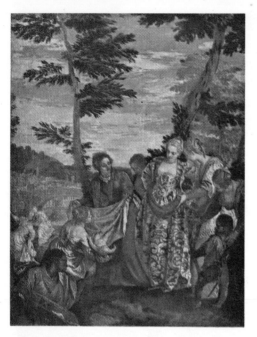

246 PAOLO VERONESE *Finding of Moses*

247 PAOLO VERONESE *Landscape*

lacks the intellectualised elements of Raphael, he has the compensating Venetian feeling for colour—indeed, an unequalled decorative colour sense. Against the silver scenes of Tintoretto he puts often golden ones, while a tranquil idyllic countryside is the setting for the calm pageantry of the *Rape of Europa (pl. 248)* or the *Finding of Moses (pl. 246)*. These are pictures by a new Giorgione, more opulently splendid in costume than his and more confident.

Veronese's decorations reveal his study of the mannerists, and at times the influence on him of Tintoretto. The perspective effects are less dramatic and arresting than Tintoretto's, but achieve the harmonious airiness of the *Allegory (pl. 249)* where limitless sky seems to open out behind the complicated wrestling of the two men with the woman, perhaps personifying Unfaithfulness. The allegory is hardly more important than it is in Bronzino; it is a pretext for marvellous silver-pink and silver-green tones, for two handsome men to clutch the outstretched hands of the blonde like a see-saw between them.

This decorative poetry is made to adorn rooms, and Veronese's frescoes for Villa Barbaro, in the country outside Venice, are a complete high-spirited scheme of such poetry *(pl. 247)* in which all is illusion. Mythological figures mingle with real ones, are seated above landscapes which open like windows on the wall; and everything, including reality, is enchanted. The same urbane atmosphere is shared by Veronese's religious pictures. A graceful Palladian screen closes in the courtyard where the *Annunciation (pl. 250)* takes place. The angel glows pinkly golden as he moves towards the praying Virgin, and the whole composition bathes in this tone.

All Veronese's people are a common stock, instinctively aristocratic, handsome, healthy. All give an air of being in costume for a gorgeous pageant in which nature has fitted them to take part. In his portraits Veronese manages to suggest confident splendour without ostentation. *Daniele Barbaro (pl. 251)* poses squarely, almost solidly; but the sweep of fur-lined robe invests him with

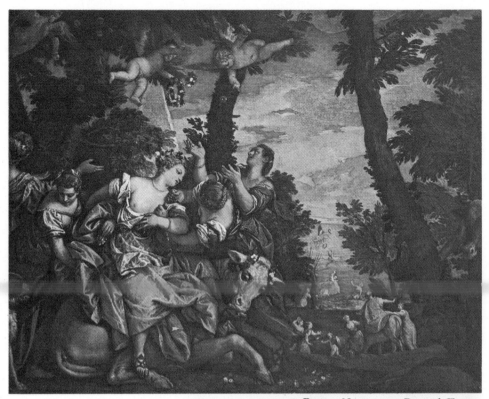

248 PAOLO VERONESE *Rape of Europa*

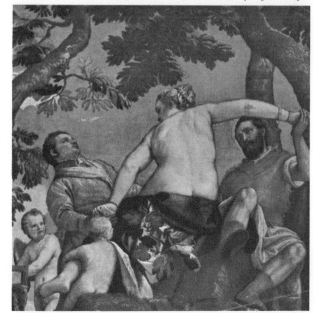

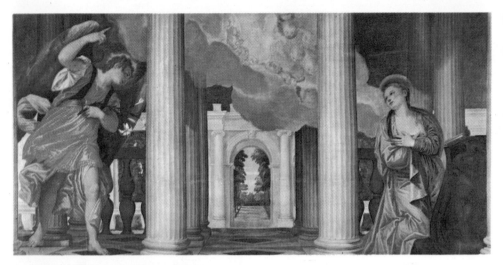

250 PAOLO VERONESE *Annunciation*

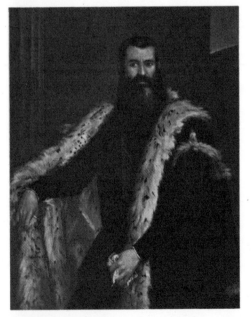

251 PAOLO VERONESE *Daniele Barbaro*

dignity. Here rather than in the portrait of some Doge is one of the rulers of Venice, incarnating the authority of the Republic.

While Veronese's religious pictures are often, but not always, splendid pageants of secular sentiment, a new solution to the eternal problem of religious pictures was reached by JACOPO BASSANO (active *c.* 1535-92), working at Bassano up in the hills behind Venice. The iridescent tonality of his pictures shows awareness of Tintoretto but he emphasises the genre aspect of biblical scenes, already apparent in the *Adoration of the Kings (pl. 254)*. The Holy Family are poor country people, and the painter is at least as interested in the animals at the adoration as in the kings. The *Good Samaritan (pl. 252)* anticipates seventeenth-century treatments of the parables as genre in its touching reduction of the subject to simple elements. Bassano is all the time working towards freedom to treat of what really interests him; and the *Pastoral scene (pl. 253)* is country life observed without any pretext, interesting for itself alone. Nothing could be further from the 'Grand Manner.'

Bassano is one sign of changing times. Across the Venetian scene there passed

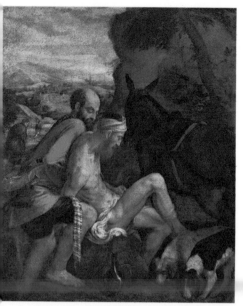

252 JACOPO BASSANO *Good Samaritan*

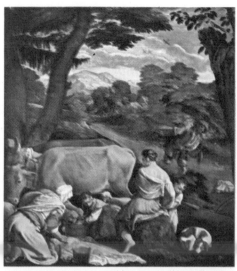

253 JACOPO BASSANO *Pastoral scene*

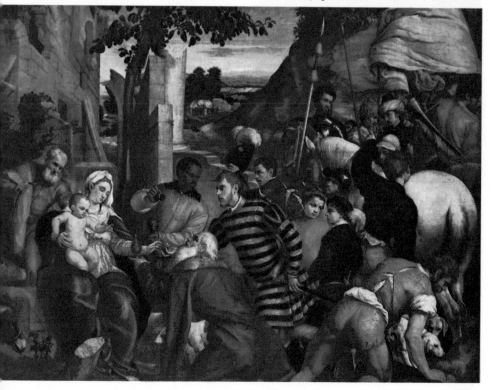

254 JACOPO BASSANO *Adoration of the Kings*

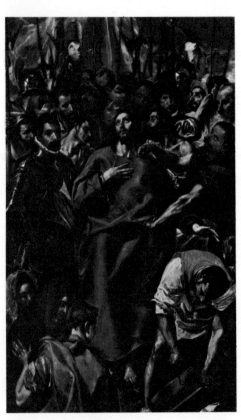

255 El Greco *Espolio*

Domenico Theotocopuli, called El Greco (1541-1614), the inheritor of Tintoretto but also a student of the work of Titian and Michelangelo, and not uninfluenced by Bassano. Born in Crete, El Greco had reached Spain and had settled in Toledo by 1577. Tintoretto had already banished Renaissance ideals of carefully projected three-dimensional space within which solid-seeming figures should move. In El Greco the concept has ceased to exist. In one of his largest pictures, the *Burial of Count Orgaz (pl. 256)*, still in the church at Toledo for which it was painted, the bodies have all the intensity of, and no more weight than, flame. Everything burns up into an agitated heaven. There is a hallucinatory power not only about the vision above but in the unquiet group below, uneasily aware of celestial events. The elaborate armour and vestments have a life of their own; and from the embroidered border of a cope a death's head disturbingly stares out.

El Greco is recorded to have preferred the light of his own inner visions to the spring sunshine and was found by a friend on such a day in his artificially darkened studio, neither working nor asleep. The activity of the imagination alone always puzzled the Renaissance; it was recorded as equally odd of Leonardo that he would often go to gaze at his incompleted *Last Supper* and then leave without working on it. To Philip II, patron of Titian and collector of Bosch's pictures, El Greco's visions were displeasing. And the *Espolio (pl. 255)* painted for Toledo cathedral was at first refused. Greco's dynamic distortions must have made it difficult for his contemporaries to see in the *Cleansing of the Temple (pl. 260)* the fusion it was of High Renaissance motifs, welded into unrecognizability by the painter's fiery individuality. The moon-blanched tones of his pictures no doubt made them seem stranger still. His figures have been fretted and made thin by piety; they are seldom so openly turned towards us as in the *Saintly king (pl. 257)* who has an unusually moving quality. More often they are as if lit by magnesium flashes, elongated by ecstasy and seeming to

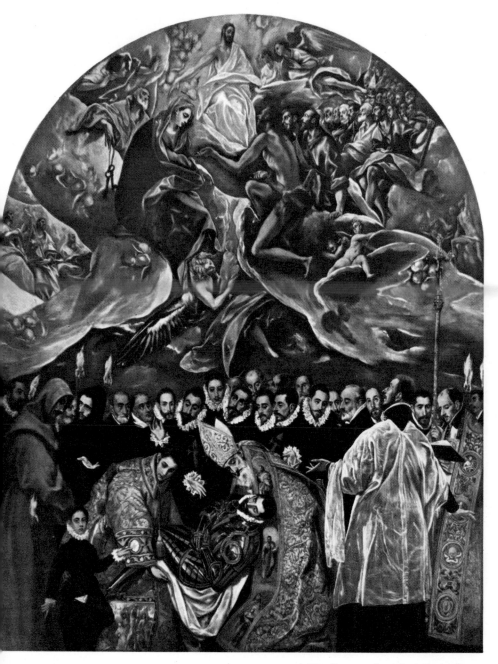

256 EL GRECO *Burial of Count Orgaz*

258 EL GRECO *Assumption of the Virgin*

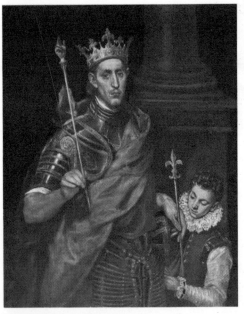

257 EL GRECO *Saintly king*

strain upwards. In the *Assumption (pl. 258)* the exaggeratedly tall Virgin rises into a lunar heaven, leaving earth far below, swept aloft by the huge fan of angels' wings and accompanied by the windy forms of other fluttering angels. Greco paints Toledo as if during an apocalyptic catastrophe *(pl. 259)*; on its acid green hill the city shakenly asserts itself while the sky is still riven by thunder clouds.

Greco's stormy spirituality closed the Renaissance. By the time he died mannerism had become baroque, his own late work foreshadowing this. He had outlived Caravaggio; Rubens had visited Italy and was back in Antwerp working for the Jesuits; and the very young Bernini was about to attract attention at Rome with his first known sculptures.

259 El Greco *Toledo*

260 EL GRECO *Cleansing of the Temple*

IV
THE SEVENTEENTH CENTURY

AFTER THE PROFOUND political upheavals and the advances of the sixteenth century Europe was a different and less integrated entity. Parts of the North had broken utterly with the Catholic South; but that was only one sign of the shift which new knowledge had brought to the established pattern. Copernicus and Galileo, Vesalius and Bacon, each was to help in destroying medieval notions and substituting new concepts. 'The new philosophy calls all in doubt', Donne writes early in the seventeenth century.

New artistic ideas were to result in quarrels and doubts too, and in the disappearance for over two hundred years of some great painters' reputations—among them those of Botticelli and Bellini and Piero della Francesca. Italy had enjoyed a century of incomparable artistic activity during and after the High Renaissance, while politically declining. By the seventeenth century none of the Italian states was any longer a power to be reckoned with in Europe: the Papacy could not check the rising nationalism which affected Catholic and Protestant countries alike; and the Venetian Republic could no longer compete with the new nations.

Now Holland and Flanders, France and Spain produced their own great painters who turned the seventeenth century into an age of international artistic genius: Rembrandt, Rubens, van Dyck, Claude, Poussin, Velazquez, these are more famous than any of their Italian painter-contemporaries.

Yet all of them, except Rembrandt, visited Italy and Rome remained the capital of the artistic world. Rome had the recent prestige given it especially by Raphael and Michelangelo, and the ancient prestige of its classical past then gradually being uncovered and appreciated. 'O Roma nobilis orbis et domina': that Dark Age invocation was to be echoed by a thousand painters descending on the city, from different parts of Italy, from across the Alps, forming their own national societies, becoming Romans, staying briefly or settling for life. And Rome itself was all the time changing its appearance under the grand architectural feats of Borromini and Bernini.

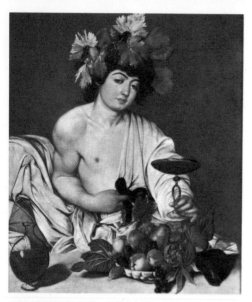

261 CARAVAGGIO *Bacchus*

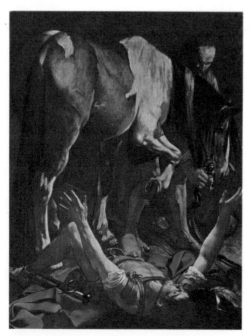

262 CARAVAGGIO *Conversion of St Paul*

But it was into a city still torpid and dazed with memories of Michelangelo that the very young CARAVAGGIO (1583-1610) came about 1590 from Northern Italy. With him he brought a brand of revolutionary realism, his own creation but fostered by the traditional 'realism' already found in Moroni and Savoldo. At first there is an Ingres-like clarity and finish in his pictures; the *Bacchus (pl. 261)* might be hung beside *Madame Rivière (cf. pl. 485)*. The white draperies, the still-life, the transparent glass and flask, are painted with a freshness almost shocking. His religious pictures have a sense of dramatic actuality which did succeed in shocking people, and there were many complaints about his failure to observe decorum. Scenes from Christ's life take place in ordinary surroundings, though never without the tremendous impact of Christ's actions on ordinary men. With almost explosive force the revelatory moment at Emmaus is depicted *(pl. 263)*. Christ summons St Matthew from the seat of custom *(pl. 264)*, and a shadow slants down the wall guiding one's eye from Christ's hand to the hand with which St Matthew incredulously indicates himself. Here light is the protagonist; and in the *Conversion of St Paul (pl. 262)*, painted about 1601, light is restricted to a few areas, and the saint fallen under his horse is an arc of outstretched arms before the miracle which is blinding him.

Violent and quarrelsome, Caravaggio lived a life made almost unbearable by criticism of his work, rejection of it often by the clergy; and he died ironically, raging feverishly against a boat he believed had sailed with his goods which actually remained safe in a nearby customs house. But his work survived. He had had rich private patrons, cardinals among them, and a vein of realistic painting throughout Europe found inspiration in him.

In Italy his followers were fewer and much less great. ORAZIO GENTILESCHI (1563-1639), was hardly capable of offering more than competent and colourful variations of Caravaggesque treatment *(pl. 265)*. The powerful, even brutal, pictures of JUSEPE

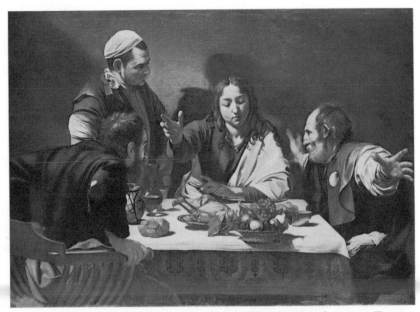

263 CARAVAGGIO *Supper at Emmaus*

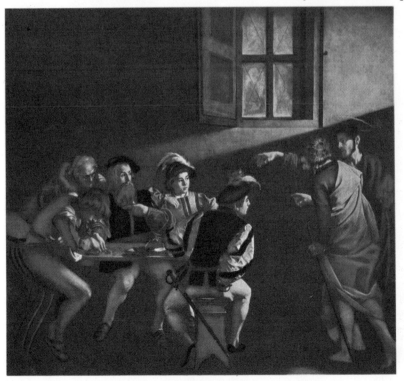

264 CARAVAGGIO *Calling of St Matthew*

265 ORAZIO GENTILESCHI *Lute player*

266 CLAUDE VIGNON
Martyrdom of St Matthew

RIBERA (1591-1652), a Spaniard working in Naples, are perhaps the most direct heirs of Caravaggio; but Ribera has a sort of careless forcefulness and indifference to the *detail* of reality which make him crude in handling of paint and in feeling *(pl. 267)* after Caravaggio.

Ribera seems to have appreciated Caravaggio chiefly as a dramatic painter of darkness, but it was as a manipulator of light and a realist that Northern painters were impressed by him and passed on their interest to Rembrandt. In Utrecht, the chief Catholic city of Holland, a group of painters settled down after visiting Rome early in the seventeenth century, and probably the first of these to return was the most distinguished HENDRICK TERBRUGGHEN (1588-1629). The *Jacob, Laban and Leah (pl. 269)* shows how his colouring had grown individual and un-Caravaggesque—though the still life of grapes is a homage to the Italian. There is a sort of porcelain effect in the painting which anticipates Vermeer, despite his very different subject matter.

Caravaggio's influence was felt all over Northern Europe; and the century remained strongly interested in genre and naturalism. The German ADAM ELSHEIMER (1578-1610), who worked in Rome, was more absorbed by landscape than by the religious or classical figures he set in it. Even in the early *St John preaching (pl. 268)* this is apparent. In

268 ADAM ELSHEIMER *St John preaching*

269
HENDRICK
TERBRUGGHEN
*Jacob, Laban
and Leah*

another Northerner at Rome, the Fleming PAUL BRIL (1554-1626) interest in landscape leads into topography, and his views of Rome *(pl. 272)* initiate a new type of picture which became very popular, culminating in the next century with Canaletto.

French painters arriving in Rome early in the sixteenth century immediately felt Caravaggio's impact. LE VALENTIN *(c.* 1591-1632) painted the *Diseuse de bonne fortune (pl. 273)* which might pass for an Italian picture. The *Martyrdom of St Matthew (pl. 266)* by CLAUDE VIGNON (1593-1670) is another tribute; attention is focused on the ferocious executioner and on the carefully realistic upturned soles of the saint's feet. Although GEORGES DE LATOUR (1593-1652) seems never to have left his native Lorraine Caravaggio's influence reached him, probably from Utrecht. He avoids drama and rhetoric; instead there is intense concentration on simple stylised forms, as in the *St Jerome (pl. 270)* and even when there is a drama of light, as in the *St Sebastian (pl. 271)*, the mood remains contemplative and quie-

270 GEORGES DE LATOUR *St Jerome*

271 GEORGES DE LATOUR *St Sebastian*

272 Paul Bril *Roman Forum*

273 Le Valentin *Diseuse de bonne fortune*

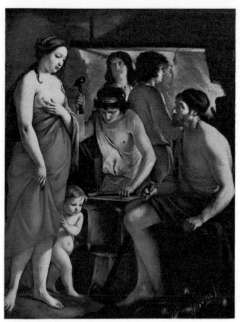

274 MATHIEU LE NAIN *Venus at Vulcan's forge*

tistic. This withdrawn air, combined with keen detail, is felt again in the work of the brothers LE NAIN, of whom the chief LOUIS (*c.*1593-1648) probably visited Rome. The same peasant models who serve for the Italianate *Venus·at Vulcan's forge (pl. 274)*, probably largely executed by MATHIEU LE NAIN (*c.* 1607-77), occur in their own humble environment in the *Peasant's meal (pl. 275)* where poverty is treated with touching dignity—not as something just picturesque, but part of the human condition.

The family of the Carracci at Bologna took a more traditional way than Caravaggio to achieve originality. The greatest, ANNIBALE CARRACCI, (1560-1609) inherited and understood the tradition of the High Renaissance represented by Raphael, Correggio and the Venetians. His cousin LUDOVICO (1555-1619) trained him but was influenced by him. At his best Ludovico had a spontaneity and Venetian response to colour well exemplified by the *Marriage of the Virgin (pl. 278)*. In the gallery of the Farnese palace at Rome, Annibale was successfully to construct a decorative scheme based on High

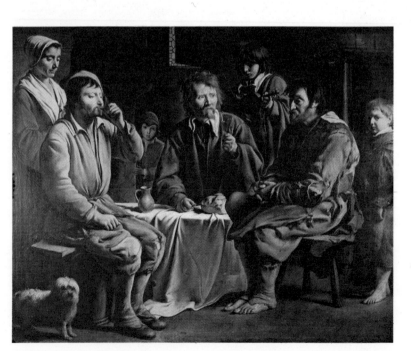

275 LOUIS
LE NAIN
Peasants' meal

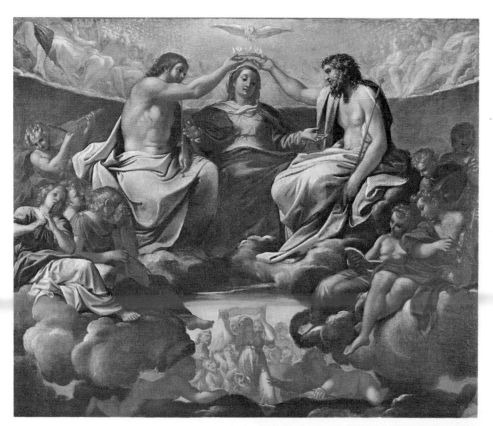

276 ANNIBALE CARRACCI *Coronation of the Virgin*

277 ANNIBALE CARRACCI *Bacchus and Silenus*

278 LUDOVICO CARRACCI *Marriage of the Virgin*

279 DOMENICHINO *Sibyl*

Renaissance concepts. The world of playful allegory and classical story which he imagined there on vast scale is caught in miniature in the panel he painted for a harpsichord *(pl. 277)*. Far from being coldly classical or 'ideal' in contrast to Caravaggio, he was the creator of landscapes like the *Fishing scene (pl. 281)* where the background is nature freshly observed but ordered, anticipating Poussin. This picture dates from before his summons to Rome in 1595 by Cardinal Farnese, but his Roman landscapes reveal the same combination of observation and intellect.

The *Coronation of the Virgin (pl. 276)* has something of the same combination; carefully planned, noble in the effect of the main group, and with a Correggio-like charm in the music-making angels who diversify the scene. Rome has classicized its North Italian impulse. Annibale's religious pictures can more fairly be opposed to Caravaggio's. There is no 'actuality' in the sense of contemporary clothes, or feeling for materials, no drama of light, in the *'Domine, quo vadis?' (pl. 280)* which is rather a clash of Raphael types, a moment of grand manner in which a handkerchief, say, would destroy the effect as much as it would in a French classical tragedy. To turn back to Caravaggio's *Conversion of St Paul (cf. pl. 262)* is to see a very different method. Annibale's is a highly finished cabinet picture; Caravaggio's an altarpiece for a poorly lighted chapel. But both artists seize on a moment of high drama. Anxious to make their effect and eager to involve the spectator, both pictures are in the new language, a baroque one, of seventeenth-century Rome.

Whereas Caravaggio's Italian followers remained almost at a disadvantage in contact with his genius, the followers of Annibale Carracci were able even before his death to evolve as individual masters. His classical tendencies grew colder in the work of DOMENICHINO (1581-1641) whose *Sibyl (pl. 279)* has all the largeness of form associated with Raphael; but Domenichino developed the landscape interest of Annibale and was able to produce a charming combination of

280 ANNIBALE CARRACCI
'*Domine, quo vadis?*'

281 ANNIBALE CARRACCI *Fishing scene*

order and nature, like the small *Tobias (pl. 283)*. Even such a strong 'naturalist' as Constable could warmly praise Domenichino's landscapes. Raphaelesque tendencies were most perfectly expressed in the work of GUIDO RENI (1575-1642), like Domenichino a Bolognese, whose reworking of the antique, enhanced by palely beautiful colour, often results in a rather insipid but authentic poetry, as in his later *Europa (pl. 282)*.

The classical ideals of the Carracci followers prevailed for some time in Rome and in Bologna. Other parts of Italy, like Naples, preferred the freedom Caravaggio had won for art, and emphasised their own idioms instead of adopting the common elevated language. A typical Neapolitan example is the *Finding of Moses (pl. 284)*, with its own elegance and individual colouring. It is probably by DOMENICO GARGIULO (1612(?)-c.1675), a highly original painter who had—as this picture shows—a keen response to landscape. Romantic landscape is most obviously conceived in the pictures of another Neapolitan, SALVATOR ROSA (1615-73), painter and poet. Rosa created a new type of landscape

282 GUIDO RENI *Rape of Europa*

283 DOMENICHINO *Tobias*

284 DOMENICO GARGIULO (?) *Finding of Moses*

285 SALVATOR ROSA *Landscape*

286 DOMENICO FETTI *Good Samaritan*

287 JOHANN LISS *Prodigal Son*

(pl. 285), sympathetically responsive to nature's most picturesque effects, and which long retained its popularity.

In Venice painting had dwindled to such an extent that the distinguished practitioners in the city were no longer natives, though earlier Venetian painting had its effect on them. DOMENICO FETTI (1589-1623) died there prematurely but was trained in Rome. That tendency for religious pictures to be treated as genre is repeated in his work, which is nearly always on a very small cabinet-picture scale. Out of certain parables *(pl. 286)* he created late in his short career scenes of almost contemporary life, keenly observant in detail, Bassanesque and brilliantly coloured. JOHANN LISS (*c.* 1597-1629/30) was a German who settled in Venice but had been in the Netherlands. The *Prodigal Son (pl. 287)* is another example of parable turned into genre, with a bold and dashing sense of colour and movement which anticipates the renaissance of painting in Venice in the subsequent century.

Studying directly under Ludovico Carracci but influenced also by Caravaggio was GUERCINO (1591-1666), born at Cento near Bologna. The second great non-conforming painter of seventeenth-century Italy, Guercino went to Rome but did not enjoy great success there. His early *Incredulity of St Thomas (pl. 288)* combines Caravaggesque honesty with Venetian opulence of colour and reveals his response at this period to the medium of oil paint. No other seventeenth-century Italian so directly continued this aspect of the Venetian High Renaissance, and it is sad that he gradually exchanged a richly worked paint surface for a Reni-like smoothness of effect. Under the same influence his vigorous compositions grew calmly classical. He gained dignity, but lost the romantic beauty which had given splendour to his altarpieces and tenderness to his groups of Madonna and Child. A too steady light fills his late canvases, in place of that poetic dusk which had, for example, shrouded *Susanna bathing (pl. 289)*.

Although Roman taste had not responded very warmly to Guercino he had been

288 GUERCINO *Incredulity of St Thomas*

289 GUERCINO *Susanna bathing*

patronised by the Bolognese Pope Gregory XV. On Gregory's death in 1623 there came to the throne Urban VIII, autocratic, artistic, and for a pope young (aged fifty-two). During his reign of twenty-one years Rome turned into the baroque city of today. It was his family, the powerful Barberini, whom PIETRO DA CORTONA (1596-1669) glorified in a huge ceiling fresco for their palace. A new lightness of colour and desire for decorative effects is felt in his pictures *(pl. 290)* which are to some extent painted equivalents of Bernini's sculpture. Under his influence too the Neapolitan LUCA GIORDANO (1632-1705) lightened his palette and produced especially decorative ceiling pictures which further presage 'rococo' effects. In 1682/3 Giordano was frescoing the enormous ceiling of Palazzo Medici-Riccardi at Florence, and the

sketches for this *(pl. 291)* show his bravura touch, lively mind and fluently fresh handling of allegory.

No painter responded more intensely to Rome as the city of classical antiquity than NICOLAS POUSSIN (1594-1665) a Frenchman who settled there in 1624 for the rest of his life, interrupted only by a miserable eighteen months in Paris. Poussin was not made for court life nor to execute pictures in the decorative-allegorical style evolved by SIMON VOUET (1590-1649) for Louis XIII, a style splendidly represented by *La Richesse (pl. 292)*.

Poussin's mind was, as Reynolds observed, naturalised in antiquity, and his patrons were as serious as himself. But he had visited Venice and greatly admired Titian; an almost wild Venetian poetry is felt in his early pictures,

290 PIETRO DA CORTONA *Erminia and the shepherds*

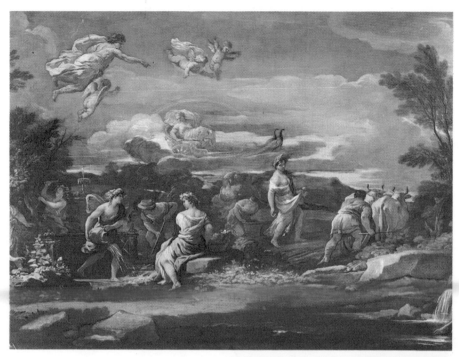

291 LUCA GIORDANO *Mythological scene illustrative of Agriculture (detail)*

292 SIMON VOUET *La Richesse*

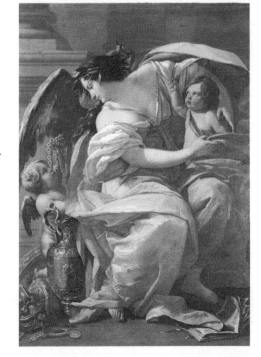

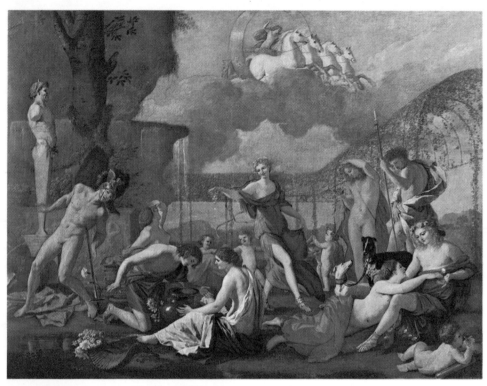

293 NICOLAS POUSSIN *Kingdom of Flora*

culminating in the smoky atmospherics
of the *Inspiration of the poet (pl. 295)*. The
firm uprights of the composition are woven
through by fleeting shadows which obscure
the Muse's classic profile and plunge Apollo's
body into darkness, while light glitters
metallically on the surface of leaves, Apollo's
lyre, the straps of his sandals, and wraps itself
around the folds of the Muse's dress. The
Muse and the god are dusky dream figures;
the poet is under their spell though he gazes
not at them but into a laurel-crowned future.
The mood is like that of Milton's early
poetry. Like Milton, Poussin was to progress
into a sterner manner with profounder moral
preoccupations. The *Lamentation (pl. 294)*

is a stark and tragic drama, still violent in its
lighting and in the desperate grief of the
mourners.

To Poussin the classical world was of equal
validity with the Christian, and his natural
habitat is that of Rome where the two worlds
meet. They are synthesised for him on a
moral plane where ethics is more important
than religion. The classical ethos of the
quite early *Kingdom of Flora (pl. 293)* is
Ovidian and still carefree: the greenclad
goddess dances decorously amid persons
who were metamorphosed into flowers. The
subject is never simply a pretext for Poussin;
he re-creates it with as much seriousness as
imagination. But learning does not exclude

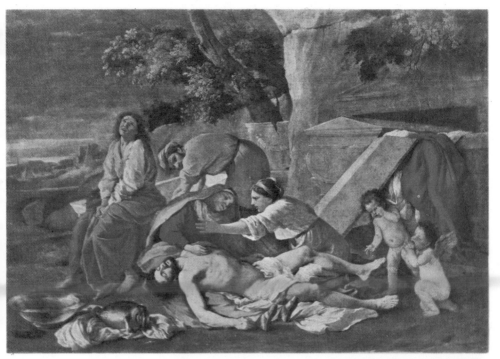

294 NICOLAS POUSSIN *Lamentation*

295
NICOLAS POUSSIN
*Inspiration of the
poet*

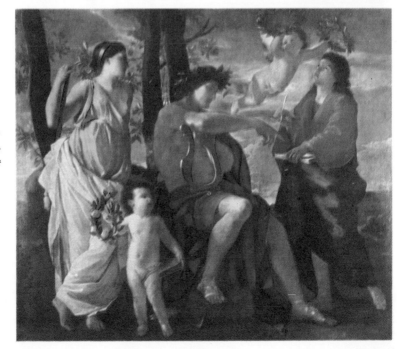

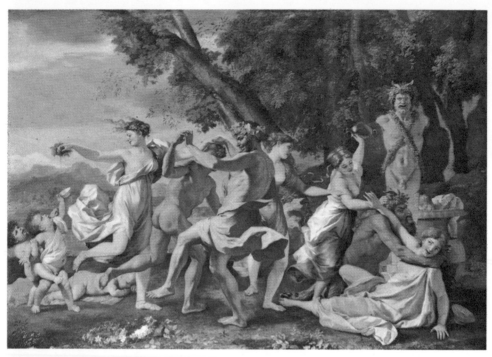

296 NICOLAS POUSSIN *Bacchanal*

gaiety if this is suitable: the *Bacchanal (pl. 296)* is both an exercise in the problems of formally interweaving a chain of figures and a spontaneous bibulous frolic; it is a classical frieze set amid Titianesque landscape. Beneath Poussin's formality there always burns passion. As intellectually concerned as Bach with problems of design and form, Poussin is like him too in those reserves of emotion which underlie the final logical structure.

His later pictures order a complete construction of landscape and figures within it. Seldom is this on such a grand scale as in the *Funeral of Phocion (pl. 297)* where two slaves carry the corpse of the Athenian leader through an elaborate countryside with Athens in the distance. The city is disposed almost cubistically on gentle slopes amid carefully plotted groups of trees; the eye

returns from it, past the bullock cart and the shepherd with his flock to the sad pair in the foreground bearing the litter, unregarded by anyone and already far from the city. Phocion's isolation in death is complete, apart from the two faithful slaves. The story of the aged Phocion, a stoic condemned to death by Athenian democracy, made a natural appeal to Poussin, himself stoic and aristocratic in temperament. The *Orpheus and Eurydice (pl. 298)* inculcates no comparable moral lesson, but the tone has deepened from gravity into tragedy. The landscape encloses a wide stretch of lake across which rise the cones and cubes of an ideal town, including prominently a formalised Castel S. Angelo. The sky is already thundery; the trees hang heavily; and the sunlight seems about to pass from the rapt group of Orpheus and his audience, still unaware of the snake

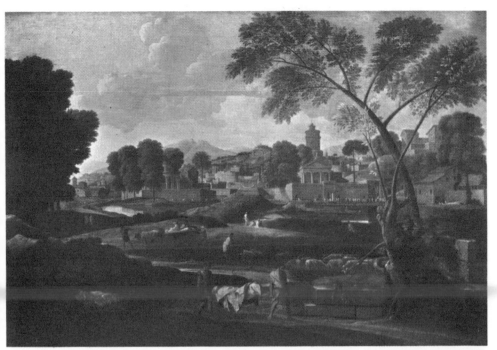

297 NICOLAS POUSSIN *Funeral of Phocion*

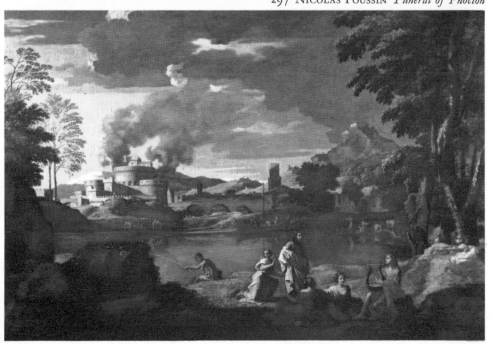

298 NICOLAS POUSSIN *Orpheus and Eurydice*

299 CLAUDE LORRAINE *Village fête*

approaching Eurydice. Nature presages disaster, and alone a fisherman has turned, too late to avert Eurydice's death.

Whereas Poussin came only gradually to landscape, it was from the first the entire subject for CLAUDE LORRAINE (1600-82), another French painter who spent most of his life in Rome, settling there before he was thirty. His organisation of nature is less rigorous than Poussin's; at first nature seems hardly disarranged in the *Village fête (pl. 299)* painted for Urban VIII. Nothing is extreme: the mood is nearly always elegiac and worthy to be evoked by Keats. Day dies softly over the water in the *Seaport (pl. 300)* and the fantasy buildings at the left are like magnificent cloud structures, unobtrusive and part of the sunset mood.

For Claude ancient Rome and the classics are not so much penetrated—as in Poussin's passionately rational approach—but dreamed over. Like Gibbon after him, he was conscious of Rome's nostalgic continuity. In the *Cephalus and Procris (pl. 301)* two lovers are re-united by a goddess, but the oxen crossing the river ignore them and they are perhaps only the herdsman's fancy as he lounges along a broken tree trunk at the left of the picture. It is not just any countryside but the Roman Campagna, and the classical trio are a reminder in the present of antiquity. In some of Claude's later pictures a muted poignancy arises from interfusion of subject and setting, as in the *Acis and Galatea (pl. 302)*, where a wide stretch of incoming sea already isolates the lovers embracing and almost laps the

300 CLAUDE LORRAINE *Seaport*

301 CLAUDE LORRAINE *Cephalus and Procris*

302 CLAUDE LORRAINE *Acis and Galatea*

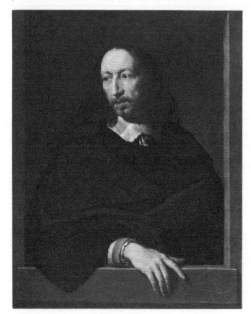

303 PHILIPPE DE CHAMPAIGNE *Portrait*

frame; and evening falls over the high wooded hills where the giant Polyphemus reclines. At times subject is elusive and the *Flight into Egypt (pl. 304)* is a calm landscape with a piping shepherd, and only far in the distance are visible the minute figures of the Holy Family.

French painters who did not go to Italy could achieve an austere and lucid classicism in Paris. PHILIPPE DE CHAMPAIGNE (1602-74) under the influence of the Jansenists at Port Royal painted portraits of grave and sober truth *(pl. 303)*. For the recovery of his daughter, a nun at Port Royal stricken with paralysis, Champaigne painted the *Ex-Voto of 1662 (pl. 305)*. The two women have that carved gravity to be found again in Zurbaran *(eg. pl. 331)* and, as in his pictures, there is quietistic acceptance of the divine will whether or not adverse.

In the courtly tradition, CHARLES LEBRUN (1619-90) was virtually the dictator of the arts under Louis XIV. His portraits *(pl. 307)*

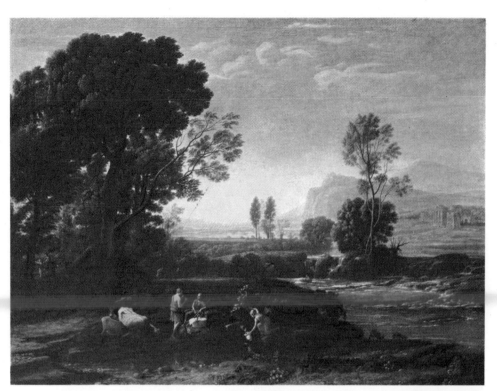

304 CLAUDE LORRAINE *Flight into Egypt*

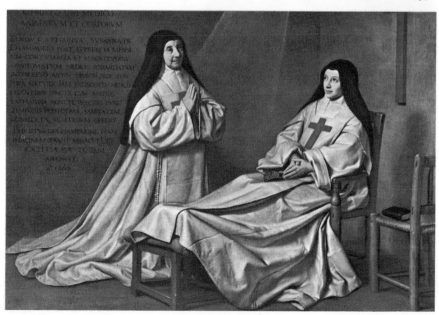

305 PHILIPPE DE CHAMPAIGNE *Ex-Voto of 1662*

show the pompous and official atmosphere of Versailles. Chancellor Séguier, the condemner of the Jansenists, is a typical court personage too: perfect opponent of all Champaigne stands for. To Lebrun there succeeded his rival PIERRE MIGNARD (1612-95) whose court portraits *(pl. 306)* have a flavour of the eighteenth century and a certain direct charm after the highflown insipidities of Lebrun.

The lure of Italy had during the Renaissance been as strongly felt in Flanders as in France. It was inevitable that the greatest Fleming, PETER PAUL RUBENS (1577-1640) should early leave Antwerp for Italy. He arrived in Rome in 1601, and was impressed not only by its classical past, and Raphael, but by the pictures of the Carracci and, more especially, of Caravaggio. He had already visited Venice and admired Titian and a first visit to Spain in 1603 allowed him to see the royal collection of Titians.

When Rubens returned to Antwerp in 1608, he had assimilated this variety of influences. Though he was to travel widely in Europe as painter, and increasingly as diplomat, he never saw Italy again. Whereas Poussin found obscurity in the cosmopolitan centre of Rome, where from a corner he might watch in his own words 'la Comédie à son aise', Rubens in the small Spanish dependency of Flanders was to become a great figure in the 'Comédie' of seventeenth-century events. How much he was at home there is revealed by the *Self portrait* with his first wife, Isabella Brant *(pl. 308)*, painted about the time of their wedding in 1609. They sit in a lovers' bower of honeysuckle, informally yet in their best clothes, their clasped hands solemnly affectionate like the gesture in Jan van Eyck's portrait of the Arnolfini *(cf. pl. 104)*. No marriage pictures had been painted in Italy, perhaps nothing where on a large scale such scrupulous detail accompanies broad conceptions of form. The vitality of the two faces, and the originality of the design, proclaim Rubens' own vitality and originality. The rest of his life was to be passed in prodigal artistic expenditure and his handling becomes broader and more vigorous, as if hurrying

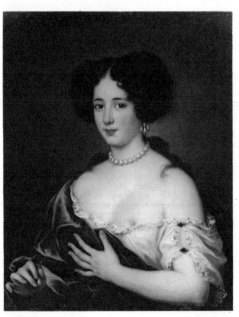

306 PIERRE MIGNARD *Maria Mancini*

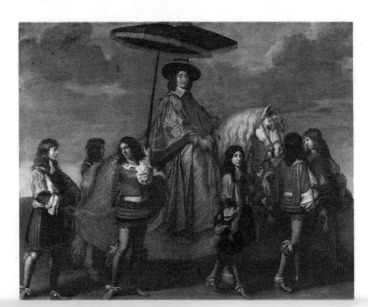

307 CHARLES LEBRUN
Chancellor Séguier

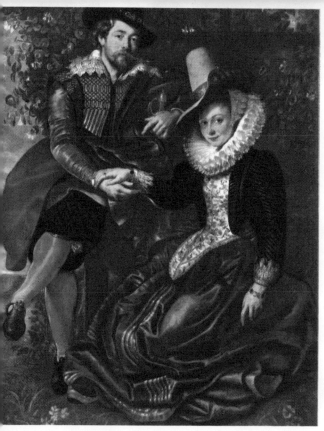

308 PETER PAUL RUBENS
*Self portrait with Isabella
Brant*

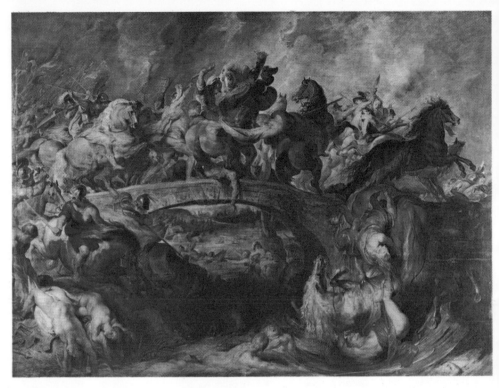

309 PETER PAUL RUBENS *Battle of the Amazons*

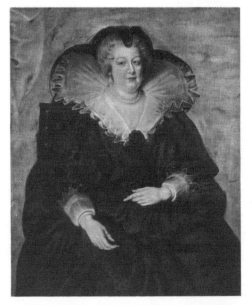

310 PETER PAUL RUBENS *Marie de' Medici*

to keep up with the ideas bursting from him. He delights in hurtling bodies *(pl. 309)* and in the scenes of allegory where heavenly powers involve themselves animatedly with mortals. Out of the inglorious existence of Marie de' Medici he made a glorious cosmic pageant, a dramatic fairytale of exuberant invention. Her history takes on plastic life; Rubens effortlessly allegorised it into the marvellous images of the *Arrival of the Queen at Marseilles (pl. 311)*, for example. When she sat for her portrait *(pl. 310)* he invested her with a regal blonde vivacity which makes her memorable and marvellous, and the sweep of her ruff alone is a triumph of paint. Yet all is done without flattery: it is partly because of its candour that the portrait is so penetrating. He responded to actuality and seized it perhaps more vividly than any other painter. Indeed, the whole world was like a meal served up to Rubens: one only he could fully digest. His own children *(pl.*

311 PETER PAUL RUBENS *Arrival of the Queen at Marseilles*

312 PETER PAUL RUBENS *Château de Steen*

313 PETER PAUL RUBENS *Chapeau de paille*

315) or his second wife, Helena Fourment, *(pl. 314)* are portrayed with as much truth— one feels—as affection. Helena Fourment haunts his last pictures with her blonde hair and pearl skin, here ravishingly set off by the caressing fur robe. After Rubens' death she wanted, it is said, to destroy this memorial to his love and genius.

Rubens' work is like life itself in its inexhaustibility, but the man aged prematurely. No failure of power is felt in the *Chapeau de paille (pl. 313)*, where an unknown woman looks out under a hat itself made almost alive by the writhing feathers along its brim. The paint is handled with absolute mastery, brushed impatiently on to the surface and leaving the portrait tingling with intensity and with a palpitating surface texture. Late in life Rubens acquired outside Antwerp a country house which still survives: the *Château de Steen (pl. 312)*. Even here, where he passed his last summers, he painted; after all his great allegories and mythologies, hunts and portraits, he turned to the landscape of his native land. Autumn has already

315 PETER PAUL RUBENS *Artist's sons*

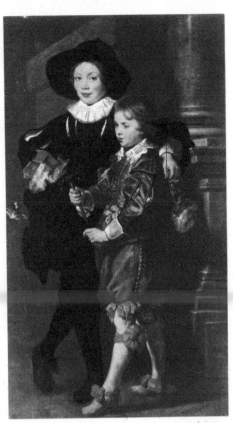

314 PETER PAUL RUBENS *Helena Fourment*

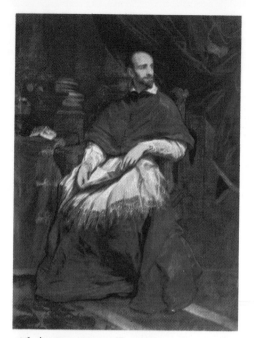

316 ANTHONY VAN DYCK
Cardinal Bentivoglio

touched the trees; a sportsman and his dog
stalk some partridges. And a crisscross of
tangled trees and streams lead the eye to the
superbly atmospheric sky where the hot
white disk of sun hangs low on the horizon,
shooting rays through flecked cloud—an
effect in painting not to be attempted again
until Turner.

Rubens had visited England and been
knighted by Charles I. His most gifted
pupil, ANTHONY VAN DYCK (1599-1641) was
to settle in England and also gain a knight-
hood. Like Rubens, van Dyck was a painter
of religious pictures but much less vigorous
and compelling ones. His response to
portraiture was keener, more neurotic and,
though restricted, capable of giving a
wonderfully graceful air to noble sitters.
Cardinal Bentivoglio (pl. 316) is one of
his achievements while in Italy and before
coming to England. The Cardinal is im-
pressively dignified while easily dissembling
dignity. Van Dyck has caught the trick of
suavity, touched with a cloudy abstraction
which makes wistfully gracious the upper
class English whom he was later to paint.
The *Charles I of England (pl. 318)* is a
refinement of all his talents: the king strolls
as an elegant gentleman, but behind him
equerries and the pawing horse (nervous
like all van Dyck's animals) hint that here is
more than a mere gentleman. The artist
proves himself a skilful courtier. The
clothes of crumpled thin silk are painted
with nearly obsessive attention; van Dyck
seems to have had a heightened feeling for
silken textures akin to Wagner's sensitivity.
His best pictures are nothing to do with
Rubens but are the product of a hot-house
talent, sick and highly-strung.

In Antwerp Rubens' death left his rather
less gifted pupil, JACOB JORDAENS (1593-
1678), to finish some pictures ordered from
Rubens and to continue his own coarse
version of the style *(pl. 317)*. More attrac-
tive is the work of CORNELIS DE VOS (1584-
1651), who occasionally worked for Rubens,
and whose portraits especially those of
children, *(pl. 319)* have a quiet individual
charm, more Dutch than Flemish.

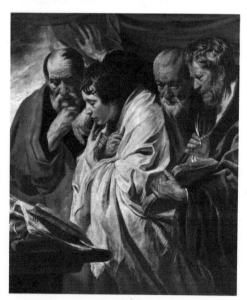

317 JACOB JORDAENS *Four Evangelists*

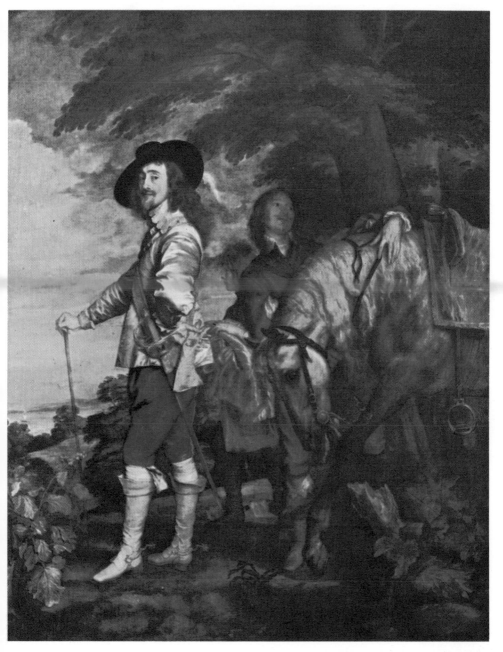

318 ANTHONY VAN DYCK *Charles I of England*

319 CORNELIS DE VOS *Two children*

320 WILLIAM DOBSON *Endymion Porter*

Van Dyck had died in an England already smouldering with civil war. His concept of the portrait dominated English painting for more than a hundred and fifty years and van Dyck costume went on being worn by sitters. As court painter he was succeeded by WILLIAM DOBSON (1610-46) in whose *Endymion Porter (pl. 320)* there is more commonsense than grace, and a positive accumulation of evidence of Porter's interests. Living much longer and enjoying a success even greater than van Dyck, Sir PETER LELY (1618-80) painted the famous people of Restoration England. A Dutchman born in Germany, Lely produced at Charles II's court a drowsy baroque style of portrait. The *Ladies of the Lake family (pl. 321)* are demurely voluptuous and pleased with themselves, their complexions set off by decolleté silk dresses.

At a court very different from that of Charles I or Charles II worked DIEGO VELAZQUEZ (1599-1660), the first great Spanish painter. Born in Seville, Velazquez early became court painter to Philip IV of Spain at Madrid, and there on a second visit in 1628 Rubens met him. Twice Velazquez escaped to Italy, but increasingly his functions as a court official enmeshed him and probably helped diminish his output as a painter.

His early pictures mingle Caravaggesque realism with a dignity of genre reminiscent of the Le Nain but more profound. A dispassionate intensity marks all his pictures: from the early *Old woman cooking eggs (pl. 322)* until the last of his court portraits. Nothing comes between him and what he sees; nothing deflects his vision. His characteristic is to suppress comment, to become an eye recording what is placed before it. Before it was placed chiefly the gloomy, rigid and vacuous Spanish court where the sickly royal children stifled amid nuns, dwarfs and dogs; and Velazquez has left a record of court life as terrifying in its depiction as Saint-Simon's memoirs.

Under the influence of Titian Velazquez' handling of oil paint was to grow more flexible and impressionistic. Just before his first visit to Italy in 1629, he was still paint-

321 PETER LELY *Ladies of the Lake family*

322 DIEGO VELAZQUEZ *Old woman cooking eggs*

ing with the solid Caravaggesque effect of the *Topers (pl. 323)*, an ambitious charade with a peasant Bacchus among equally earthy peasants. Back in Spain Velazquez was soon able to produce portraits of staggering freedom, like the *Baltasar Carlos (pl. 325)*, a canvas nearly seven foot high and probably the first grand equestrian portrait of a child. A new fluency rapidly sketches in the mountain background, and touches into bright points of light the embroidered costume. The silver-pink sash is a homage to Titian, but the dashing pose of horse and rider is a new baroque concept —inspired rather by Rubens. At the centre of all this bravura is the pale, timid, unformed face of the five-year-old heir to the Spanish throne, doomed to die long before he could inherit it. Velazquez records without comment his defenceless air, but it does not escape him. Painting *Francisco Lezcano (pl. 326)*, a dwarf attached to Baltasar Carlos for amusement, he achieved an overwhelming effect by the simple direct honesty of the portrayal. And Lezcano has

the poignancy of being, like Baltasar Carlos, alive and aware; whereas Philip IV in all Velazquez' portraits of him is as dull-witted as arrogant.

In the vast composition, the *Surrender of Breda (pl. 324)*, Velazquez showed an ability far beyond that of the tableau of the *Topers* to organise a crowded scene. It has even a disconcerting sentiment, an honesty of imagination which makes it very different from the usual battle picture. It commemorates a great Spanish victory in the Netherlands; yet the defeated Justin of Nassau, who offers the city key, and the conquering Spinola meet like host and guest. There is very little baroque vigour, but a feeling rather for the sheer facts of two armies: at the left the jerkined Netherlanders with a few clumsy pikes, while at the right a threatening palisade of Spanish lances rises above the foreground group of nobles in full armour. Military conquest is translated into psychological terms. The *Surrender of Breda* is a capital piece of evidence for establishing how highly conscious

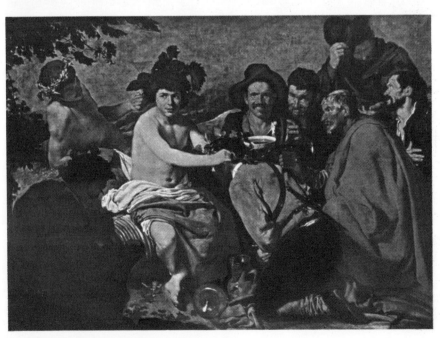

323 Diego Velazquez *Topers*

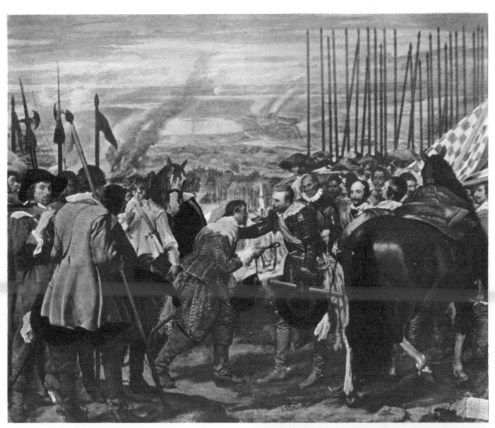

324 DIEGO VELAZQUEZ *Surrender of Breda*

325 DIEGO VELAZQUEZ *Baltasar Carlos*

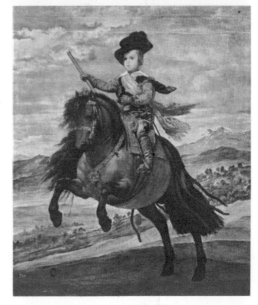

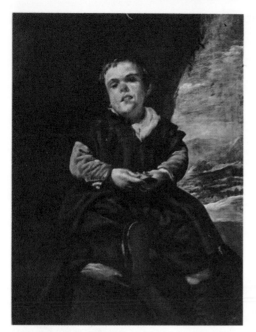

326 DIEGO VELAZQUEZ *Francisco Lezcano*

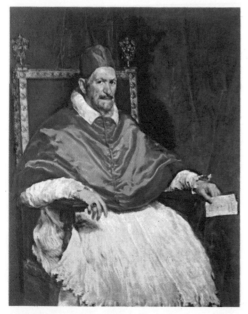

327 DIEGO VELAZQUEZ *Pope Innocent X*

Velazquez was, even though he preferred or was required to mute it in portraiture.

After the restricted circle of sitters and the monotonous etiquette of the Madrid court Velazquez must have welcomed his second visit to Italy, charged with acquiring pictures and objets d'art for Philip IV. At Rome in 1650 the reigning Pope Innocent X sat for a portrait *(pl. 327)* where Velazquez' confident freedom in handling paint reaches a sumptuous height. The Pope's high colour clashes with the red cape he wears, itself a masterpiece of silken texture contrasted with the white linen and lace of the other clothes. For all its technical brilliance —and no doubt Velazquez meant to show Rome how brilliant he could be—its pungent portrayal of the sitter has a penetration equalled only by Titian. It has an easy air after the formality of Spanish court life as seen by Velazquez, and which he finally painted on his return in a last unusually complex composition *(pl. 328)*.

The trick effect of a mirror at the end of a recessed room, reflecting spectators who stand where the actual spectator stands to see the picture, may even have been inspired by van Eyck's Arnolfini group *(cf. pl. 104)*, then in the Spanish royal collection. But here the room is filled by the maids around the Infanta Margarita Teresa and the painter himself at work, conceivably on a double portrait of the King and Queen whose reflections are seen in the mirror. Amid the complicated game of appearances and illusion there remains firm this group, not obviously posed for portraiture, but seized in a moment of action: a maid kneels before the Infanta, a boy caresses the dog with his foot; in the background a door opens and a man is seen framed by it in the light beyond. Not only is the paint applied impressionistically but the picture might seem at a casual glance an 'impression' of court life. Nothing is known of how it originated; it remains unique in Velazquez' work and was probably intended to be kept, like the royal treasures of ancient Egypt, from ordinary men's eyes.

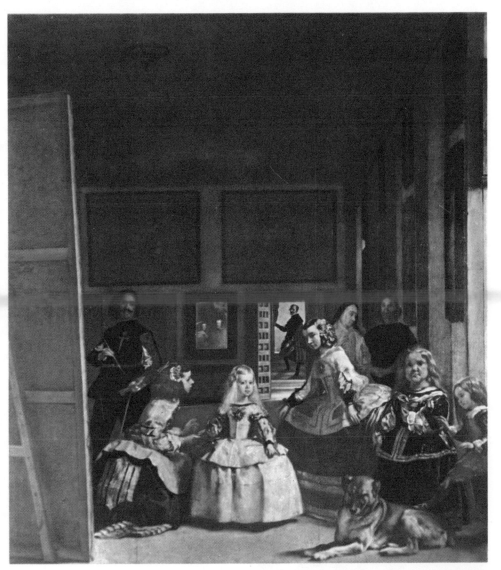

328 Diego Velazquez *Las Meninas*

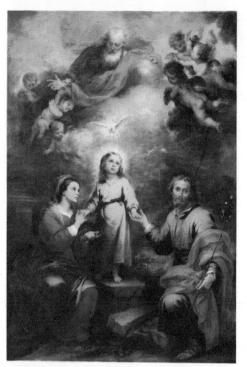

329 BARTOLOMÉ ESTEBAN MURILLO
The Two Trinities

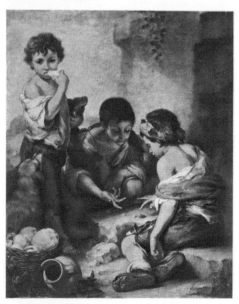

330 BARTOLOMÉ ESTEBAN MURILLO
Boys with fruit

Largely outside the court circle was FRANCISCO DE ZURBARAN (1598-1664) who knew Velazquez quite well. Zurbaran's artistic career was passed at Seville, and his pictures are chiefly religious, often rather obscure incidents from the lives of less well-known saints. Like Velazquez, he calmly states what is: with supernatural tranquillity St Bonaventure lies on his bier *(pl. 331)*. The outline of his mitred head is seen with complete clarity, the shape explored dispassionately and beautifully stated with brushwork reminiscent of Velazquez' early work. His saints calmly accept their own sanctity, for in Zurbaran's world the extraordinary and the miraculous are everyday events. Zurbaran's *Still life (pl. 332)* seems more than a still life: as if by contemplating it one could penetrate the mystery of existence.

The religious pictures of BARTOLOMÉ ESTEBAN MURILLO (1617-82), also of Seville, show a much warmer, sweeter piety. The subjects are not harsh but pleasing, feminine and graceful, where soft draperies and softer clouds obscure the forms. Indeed, too often in Murillo real ability is concealed by faintly tinted vapour, incense-laden, which softens the effect. His best decorative altarpieces, like the *Two Trinities (pl. 329)* are really more rococo than baroque, and they anticipate eighteenth-century religious pictures. Positively nineteenth century is his sentimental view of poor children *(pl. 330)*, so far removed from the dignified genre of Velazquez *(cf. pl. 322)*, itself always characterised as 'profoundly Spanish.' Murillo suggests an aspect of the Spanish character inconvenient for wide generalisations and less obviously praiseworthy.

The century loved genre painting, even when—as with Murillo—genre was prettified and the sting of actuality removed. In Holland there now arose the greatest school of genre painting, arising while Holland itself was evolving as a nation from those United Provinces which had successfully defied Spain. And the *Angry Swan (pl. 333)* by JAN ASSELYN (1682-1749) was easily turned into a symbol of Dutch independence.

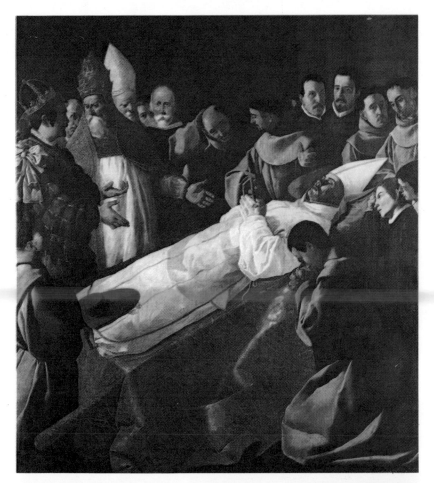

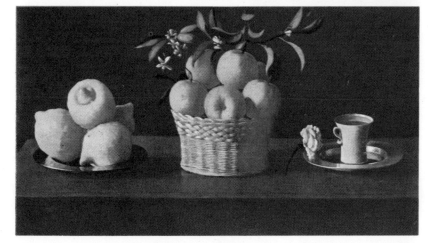

333 JAN ASSELYN *Angry swan*

In some ways Dutch painters had harder lives than those of their contemporaries elsewhere. There was virtually no court or church patronage; there was no tradition of princely painters, and the artist was little more than a tradesman, stocking the goods the public would buy. The Dutch public required chiefly portraits of themselves and their land.

The demand for different types of picture resulted in many painters specialising in particular divisions, and this specialisation was something new in history. But one painter stood out above all the sub-divisions, leaving few of them uninfluenced by his achievements: REMBRANDT VAN RIJN (1606-69). Although Rembrandt never visited Italy, probably never left Holland, he was far from unaware of Italian painting and, like the great artists of the High Renaissance, he was eager to raise the reputation of painting. In the days of prosperity he owned as well as Italian pictures engravings after Raphael and a book said to be illustrated by Mantegna. Himself early prosperous, happily married, by 1640 famous well beyond Holland, he might have seemed to have nearly rivalled Rubens in success and talent. Yet at Rembrandt's death, Amsterdam did not mourn. There was none of the public grief felt in Italy at the deaths of Raphael or Michelangelo. And the list of Rembrandt's possessions in 1669 hardly extends beyond a quilt or two, a bedstead, some clothes and painting equipment.

As a young man Rembrandt left the university town of Leyden, where he was born, for the commercial centre of Amsterdam. Here he was taught by PIETER LASTMAN (1583-1633) who had worked in Italy and whose Italianate pictures, usually on a small scale, have rather grotesque drama but often sumptuous colour *(pl. 335)* Lastman's miniature baroque scenes, Caravaggio in a teacup, had their effect on Rembrandt whose own dramatically-lit baroque pictures, like the *Blinding of Samson (pl. 336)*, are a tribute to Italian art. But from the first Rembrandt's skill as a portraitist was what brought him success. Very early he was

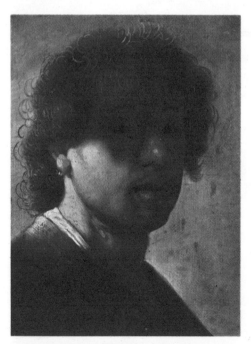

334 REMBRANDT VAN RIJN *Self portrait*

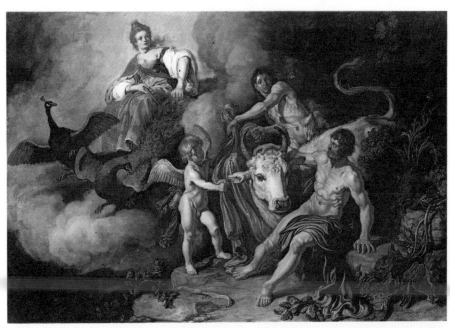

335 PIETER LASTMAN *Juno discovering Jupiter with Io*

336 REMBRANDT VAN RIJN *Blinding of Samson*

195

337 REMBRANDT VAN RIJN *Titus reading*

338 REMBRANDT VAN RIJN
Supper at Emmaus

able to achieve the brash unconventionality of his youthful *Self portrait (pl. 334)*, contrast enough with the late familiar self portraits where events and age have bruised the features until the face is like that of a perpetually beaten but never quitting boxer. Public attention on Rembrandt as a portraitist came in 1632 when he painted the group *Anatomy lesson of Dr Tulp (pl. 339)*, which not only satisfied the sitters but represented for the painter a problem solved in the distribution of light and shade; and the Amsterdam surgeons are less interesting than the dissected corpse before them.

In fact Rembrandt was working all the time towards what interested him, ceaselessly drawing, painting, etching: his feeling for humanity deepening as he drew away from conventional portraiture, simplifying drama to obtain more profound effects. There is no baroque moment in his *Supper at Emmaus (pl. 338)*, though the elements are similar to Caravaggio's *(cf. pl. 263)*, but an almost tragic manifestation of the pilgrim as Christ—as if on breaking the bread the Last Supper and his Passion were recalled to his weary mind.

In a concentration on essentials Rembrandt's portraits took on a penetrating intimacy, an affection for the sitter which is only increased in the portraits of the few people in his small, gradually dwindling, family circle, most of whom died before him. The portrait of his son, *Titus reading (pl. 337)*, is a revolution of simplicity: nothing could be less posed or more economical in concentrating on essentials. The figure emerges out of dusk; light dissipates darkness to illumine only the face and hands. There is a positively Shakespearean grasp of life in Rembrandt's very late portraits, like that of the *Family group (pl. 340)*, which assaults the emotions. The group is painted with a bold tenderness; paint alters its consistency under Rembrandt's demands, creating texture and tone as it is rubbed, scrubbed, or deeply clotted to make a patch of amber-red sleeve, a crease of flesh, a thread of embroidery or a jewel. The careful handling of the *Anatomy lesson*, of about thirty years

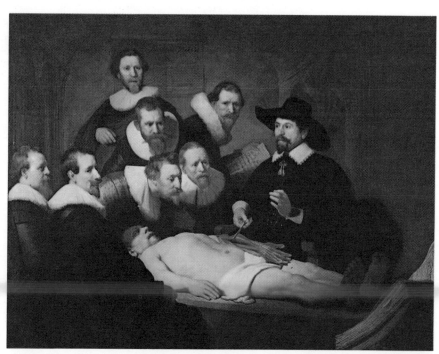

339 REMBRANDT VAN RIJN *Anatomy lesson of Dr Tulp*

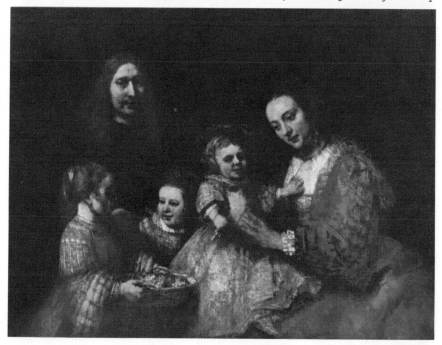

340 REMBRANDT VAN RIJN *Family group*

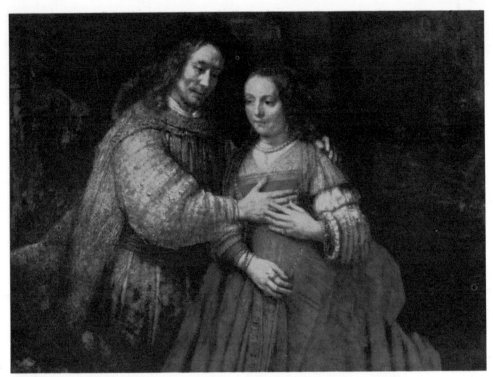

341 REMBRANDT VAN RIJN *Jewish bride*

earlier, has given way to this warm-toned free painting by which a portrait commission is transfigured. In these late years Rembrandt seems utterly unconstrained. The strangely moving *Jewish bride (pl. 341)* has an intensity and mystery which makes irrelevant its subject. Even when given an official commission as in the *Syndics (pl. 342)*, of 1662, Rembrandt responded with a group portrait of overwhelming intensity, concentrating about the red-carpeted table five plainly dressed syndics of the Drapers' Guild, and charging them with all the indefinable gravity of power. They have no symbols of power or status; they are ordinary prosperous bourgeois, unaware of the immortality being conferred on them as they sit in their panelled room.

The humanity and sympathy of Rembrandt's work could not be duplicated. His studio,

however, in the prosperous years of the thirties and forties was full of young men touched into talent by his example, excited by his experiments with effects of lighting. Even a much older painter, FRANS HALS (1580/5-1666), working at Haarlem, felt his influence. The dashing bravura style of Hals' rather superficial manner was modified in his later pictures and deepened into an impressive feeling for character, as in the *Governesses (pl. 343)*. And there is a poignancy in these groups of the administrators of charities, not due entirely to the fact that Hals himself had become destitute and dependent on charity. Rembrandt's greatest pupil was CAREL FABRITIUS (1622-54), little of whose work has survived. In his *Self portrait (pl. 345)* the lighted wall is almost more important than the shadowed face, and the rough brickwork

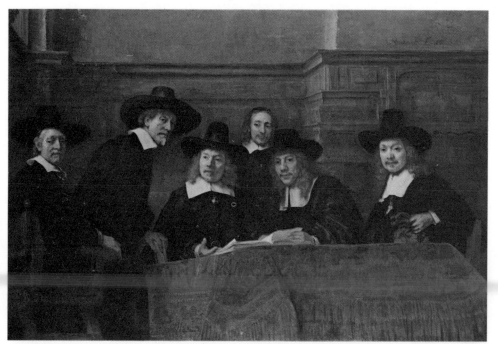

342 REMBRANDT VAN RIJN *Syndics*

343 FRANS HALS *Governesses*

344 JOHANNES VERMEER *View of Delft*

has a gritty texture anticipating Chardin. In reverse to Rembrandt's usual device, it is the background which is lit and the figure darkly silhouetted (but *cf. pl. 334*).

The explosion of the powder magazine at Delft in 1654 killed Fabritius, but—says a contemporary—from the fire which destroyed him rose JOHANNES VERMEER (1632-75). He owned some pictures by Fabritius and was possibly his pupil.

Vermeer's light effects are equally novel but usually set within a room: interior settings mute the brightness and give a pearly quality in place of Fabritius' rather brash daylight. Vermeer is an artist with perfect pitch. His tonal sense is uncanny and the *View of Delft (pl. 344)* combines almost photographic truth with a refusal to single out any incident or object. In some ways the picture belongs with Dutch topographical pictures, but it has the same discreet and dispassionate quality which marks Vermeer's *Girl reading (pl. 347)* where genre passes into a solemn tranquillity: room and sitter are fused together by the cool light which holds everything from dissolution—as if within a prism. Such a picture is not genre but a moment of pure contemplation, and the lucid *Artist in his studio (pl. 346)* is more interesting to us for the pattern of black and white tiles than for any apparent information about painters' studios in seventeenth-century Holland. Just as chairs and curtains and brass candelabra achieve new dignity when caressed by Vermeer's light, so man loses actuality and takes on a

346 Johannes Vermeer
Artist in his studio

345 Carel Fabritius *Self portrait*
347 Johannes Vermeer *Girl reading*

348 PIETER DE HOOGH *Interior*

349 GERRIT DOU *Poulterer's shop*

timeless quality: forever a girl reads or just touches the keys of an instrument, a painter puts in the first outlines on an easel.

PIETER DE HOOGH (1629-after 84?) is a much more obvious painter, but Delft had its effect on him too. Even today the town retains a withdrawn and placid air, and during the period he lived there de Hoogh was capable of the virtuosity and placid beauty of the *Interior (pl. 348)*, warm-toned after Vermeer's silvery coolness. Light is positively trapped in the glass held up by the hostess, herself luminously silhouetted against the light in a way recalling Fabritius. Here the subject matter is not obtrusive; but soon it began to develop into rather trivial genre. Highly polished and utterly dull little pictures came from the prolific GERRIT DOU (1613-75), and his contemporaries greatly admired work like the *Poulterer's shop (pl. 349)*. Sentimentality enters into the *Idle servant (pl. 350)* by NICOLAES MAES (1634-93), though the picture (dated 1655) is one of the earliest interiors with a view into a further room; Maes returns us to the mysterious penumbra of Rembrandt's interiors.

Music provides the theme again and again for Dutch interiors and GERARD TER BORCH (1617-81) gives a close-up scene of music making in the *Concert (pl. 351)*, without perspective ingenuity and an excuse rather for the brilliant painting of silks and fur. The preoccupations with light—and it is light which lifts genre scenes out of being trivial—are still found in the best pictures of JAN STEEN (1625/6-79) whose *Skittle players (pl. 352)* is a surprise after his usual crowded riotous scenes. Here in about a square foot of board Steen creates a luminously peaceful scene. The seated trio at the left, with the still life of barrel and white earthenware jug, are conceived as part of a *fête champêtre*, ludicrously different from that by Giorgione *(cf. pl. 218)*, but still part of the same attitude which takes pleasure in sitting out in the open air on hot summer days.

Very different genre scenes were being produced across the border in seventeenth-

350 NICOLAES MAES *Idle servant*

351 GERARD TER BORCH *Concert*

352 JAN STEEN *Skittle players*

353 ADRIAEN BROUWER *Boors carousing*

354 JAN VAN HUYSUM *Fruit, flowers and insects*

century Flanders, where ADRIAEN BROUWER (1605/6-38) produced his riotous scenes of peasant low life, usually *Boors carousing (pl. 353)*, saved by their delicacy of handling from being repugnant and trivial. Perhaps the same excuse should be offered for DAVID TENIERS (1610-90) whose tavern scenes stem from Brouwer and whose grotesque subjects, like the *Temptation of St Anthony (pl. 356)* are in a recognizable tradition of Flemish painting.

The Northern tendency, already apparent with Robert Campin in the fifteenth century, to record the immediate and the everyday, was developed by the Dutch not only with genre scenes but with a new category of picture, the still life. A still life becomes in itself a fit subject for painting; though in the 'realism' of some of these are present symbolic overtones. Shells and tulips easily symbolised vanity and stupidity in a country where people could ruin themselves in pursuit of them. JAN VAN HUYSUM (1682-1749) one of the highest paid painters of his time, is frankly decorative in his flower and fruit still lives *(pl. 354)* where the flowers are often of different seasons. The painters of pure still life are content usually with simpler and more austere arrangements. An almost Vermeer-like repose is apparent in the delicately cool pictures of WILLEM HEDA (1594-1682). His *Still life (pl. 355)* shows little food, and is really an intellectual arrangement of certain shapes, silvery even when not made of silver; and the pleasure of arranging still life shapes returns in the twentieth century with Cubism.

The best Dutch still lives have a quality of intimateness which they share with Vermeer's pictures. Less intense then Zurbaran *(cf. pl. 332)*, they still concentrate on aspects of daily life: the glasses, the dishes, the Turkey rug tablecloths of the painters' own homes. Beyond the homes was their town and their countryside, the land for which the Dutch had fought Spain. Low lying, easily the victim of invasion by the sea, it was the perfect country in which to notice fleeting atmospheric effects. JACOB

355 WILLEM
HEDA *Still life*

356
DAVID TENIERS
*Temptation of
St Anthony*

357 ESIAS VAN DE VELDE *Ice scene*

VAN RUISDAEL (1628/9-82), born at Haarlem, was the greatest discoverer of Holland's moody beauty. The very flatness of Holland is an advantage as the eye travels over the extensive landscape *(pl. 358)* to the cloudy sky. That lesson Constable said was the best he ever learnt, 'Remember, light and shade never stand still', was instinctively grasped by Ruisdael, as it had already been by Rembrandt. Ruisdael's skies are cloudy shifting pageants, where a break in a grey rift suddenly lights a patch of water or wooded countryside. None of the other Dutch landscapists can rival the variety of Ruisdael. Before him landscape had been practised by HERCULES SEGHERS (1589/90-1638?) whose monochrome romantic pictures *(pl. 359)* had an influence on Rembrandt. ESIAS VAN DE VELDE (c. 1590?-1630) also played an important part in the development of realistic landscape out of the fantasy landscapes of the Flemish late sixteenth-century school in which arbitrary divisions of the landscape—the distance for instance always blue—were still made. Van de Velde's *Ice scene (pl. 357)* is a scene of real life with a new truth to tone. The same is true of the delightful ice scenes animated by lively puppet figures *(pl. 360)* of HENDRICK AVERCAMP (1585-1634); and one may feel that growing naturalism of the Dutch landscapists stifled the gaiety and freedom found in the early painters and inherited from Bruegel. Apart from the Haarlem 'naturalists', there was a group of landscape painters who had visited Italy and returned to their native land to paint Italianate landscapes. Like Claude they too often worked from nature. The Italian landscapes of NICOLAES BERCHEM (1620-83) working partly in Haarlem, show an idealised but still naturalistic world in which light, purer

358 JACOB VAN RUISDAEL *Extensive landscape*

359 HERCULES SEGHERS *Landscape*

360 HENDRICK AVERCAMP *Frozen river*

and more golden than any Northern light, bathes everything. Frankly decorative is the *Landscape with ploughmen (pl. 361)* which once belonged to Boucher, and which has an almost rococo feeling and elegance, looking forward to Gainsborough's landscapes.

Emerging from straightforward naturalism, and becoming affected by the Italianizers' use of light, was one of the greatest Dutchmen, AELBERT CUYP (1620-91) who spent most of his life in the small town of Dordrecht, which often appears in his pictures *(pl. 362)*. His landscapes are usually straightforward scenes often with a few cattle and a herdsman; the figures and animals clumsily painted but the whole picture glowing with subdued light, an expanse of golden sky reflected in still water. Such pictures were later to have a great effect on not only the Norwich painters but also on Turner and Constable.

The Dutch more and more were using art as a mirror, not only of themselves but of their cities too. They are creators of the townscape picture, often painted with literally peepshow effect. And in the work of PIETER SAENREDAM (1597-1665) one penetrates again and again into the blonde interior of churches *(pl. 364)*. Few of the painted perspective boxes which influenced this type of picture have been preserved, but the diarist Evelyn in 1656 saw in London a 'triangular' one of a church interior.

The greatest of all the city painters was JAN VAN DER HEYDEN (1637-1712) whose luminous clarity is a reminder that he was apparently the pupil of a glass painter. His pictures are less topographically accurate than they seem, and at times are in part 'ideal' towns created for artistic reasons *(pl. 363)*.

Like many Dutch painters van der Heyden had other careers: his urban interests made him an authority on street lighting and fire engines in Amsterdam. Less successful Dutch artists died in the workhouse; others became customs officers or kept inns. And when van der Heyden died, the great age of Dutch art had closed.

361 NICOLAES BERCHEM *Landscape with ploughmen*

362 AELBERT CUYP *View of Dordrecht*

363 Jan van der Heyden *View of the Oude-Zijds-Voorburgwal in Amsterdam*

364 Pieter Saendredam *Interior of the Grote Kerk at Haarlem*

V
FROM THE ROCOCO
TO GOYA

THE EIGHTEENTH CENTURY is perhaps the first period when art freed itself from convictions. No longer did painting *need* to state religious beliefs, record the natural world or explore space. Significantly, painting held little interest for most of the century's great intellectuals; and with new emphasis on it as decoration it often passed unperceived. The imaginative painters of the period were working against current academic standards, sometimes to the peril of their reputations. Men felt there would never again be a Raphael, a Poussin, an Annibale Carracci—without understanding that there could come painters as great yet totally different.

Indeed, belief in art as a power had weakened. The eighteenth century could hardly fail to be sceptical and scrutinising of imagination, for it accomplished so much by its rationality and could advance civilization only by destroying myths. Decorative painting flourished especially at out of date royal courts like those of France and Spain, and in hopelessly retardataire countries like Italy; these with Germany (where numerous petty kingdoms existed) produced the rococo style which never established itself in England, too busy relentlessly demanding portraits. And all the time the rococo was a sort of *infâme* which needed to be crushed. The age was rational, scientific, exploratory in all branches of knowledge; it was interested in Sir Isaac Newton, not in nymphs and satyrs. Along with the rococo, and rising as it fell, was a more serious style of painting, firmly based on reality: recording the natural world, or everyday life, whether of people or animals. And the neo-classic was really part of this, a preference for history over mythology—Poussin's preference—and a desire to be factual and accurate in recording the ancient world as well as the modern one; hence most neo-classical artists, as well as being history painters, were excellent portraitists.

At the end of the seventeenth century clashes in France between the supporters of Poussin and those of Rubens had closed with the triumph of *Rubénisme* publicised by

365 ANTOINE WATTEAU *Gilles*

366 ANTOINE WATTEAU *Mezzetin*

the election to the Académie in 1699 of Roger de Piles, Rubens' champion and biographer. The artistic triumph of Rubens is illustrated by the decorative painters of the eighteenth century, and most superbly by ANTOINE WATTEAU (1684-1721). Watteau was born at Valenciennes, a Flemish town just then become French, and the effect on him of Rubens' Marie de' Medici series when he reached Paris, friendless and penniless in 1702, was tremendous. With Rubens' influence went that of another great decorative painter, Veronese. Yet Watteau's resulting work was very different in mood and scale from the large, healthy, cheerful pictures of his two predecessors. Early tubercular, he lived a restless discontented life; melancholy marks even his gayest pictures and there is a profoundly sympathetic feeling in his portrayal of clowns and wandering players *(pls. 365, 366)* which suggests his affinity with society's rejects and misfits. He himself was accepted; he found devoted friends and became a member of the Académie de Peinture, to whom he presented as *morceau de réception* in 1717 the so-called *Embarkation for Cythera (pl. 367)* which really shows pilgrim lovers leaving Cythera after having paid their vows at the island shrine of Venus. A chain of paired-off lovers links the rose-hung term to the waiting boat; a pair of lovers still dally, another pair rise to their feet, a third set off for the boat, but the woman turns back sadly. Time is inexorable. The boat waits; and the lovers' pilgrimage is over.

The handling of the paint is like that of Rubens turned miniaturist, with its nervously silken touch on the clothes, the foliage, the Claude-like mists which swirl about the distant sea and peaks. Elegant, artificial and half sad, the picture is yet as it were the rosiest possible view of eighteenth-century society. In one of Watteau's last pictures, the *Enseigne de Gersaint (pl. 368)*, we are given an actual view of that society, no longer dallying amorously, but engaged in inspecting pictures and *objets* in the shop of Watteau's friend, Gersaint, for whom this 'sign' was painted. The genre preoccupa-

367 ANTOINE WATTEAU *Embarkation for Cythera*

368 ANTOINE WATTEAU *Enseigne de Gersaint*

369 NICOLAS LANCRET *Moulinet*

370 FRANCOIS LEMOYNE *Narcissus*

tion of the century is asserted here, with ravishing effect. Watteau's mastery of handling is now complete, broad and confident at the very period when the painter was failing. Gersaint records that Watteau was too ill to work except in the mornings; and a year later he was dead.

Only in Mozart and Keats can be found the parallel to Watteau's secret bitter-sweetness. All his pictures have that feeling of transitoriness: 'Joy whose hand is ever at his lips, Bidding adieu'. Like Mozart, like Keats, Watteau is always in pursuit of the elusive. And Pater's cadence catches the tone of the work and the man: 'He was always a seeker after something in the world that is there in no satisfying measure, or not at all.'

After the untypical genius of Watteau, the other painters of 'fêtes galantes', however delightful, are bound to seem rather insipid. NICOLAS LANCRET (1690-1743) is perhaps still too overshadowed by the juxtaposition. The sheer civilized charm of his *Moulinet* *(pl. 369)* and the grace of *Camargo (pl. 371)* are not to be equalled in the eighteenth century outside France; and the *Moulinet* belonged with twenty-five other Lancrets (and the *Enseigne de Gersaint)* to that clumsy lover of French elegance, Frederick the Great.

Classical subjects preserved their popularity but could now be treated without too much solemnity. Venice pioneered a decorative treatment which influenced French art considerably. The *Narcissus (pl. 370)* of FRANÇOIS LEMOYNE (1688-1737) shows this new playful air which emphasises grace and colour. The zenith of frivolity is reached in JEAN-HONORÉ FRAGONARD (1732-1806) whose verve is almost defiant dancing on the volcano's edge, and who lived to see the eruption. Fragonard's eager curving lines sway and unite amorously throughout his compositions. The *Swing (pl. 373)* where everything including the foliage looks like frilly underwear, is a slyly erotic joke which must not make one think that life in eighteenth-century France was always so gay or so gallant. But women remained objects of lascivious attention rather than people; they

371 NICOLAS LANCRET *Mademoiselle Camargo dancing*

372 JEAN-HONORÉ FRAGONARD *Bathers*

are forever bathing, *(pl. 372)* or putting men under their immoral spell, as the vogue for pictures of the *Rinaldo and Armida* story *(pl. 374)* proves.

In the great court painter FRANÇOIS BOUCHER (1703-70) gallant subjects and the urge for decorations meet. He too had studied Rubens. Patronised by Madame de Pompadour *(pl. 375)*, Boucher produced countless tapestry designs and created a brilliantly artificial world of mythological subjects which are hardly more than pretexts for ravishing female nudes *(pl. 377)* often set off as here by blue draperies. His portraits of Madame de Pompadour show his ability as a serious portraitist, while pictures like the *Breakfast (pl. 376)* show another aspect of him, absorbed by the genre subjects of his own period. Nevertheless, it is as a great designer of female nudes, often less voluptuous than they seem at first glance, that he is justly famous. The reclining girl *(pl. 379)*, perhaps one of

373 JEAN-HONORÉ FRAGONARD *Swing*

374 JEAN-HONORÉ FRAGONARD *Rinaldo and Armida*

375 François Boucher
Madame de Pompadour

376 François Boucher *Breakfast*

377 François Boucher *Diana bathing*

Louis XV's mistresses, (little as that particularises her), is a triumph of simple and memorable design, and shows Boucher's delight in the sheer painting of flesh. Such pictures were certainly appreciated outside France, but significantly enough, the female nude was by no means a popular subject for painters in either Italy or England.

Already towards the end of the seventeenth century, France had produced fine portraitists in the friendly rivals NICOLAS DE LARGILLIERRE (1656-1746) and HYACINTHE RIGAUD (1659-1743). Rigaud's impressive *Cardinal de Bouillon (pl. 380)* is the most superb of parade portraits yet partly conveys the sitter's character. While Rigaud painted court personages, Largillierre had often less aristocratic sitters where stiffness was dissolved in rococo charm. The *Painter and his family (pl. 381)* is a fresh view not only of family life but of life in relation to the countryside. It has a relaxed air that preludes the easy unaffected manner of Gainsborough's pictures.

378 MAURICE QUENTIN DE LATOUR
Madame de Pompadour

379 FRANCOIS
BOUCHER
Reclining girl

380 HYACINTHE RIGAUD
Cardinal de Bouillon

381
NICOLAS DE
LARGILLIERRE
*Painter
and his family*

382 JEAN-BAPTISTE GREUZE *La cruche cassée*

383 LOUISE VIGÉE LEBRUN *Queen Marie Antoinette*

Gallantry in France applied itself to portraiture in a way untypical of other countries. JEAN-MARC NATTIER (1685-1766) flattered in loosely mythological guise most of the court ladies. *Madame Henriette (pl. 386)* appears in a negligent attitude which would have not been quite acceptable in either Venice or London. Paris alone of the three was the centre of a powerful royal court utilising painting for its pleasure. At the heart of it for some years ruled Madame de Pompadour, and it is in a pastel by MAURICE QUENTIN DE LATOUR (1704-88) that we have the most elaborate depiction of her as queen of the arts and sciences, yet portrayed gracefully at ease *(pl. 378)*, waiting, with the 'Esprit des Lois' on the table and music in her hands, for the arrival of her servant, Louis XV.

This mood of graceful ease was not long to survive, and the very conditions which made it possible were doomed. Diderot rose to castigate Boucher and despise Watteau. Moral simplicity became the vogue. Madame LOUISE VIGÉE LEBRUN (1755-1842), the friend of Marie Antoinette, portrayed her not like a queen but as a country woman *(pl. 383)*; and in JEAN-BAPTISTE GREUZE (1725-1805) Diderot found a painter of pathetic and 'truthful' pictures which inculcated high moral principles. Greuze's *larmoyant* and often sly pictures of young girls in trouble *(pl. 382)*—in more senses than one—were themselves to drop dramatically out of fashion with the French Revolution. Anticipations of romanticism are apparent in the landscapist, HUBERT ROBERT (1733-1808), whose *Waterfall near Roncilione (pl. 385)* combines decorative flair with a real appreciation of nature. And LOUIS MOREAU (1740-1806) was capable of equally bold effects, as in the *Gallant company in a park (pl. 384)* where landscape makes the figures insignificant.

Outside the rococo and the proto-romantic stood the greatest eighteenth-century French painter after Watteau, JEAN-BAPTISTE-SIMÉON CHARDIN (1699-1779). In some ways he seems the culmination not of French but of Dutch painting, yet with a profundity which

384 LOUIS MOREAU *Gallant company in a park*

385 HUBERT ROBERT *Waterfall near Roncilione*

386 JEAN MARC NATTIER *Madame Henriette*

388 JEAN-BAPTISTE-SIMÉON CHARDIN
Housewife

387 JEAN-BAPTISTE-SIMÉON CHARDIN
Still life

recalls Poussin's. Taking the most ordinary of subjects, a breakfast table *(pl. 389)*, a woman returned from shopping *(pl. 388)*, Chardin seized on their essence and placed them firmly on canvas without triviality or sentimentality, and mercifully without Dutch ideas of humour.

Objects are invested by him with all the dignity of existence: his *Still life (pl. 387)* is almost moral in its gravity. Indeed, pots and pans painted by him are more interesting and more dignified than many human beings. But he has marvellously caught as well the gravity of children absorbed in a task *(pl. 390)*. The truth to tone, the austere plotting of the composition, are only two of Chardin's achievements. The quality of the paint itself is the final miracle, almost gritty in texture yet made to interpret the bloom on flesh or fruit, the metal of a saucepan, the crispness of linen. Chardin's brush, exclaimed Diderot, has on it the actual substance of objects.

Watteau and Chardin are not to be explained by hasty generalisations about their century or their country. Like all great painters they are raised above the average painter's pre-

389 Jean-Baptiste-Siméon Chardin *Breakfast table*

390 Jean-Baptiste-Siméon Chardin *Young schoolmistress*

391 GIOVANNI ANTONIO PELLEGRINI
Putti with ducal coronet

392 ALESSANDRO LONGHI *Jacopo Gradenigo*

occupations in the age in which they lived, and the court at Versailles as little concerned their art as the Second Empire was to concern that of Cézanne.

The eighteenth century's extremes of the grand manner and genre are found in Italy as much as in France. Indeed, Italy—Venice above all—was more than is yet recognised the inspirer of much French eighteenth-century art. In the early years of the century Paris saw the arrival of a number of the first generation of talented Venetians, as Venice awoke after its seventeenth-century drowsiness. GIOVANNI ANTONIO PELLEGRINI (1675-1741) was one of those travelling Venetian decorators largely employed outside Venice. At Paris he painted an enormous ceiling for the Banque de France, soon destroyed but influential on French rococo painting. In England some of his decorations survive *in situ*, as those for the Duke of Manchester's house, Kimbolton *(pls. 391, 395)*. Painting, not in fresco but in oil direct on plaster, Pellegrini achieved about 1711 the silvery beauty of these exotic musicians and *putti*, irridiscent in colour and painted with a feathery enchanted touch.

Pellegrini's sister-in-law was the famous Venetian pastellist ROSALBA CARRIERA (1675-1757) who triumphantly visited Paris in 1720/21, met and portrayed Watteau, and revealed to Latour, for example, the possibilities of the pastel medium. Not stooping to flattery, she yet gave a direct charm to her sitters *(pl. 393)* which was part of the new taste for spontaneity. And her portraits, with their 'close-up' effect of intimacy were appreciated all over Europe. Yet pompous portraits were in demand also at Venice, perhaps more than elsewhere. The full-blown *Gradenigo (pl. 392)* by ALESSANDRO LONGHI (1733-1813) is a curiously archaic figure, not unludicrous, and part of Venetian outdatedness in eighteenth-century Europe. A much greater portraitist, the greatest produced in Italy in that period, is the Bergamo painter VITTORE GHISLANDI (1655-1743), the sober reality of whose work seems derived from Moroni but is much more exciting in colour *(pl. 394)*.

393 ROSALBA CARRIERA *Portrait of a lady*

394 VITTORE GHISLANDI *Portrait of a man*

395 GIOVANNI ANTONIO PELLEGRINI *Musicians*

396 SEBASTIANO and MARCO RICCI
Tomb of Duke of Devonshire (detail)

397 GIOVANNI BATTISTA PITTONI
St Prosdocimus baptising

The Italian impetus in decorative painting was provided by Luca Giordano's peripatetic example. At Naples the great painter was FRANCESCO SOLIMENA (1657-1747) who became one of the most famous of eighteenth-century artists. Perhaps because of the traditional 'baroque' elements in his style *(pl. 399)* he was popular where the Venetian decorators, more air-borne in conceptions, were often ignored.

But Venice was the centre of artistic activity. Here early in the century SEBASTIANO RICCI (1659-1734) established himself but remained a traveller in demand throughout Europe. His pioneering of a lighter gayer style of picture, and a lighter application of paint, makes him in a way the father of all Venetian decorative artists. Pellegrini is only one of those who directly studied under him. Ricci's own altarpieces are usually a homage to Veronese, and in this he was an anticipation of, and example to, Tiepolo. With his nephew, Marco, a greatly gifted landscapist, Ricci joined in the execution of painted 'tombs' of various English Whig figures *(pl. 396)*, which represent one of the most curious sides of English patronage of foreign painters. Ricci visited London in 1712, and the *Resurrection (pl. 398)*, painted in the apse of Chelsea Hospital chapel, has a sparkling decorative freedom quite revolutionary in England, and doubtless deplored. Drama is treated in a colourful and gay manner; the intention is to adorn the apse, and this takes precedence over any particularly religious overtones.

Ricci's death left Tiepolo the most important, as well as the greatest, of the Venetian decorators. Of considerable importance, however, was GIOVANNI BATTISTA PITTONI (1687-1767) not a pioneer but a fluent practitioner of the new manner *(pl. 397)*. Pittoni's work was much appreciated in Germany and Austria. In both countries an even gayer and more reckless style of rococo painting was soon being practised, well exemplified in FRANZ ANTON MAULPERTSCH (1724-96), whose shimmering *Holy Family (pl. 400)* is restless with rococo energy and swooning mists of scintillating tonality.

398 SEBASTIANO RICCI *Resurrection*

399 FRANCESCO SOLIMENA *Madonna
and Child*

400 FRANZ ANTON MAULPERTSCH
Holy Family

Dwelling apart at Venice from the school of light colours and speedy execution was GIOVANNI BATTISTA PIAZZETTA (1683-1754), almost the Chardin of his city in temperament. The century's love for genre had in Italy been already expressed in Piazzetta's master, the Bolognese GIUSEPPE MARIA CRESPI (1665-1747). Subjects such as the Seven Sacraments he treated as simple, even touching, incidents in humblest everyday life: scenes in an ordinary Italian church *(pl. 403)*. And this sympathy for the apparently prosaic is to be found, made more moving, in Piazzetta's work.

His religious pictures are not chromatically brilliant but soberly restrained in colour and effect. Compared with Maulpertsch, for example, everything in his work is sculptured and solid. *Rebecca at the well (pl. 401)* is like a scene of rustic seduction, a piece of country manners rather than a religious picture.

Piazzetta's wonderfully controlled tonal gift is shown in the altarpiece of three Dominican saints *(pl. 402)* which was set up in the Gesuati at Venice at the height of rococo, and which is a demonstration of the effect achievable by black, white and brown. A slow worker and a melancholy person, Piazzetta gave to all his best pictures a poetic integrity and an ability to touch us which elude explanation. The boy posed as the so-called *Standard-bearer (pl. 404)* is wrapped in a dream and is as unaffectedly moving as a child absorbed in a game of dressing up. There is an air of wistful make-believe which seems to express the

401 GIOVANNI BATTISTA PIAZZETTA *Rebecca at the well*

402 GIOVANNI BATTISTA PIAZZETTA
SS. Vincent, Hyacinth and Lawrence Bertrando

403 GIUSEPPE MARIA CRESPI *Ordination*

404 GIOVANNI BATTISTA PIAZZETTA
Standard-bearer

405 JEAN-ETIENNE LIOTARD *Girl with chocolate*

406 PIETRO LONGHI *Rhinoceros*

painter's own withdrawn mood. Piazzetta paid the price of nonconformity and slow working; he died desperately poor.

Crespi's influence was felt in a much more trivial way in another of his pupils, PIETRO LONGHI (1702-85) whose little pictures of upper class life in Venice were much collected by the upper classes. That interest in its own existence which made the century a great lover of newspapers, memoirs and journals, was catered for in Venice by such pictures as the *Rhinoceros (pl. 406)*.

Hogarth in England and Goya in Spain were later to raise genre painting to a much sharper level. Meanwhile the events of everyday, already prettily presented in Boucher's *Breakfast (cf. pl. 376)* found painters elsewhere; and the Swiss, JEAN-ETIENNE LIOTARD (1702-89), produced some technically brilliant pastels, like the *Girl with chocolate (pl. 405)*, at once decorative and realistic.

Whereas eighteenth-century genre is virtually a softened version of earlier Dutch work, the century developed the townscape with less debt to previous art. In Venice the eighteenth century had a city of fantasy wilder than anything it could imagine; and views of Venice were in demand throughout Europe, especially in England. For more than forty years GIOVANNI ANTONIO CANALETTO (1697-1768) was *the* recorder of Venice. His early pictures like the *Stonemason's yard (pl. 407)* are atmospheric views of a type never painted before. *The Stonemason's yard* is no tourist souvenir but an intimate behind-scenes view of Venice seen by a Venetian: huddled, almost squalid, and painted with instinctive feeling for the texture of stone and bricks and slate. Canaletto's more obvious scenes of festivals *(pl. 408)* still have a bustle and vivacity which is equally part of Venice; and the Ascension Day feast was the last sign left to the doomed Republic that it yet ruled the waves.

Visiting England, Canaletto was able to capture another urban scene and London *(pl. 409)* is now viewed with at least adopted sympathy and insight. Faced with the countryside he was—like so many people of

407 GIOVANNI ANTONIO CANALETTO *Stonemason's yard*

408 GIOVANNI ANTONIO CANALETTO *Feast of the Ascension in Venice*

409 GIOVANNI ANTONIO CANALETTO
View of the City of London from Richmond House

his period—not quite at ease. Canaletto's nephew BERNARDO BELLOTTO (1720-80) left Italy as a young man and practised view painting chiefly in Dresden *(pl. 410)* and Warsaw, with colder colouring and emphasis on genre details which makes him less purely a painter of stone. Canaletto's enormous popularity had gradually turned him into a mechanical purveyor of views, and at Rome a sustained demand seems to have dessicated the gifts of GIOVANNI PAOLO PANINI (*c.* 1692-1765/8) whose view of Rome *(pl. 411)* are perilously close to picture postcards in all except size.

The landscape of Italy was of lesser interest than its cities and ruins; and for most people it had already been sufficiently portrayed in calm moods by Claude and in harsh ones by Salvator Rosa. MARCO RICCI (1676-1730) paid homage to the Salvatorian type in such romantic and wild scenes as *pl. 412*, while the

410 BERNARDO BELLOTTO *View of Dresden*

411 GIOVANNI PAOLO PANINI *Piazza Navona flooded*

412 MARCO RICCI *Landscape*

413 FRANCESCO
ZUCCARELLI
Bull hunt (detail)

414 RICHARD WILSON
'Villa of Maecenas' at Tivoli

rather artificially Arcadian-classical paintings *(pl. 413)* of FRANCESCO ZUCCARELLI (1702-88) satisfied the demand for sweetened Claude. The taste of the age preferred Zuccarelli's bland nature to the more realistic and honest work of RICHARD WILSON, (1713/4-82). Wilson travelled in Italy and probably at Zuccarelli's instigation turned from portrait painting to landscape. But it was Rome and the Campagna which deeply impressed him and formed his art: the *'Villa of Maecenas' (pl. 414)* has a Claudian melancholy. His views in England and Wales are classical too, in their design and austerity. There is a dignified generalised truth to nature in the *View of Snowdon (pl. 416)* which manages to be at once elevated and yet realistic. The direct view of nature, so little the concern of Italian painters, found other Northern exponents and there is an almost livid, raw actuality in the *Landscape with a sandpit (pl. 415)* by JOHANNES CHRISTIAN BRAND (1722-95), a Viennese landscapist who owes nothing to other artists or to literary ideas.

In contrast to this actuality, but equally divorced from precedent, is the work of

415 JOHANNES CHRISTIAN BRAND *Landscape with a sandpit*

416 RICHARD WILSON *View of Snowdon*

417 FRANCESCO GUARDI *Torre di Mestre*

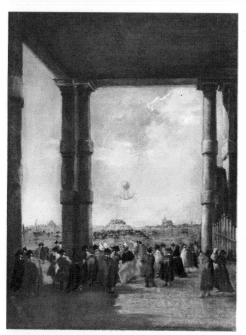

418 FRANCESCO GUARDI *Ascent in a balloon*

FRANCESCO GUARDI (1712-93), a Venetian view painter who was more than a view painter. He too recorded events, like Conte Zambeccari's ascent in a balloon in 1783 *(pl. 418)* or the Doge embarking on the bucintoro *(pl. 419)*, but people and events matter much less than his own enchanted interpretation of Venice. Whereas Canaletto had built up a solid Venice from blocks of masonry, tubes of chimneys, façades as firm as marble, Guardi creates a shimmering insubstantial city, forever rocking on the water *(pl. 420)*. The light is always refracted into lively dancing points which gleam on the dots of people and glitter on buildings. Eventually light and air and water are the only 'subjects' of his work: the waters of the lagoon flood the composition, and the *Torre di Mestre (pl. 417)* becomes not a view but an atmospheric 'harmony in grey.' The way is prepared for Turner and the Impressionists. The greatest decorative painter of the century was also a Venetian, GIAMBATTISTA TIEPOLO (1696-1770), who married Guardi's sister. Brilliant draughtsman and colourist, Tiepolo was above all a great imaginative painter and perhaps the last artist to be at home in themes of allegory and classical mythology. He could treat them with a certain witty frivolity or invest them with a dreamy romantic

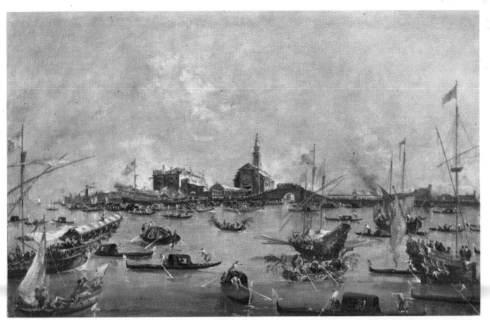

419 FRANCESCO GUARDI *Doge embarking on the bucintoro*

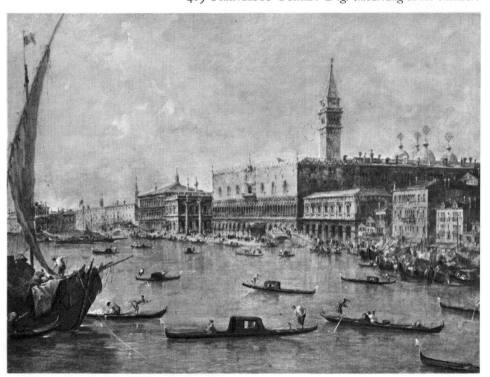

420 FRANCESCO GUARDI *Doges' palace*

languor *(pl. 422)*. His often vast fresco schemes are the last visions of the Renaissance tradition, where men and gods can freely mingle in one element. Tiepolo was famous in Venice and active all over Northern Italy; but his exuberant imagination was not in demand at Rome. He worked in Spain, would have gone to Stockholm if Sweden could have afforded him, and created at Würzburg in the Prince Bishop's Residenz, itself a masterpiece by his contemporary Balthasar Neumann, the most inspired of all his fresco schemes.

Out of the Dark Age story of Frederick Barbarossa he conceived the superb *Marriage (pl. 423)* dressed firmly in the sixteenth-century costumes of Veronese. Across the staircase ceiling of the Residenz he flung a vast fresco where the four Continents assemble to hear Fame trumpet the Prince Bishop's glory to the ends of the earth. Despite its huge scale, Tiepolo kept the whole scheme airborne and lively. Exotic assemblages of people and animals crowd about the Continents, painted with a dazzling speedy touch which turns every detail to enchantment *(pl.421)*. It is as if speed inspired Tiepolo to his finest flights. His imagination naturally dwelt in this heavenly sphere where ceilings are dissolved into Olympian skies with radiant personages of supernatural beauty confidently floating there *(pl. 426)*.

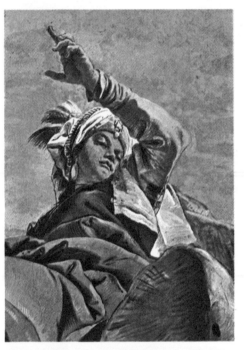

421 GIAMBATTISTA TIEPOLO *Asia (detail)*

422 GIAMBATTISTA TIEPOLO
Angelica and Medoro

423 GIAMBATTISTA TIEPOLO *Marriage of Frederick Barbarossa and Beatrice of Burgundy*

424 DOMENICO TIEPOLO *Tumblers (detail)*

A very different vision was his son's, DOMENICO TIEPOLO (1727-1804), devoted collaborator of Giambattista but with a flair for the antics of society which preludes Goya. A dash of satire enlivens Domenico's work, and with it a keen sense of the beauty of trivia like parasols and fans, and a Picasso-like feeling for clowns *(pl. 424),* frescoes of whom decorated his own villa. Father and son are really two facets of their age: the grand manner at its grandest and genre at its most amusingly attractive. Just at the end of the century Mozart juxtaposed the two worlds in 'The Magic Flute'; and while Tamino and Pamina might have been created by the elder Tiepolo, Papageno is a character out of Domenico.

Though the English remained utterly indifferent to and largely ignorant of, the Tiepolo, they were early great lovers of Watteau, even though English painting still adhered to its stern duty of recording the English face. But the eighteenth century produced great English artists able to make works of art out of the least imaginative commissions, as well as isolated artists of unexpected originality.

The century's taste for strong satire is expressed in art most robustly by WILLIAM HOGARTH (1697-1764) who was yet able to be a great painter. The *Marriage à la mode* series is full of delicate painting as well as moralistic intentions. The *Countess's levée (pl. 427)* is thus not only a 'modern moral' on snobbery and aristocratic behaviour, strong enough to have impressed Hofmannsthal when writing 'Der Rosenkavalier', but a dramatic depiction sensitively painted. And like Domenico Tiepolo and like Goya, Hogarth reveals that good painting can be witty: a discovery made suitably enough only in the age of wit. Hogarth creates in his portraits a new type of sitter, or rather a new and almost heroic treatment of the bourgeois sitter *(pl. 425).* The founder of the Foundling Hospital is bluff, kindly, no-nonsense, but a dominating figure, painted with a sturdy baroque vigour very different from the average eighteenth-century portrait.

Hogarth's opinions were militantly insular,

425 WILLIAM HOGARTH *Captain Coram*

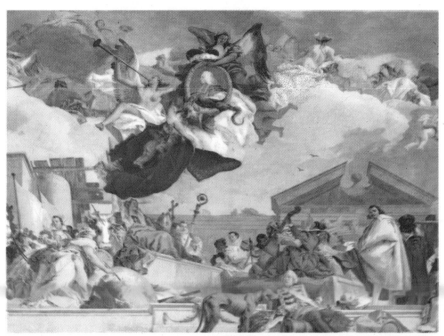

426 GIAMBATTISTA TIEPOLO *Apotheosis of the Prince Bishop*

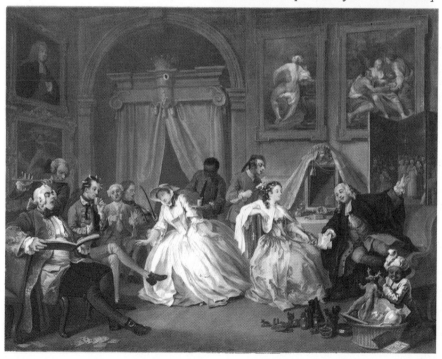

427 WILLIAM HOGARTH *Marriage à la mode*: *Countess's levée*

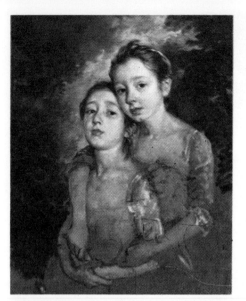

428 THOMAS GAINSBOROUGH
Painter's daughters

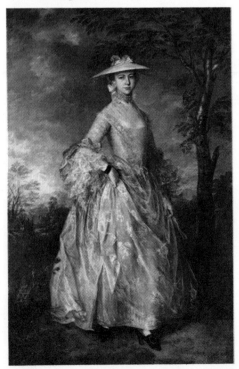

429 THOMAS GAINSBOROUGH
Mary, Countess Howe

though he was certainly influenced in his art by French painting. A more obviously Frenchified elegance is felt in the weaker but pretty work of FRANCIS HAYMAN (1708-76), one of the few English decorative painters. His picture taken from '*As You Like It*' (*pl. 430*) is charmingly light-hearted and 'rococo' to suit its subject, and introduces into the gloomy earnestness of English art some long overdue graces.

It was largely thanks to the engraver Gravelot, a friend of Hayman's, that French ideas of elegance were passed on to THOMAS GAINSBOROUGH (1727-88) who was as a young man also influenced by Hayman. Gainsborough was the great non-conforming genius of eighteenth-century English painting, and his countrymen do not seem quite to have forgiven—or understood—him even now. Unconventional and, in words from one of his own vivid letters, 'a wild goose at best', Gainsborough evolved his style from ravishing 'naive' early pictures, where the very awkwardnesses are a felicity, to the gauzy impressionism of his late work. The masterpiece of his early Suffolk period is *Mr and Mrs Andrews* (*pl. 431*) which is almost a Watteau in an English landscape setting. Painted with an incredible freshness, the young squire and his bad-tempered wife are juxtaposed to that cornfield which is rightly recognized as a superb piece of direct response to nature.

Gainsborough never had any difficulty in getting a likeness—as opposed to his rival, Reynolds—and all his best work has a Mozartian spontaneity. His own daughters are brought before us again and again (*pl. 428*), rather melancholy girls, not particularly pretty, but seen with candour and breathtaking directness. Gainsborough was a pure painter (though, suitably enough, one fond of music) and even on his large portraits the work is all his own.

His response to dress has something of Watteau's sensitivity, and the fluent boldness of his later pictures, like *Mary, Countess Howe* (*pl. 429*) is unexpected in English art, anticipating Renoir rather than the academic dullness of that Royal Academy with whom

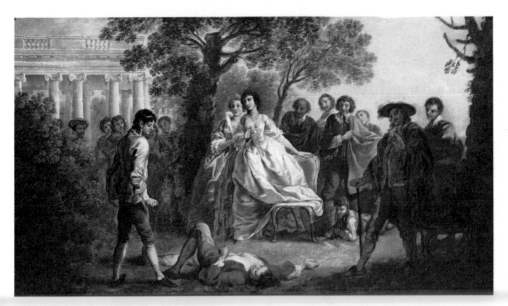

430 FRANCIS HAYMAN *Wrestling scene from 'As You Like It'*

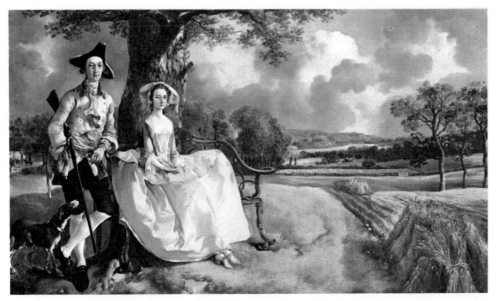

431 THOMAS GAINSBOROUGH *Mr and Mrs Andrews*

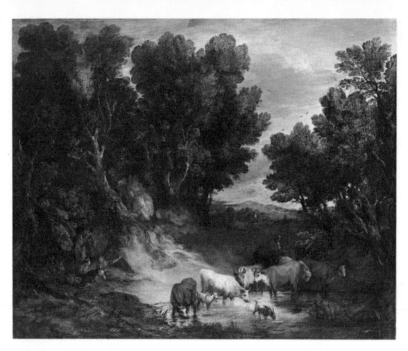

432 THOMAS
GAINSBOROUGH
Watering place

he quarrelled. Lady Howe's wonderful raspberry-pink dress is enough to show that Gainsborough was no mere countryman yearning to paint landscapes, but a sophisticated painter with an eye for textures. The *Morning walk (pl. 433)* is far removed from the precision and 'Dutch' air of his early work. The newly-married couple stroll nonchalantly amid gauzy foliage, and everything has a sketch-like feathery grace: ribbons and drapery, and the fine white fur of the dog. It is this lightness of touch which is so un-English but which unites Gainsborough not only to Watteau but to Tiepolo. His grand landscapes often have an air of silken artifice about them; even his cattle are elegant. The *Watering place (pl. 432)* of 1777 was called by Horace Walpole 'the most beautiful landscape which has ever been painted in England', and it is the peak of eighteenth-century combinations of the ideal and the natural, less artificial than Boucher, less clumsy than Wilson.

By this time Gainsborough was well established in London, after a successful interlude at Bath. But though the favourite painter of the Royal Family, he was not the leading painter of the day in academic eyes. Sir JOSHUA REYNOLDS (1723-92) held this position and by his preaching rather than his practice raised the status of the artist in England. His discourses to the newly founded Royal Academy, of which he was first President, are not only a repository of sound sense but include a generous and movingly perceptive tribute to Gainsborough, delivered after his rival's death. Eager to be 'learned' and anxious to employ a grand manner in portraiture, not only was Reynolds able to compose elaborate groups, like that of the *Duke of Marlborough and his family (pl. 435)* but his romantic feeling for his sitters, especially when they were men, resulted in the bravura sweep of, for example, *Colonel Tarleton (pl. 436)*. Painted in 1782, it shows Reynolds' natural affinity with the baroque, while its military swagger preludes Gros. And at his best Reynolds had a direct simplicity which, when given an ungrand and sympathetic sitter, resulted in a master-

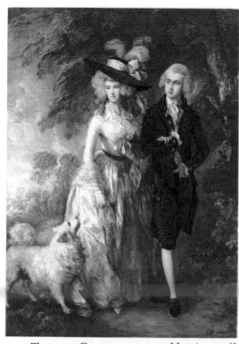

433 THOMAS GAINSBOROUGH *Morning walk*

434 JOSHUA REYNOLDS *Nelly O'Brien*

436 JOSHUA REYNOLDS *Colonel Tarleton*

437 GEORGE STUBBS *Lady and gentleman in a carriage*

piece like *Nelly O'Brien (pl. 434)* where the sitter's charm is not synthetic but is wonderfully conveyed in a solidly built up portrait which could hardly be less 'rococo', and beside which Gainsborough's later work may appear flimsy.

Gainsborough and Reynolds are the twin aspects of the highest eighteenth-century English art. There was also a humbler demand for portraits on a small scale, of ordinary people in their homes and gardens, honest rather than elegant. They appear in the work of GEORGE STUBBS (1724-1806) where the people actually matter much less than the wonderful portraits of horses *(pl. 437)*. Stubbs was convinced that 'Nature was and always is superior to Art', and his studies of natural life, horses above all, go far to explain what he meant. The profundity of his work has only recently been recognized, based as it is in the first place on his anatomical knowledge; he is fully an eighteenth-century man in his scientific seriousness, and his pictures have a Chardinesque dignity of vision.

There is often no need for any human interest and in the *Baboon and albino macaque monkey (pl. 438)*, painting returns to the Renaissance task of recording phenomena. The picture was commissioned about 1772 by the surgeon John Hunter as an illustration of physiology in the animal kingdom. These pictures seem to express Stubbs' convictions and interest much more than the contrived grand manner of his horses frightened by lions.

Scientific interests are illustrated by JOSEPH WRIGHT 'OF DERBY' (1734-97) whose Italian travels produced no classical or fancy results but views of, for instance, Rome lit by fireworks. Lighting effects fascinated him and it is by dramatic candle light that the *Experiment with an air pump (pl. 439)* is conducted. The picture unites science and

438 GEORGE STUBBS *Baboon and albino macacque monkey*

439 JOSEPH WRIGHT 'OF DERBY' *Experiment with an air pump*

440 JOHANN ZOFFANY *Family group*

Caravaggesque light and shade with the pathetic anecdote—as the elder girl weeps on learning that the dove will die.

Meanwhile the dreadful fashionableness of portraiture remained, and towards the end of the century it seemed as if English painters no longer had the vigour to cope. The work of GEORGE ROMNEY (1734-1802) has achieved celebrity through his continuous portrayal of the notorious Lady Hamilton. A Greuze-like monotony robs Romney's portraits of her *(pl. 441)* of much more than factitious charm, and a determination to please enfeebles his handling. More varied and accomplished, JOHANN ZOFFANY (1734/5-1810) settled in England from Germany and his bourgeois pictures—suitably bourgeois when of the Royal Family—throw yet further light on society at the period, as families united to drink tea or sit under the trees *(pl. 440)* and get themselves painted.

None of this contented recording of society hints at the impending storm of the French Revolution. Long before the divine right of kings received the rude blow of Louis XVI's execution, the rococo which had accepted such simple concepts was under attack. The old cult of antiquity and classicism had only temporarily yielded to *Rubénisme*. It now reached a new culmination, encouraged by the excavations at Herculaneum and Pompeii from 1748 onwards, and the arrival on the artistic scene of the aesthetician Winckelmann, fulminating against the rococo and praising the noble simplicity of Greek art.

Rome was the goal and here one could

441 GEORGE ROMNEY *Lady Hamilton*

442 JOHANN HEINRICH TISCHBEIN *Goethe in Italy (detail)*

443 ANTON RAPHAEL MENGS
Maria Luisa of Parma

444 POMPEO BATONI *Time destroying Beauty*

commune with antiquity, as Goethe is shown doing in the portrait *(pl. 442)* by JOHANN HEINRICH TISCHBEIN (1722-89), which represents man in contact with nature as well as antiquity.

High seriousness marks the neo-classic, frigidly rebuking any attempt to treat classical subjects in a cheerful or frivolous spirit. In place of the gay mythologising of Tiepolo there is the chaste, pseudo-sculptural truism of *Time destroying Beauty (pl. 444)* by POMPEO BATONI (1708-87), pure, calm, and coldly finished. Like many neo-classic painters Batoni was an admirable portraitist, chiefly of young Englishmen on the Grand Tour who pose—less profoundly than Goethe—with a suggestion of classical ruin or statue in the background. Highly finished painting marks one difference from the speedy sketch-like air of rococo work. The work of Winckelmann's close friend ANTON RAPHAEL MENGS (1728-79) is 'classical' to the point of feebleness in his subject pictures but he too had considerable portrait abilities *(pl. 443)*.

The ability to move between ideal classical subjects and powerfully realistic portraits is most supremely expressed by JACQUES LOUIS DAVID (1748-1825). Unlike most other neo-classic painters, David was swept up by politics and practised violently revolutionary sentiments which brought him considerable power under Napoleon and disgrace on Napoleon's fall. The extraordinary world of Napoleon's Paris is made eternally memorable by David's painting of its patron virgin, *Madame Récamier (pl. 445)*, resting to receive our adoration, so beautiful, so much loved and so unloving. The picture is almost a triumph of the obvious, a masterpiece of neo-classic portraiture achieved without posturing, deceptively simple in its originality.

The *Death of Marat (pl. 446)*, of 1793, is a forceful piece of propaganda as well as almost brutally realistic: a martyrdom in the cause of the new religion is shown, to excite fervour as had once pictures of flagellated Christs and mutilated saints. On a much more elevated plane is a death David could

445 Jacques-Louis David *Madame Récamier*

446 Jacques-Louis David *Death of Marat*

447 PIERRE-PAUL PRUD'HON
Empress Josephine

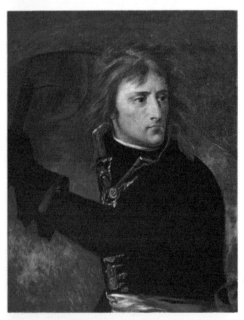

448 ANTOINE JEAN GROS
Napoleon at Arcola

depict with less emotional involvement, the *Death of Socrates (pl. 449)*, a subject perhaps inconvenient in its hints of democracy wrongly condemning the innocent. But all has the calmness of a bas relief, and actuality is replaced by dignity. Socrates' death was an act of stoicism. It teaches us how we too should die; David's picture is a morality which Diderot could have approved of.

David's lucid classicism was a personal achievement. The period was able to accomodate also the blended Correggio-Leonardo style of PIERRE-PAUL PRUD'HON (1758-1823) whose portrait of his patroness, the *Empress Josephine (pl. 447)*, shows her reclining in a wild wooded spot very different from the chaste empty chamber of Madame Récamier; and the background of Prud'hon's picture is full of foliage as mysterious as that in late Corot. The response to romantic literature resulted in numerous pictures from Chateaubriand's 'Atala' of which that by ANNE-LOUIS GIRODET (1767-1824) was disapproved of by David *(pl. 450)*; and David's own pupil ANTOINE-JEAN GROS (1771-1835) was by nature romantic despite all his striving for classicism. Girodet's *Atala* sought dramatic effects of light, and Gros had already revealed his 'palette brûlante' as Girodet apostrophised it. *Napoleon at Arcola (pl. 448)* displays what we know: Gros' admiration for Rubens when he painted this in 1801. All the dash and vigour of the *Napoleon* disassociate it from David's strivings, and lead on to the romantic achievements of Géricault and Delacroix.

But the longest-lived and most influential genius of the eighteenth century was born outside any of the established European artistic centres. ⁔ Spanish painting abruptly revived in the work of FRANCISCO DE GOYA (1746-1828) whose early pictures are partly under Tiepolo's influence and whose later ones influenced Manet. Goya makes nonsense of the centuries and nearly makes nonsense of art history, so little does he fit into any category but his own. Like his contemporary Talleyrand, he happened to span a peculiarly significant and more than usually disturbed period.

449 Jacques-Louis David *Death of Socrates*

450 Anne-Louis Girodet *Atala*

451 FRANCISCO DE GOYA
Doña Tadea Arias de Enriquez

Goya was born at Saragossa but early worked in Madrid where the opposing personalities of Tiepolo and Mengs were creating pictures which had their effect on him. Nevertheless, Goya's observation was from the first much more psychologically penetrating than that of Mengs; and despite his marvellous decorative ability it was the ordinary world of Domenico Tiepolo which interested him much more than Giambattista's mythologising one. Men and women were his subject; his pictures exclude as far as possible landscape, interiors, still life, to concentrate on people and their behaviour. His early cartoons for tapestries are, artistically, a continuation of the younger Tiepolo's decorative realism. Their endless charming inventiveness in country scenes can be appreciated only when they are seen in bulk at the Prado, but one of the best examples, the *Parasol (pl. 452)*, is witty, sharp unsentimental genre which is yet enchanting in decorative effect. For all their effortless charm, such pictures reveal Goya's keen eye which events were to make keener and satiric. His most biting observations on behaviour are not painted but etched in the *Los Caprichos* series which are concerned with urban life and were produced first at the turn of the century.

Meanwhile, Goya had become a fashionable portraitist and painter to the king. *Doña Tadea Arias (pl. 451)* is a portrait of deceptive simplicity in which the sitter is frankly stared at with almost 'naive' results. Yet her dress has a cloudy sketchy freedom similar to the handling of Gainsborough and Tiepolo. This freedom allows Goya to keep animated even such a large official group portrait like the *Family of Charles IV (pl. 453)*. He observes without comment the moronic royal figures glinting in their brilliant court dresses, and colour does its best to help their undecorative personalities. The paint on the Queen's skirt is clotted a brownish-amethyst, clotted again on the diamond stars and embroidery of the clothes, and then is diluted into pale mists of mauvish tones on the gauze of the dresses. Only the little boy in red, the Infante Francisco, more attractive

452 Francisco de Goya *Parasol*

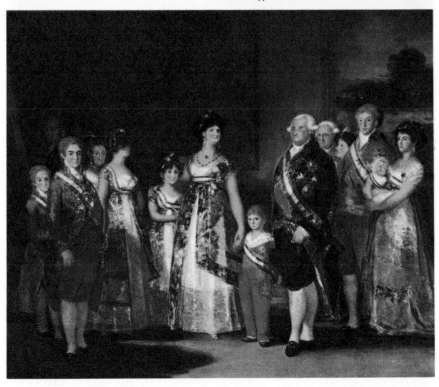

453 Francisco de Goya *Family of Charles IV*

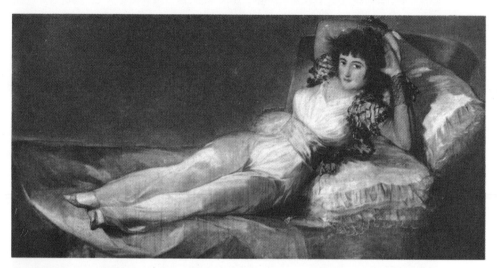

454 FRANCISCO DE GOYA *Maja clothed*

than the rest of his family, stands out hard and bright amid the mists of subtle colour.

The *Maja clothed (pl. 454)* is more freely painted still, the head indeed put in with almost reckless boldness. There is hardly any drawing: just shapes of paint which impressionistically indicate the heaped-up pillows, the clinging dress—as if damped, so closely does it fit the body—and the rococo curve of the slippers which seem to protrude at the spectator. Events in Spain soon offered Goya a less agreeable reality to depict. The French invasion of Spain temporarily toppled the reactionary Bourbon

monarchs. Man's brutality to man was never more vividly indicted than in the lamplit scene of *3 May 1808 (pl. 456)* where the French shoot hostages, painted six years later with no loss of actual horror. Reality pushed under Goya's nose something harsher than Domenico Tiepolo ever dreamt of; and forced him to replace amused cynicism with savage pity. The late *Colossus (pl. 455)*, looming over a darkened cosmos, may symbolise what we please: the collapse of rationality, perhaps, and the birth of monsters; a feeling of despair as the modern world comes painfully into existence.

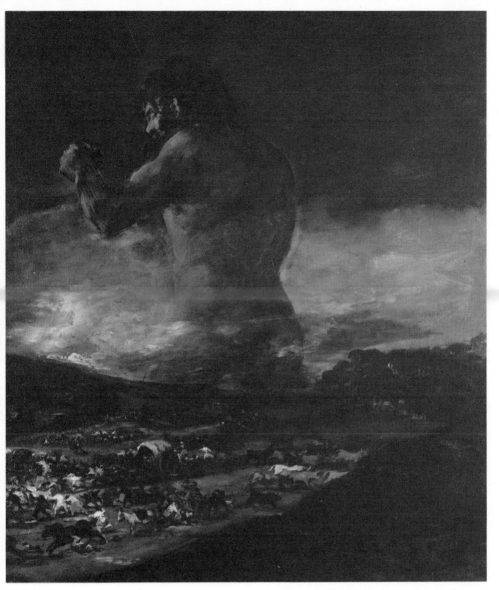

455 Francisco de Goya *Colossus*

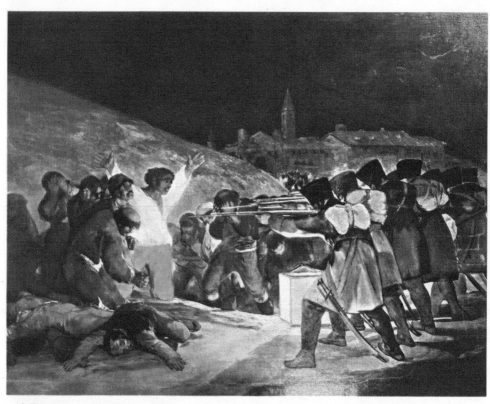

456 FRANCISCO DE GOYA *3 May 1808*

VI
FROM ROMANTICISM TO CÉZANNE

'SHOCKINGLY MAD, madder than ever, quite mad', wrote Horace Walpole in 1785, having seen at the Royal Academy a picture by HENRY FUSELI (1741-1825). This comment is all the more interesting since Walpole himself was a bit of a romantic: author of the 'horrid' 'Castle of Otranto' and builder of a mock-Gothic villa at Strawberry Hill. But whereas Walpole was a primly rational eighteenth-century aristocrat who liked to indulge in fantastic nonsense, Fuseli was a powerful imaginative artist daring to depict dreams and obsessions—as well as being a bitter-tongued democrat. His *Lady Macbeth (pl. 547)* is a blow struck for Romanticism, part of a new appreciation of Shakespeare and the cult of the bizarre. Spectacular fantastic effects were part of the new feeling of freedom from too much rationality: they culminate in Turner's depictions of nature at its most freakish, and at their most melodramatic and megalomaniac in the work of JOHN MARTIN (1789-1854) where buildings or landscape dwarf humanity to insignificance: *Sadek (pl. 459)*. Swiss by birth, Fuseli early settled in England and held important posts at the Royal Academy. Among his pupils were Constable and Etty, and a close friend whom he found 'damned good to steal from' was the poet and artist WILLIAM BLAKE (1757-1827).

Blake's revulsion from the official art of the eighteenth century, and his loathing of Reynolds, were inevitable. His own deeply visionary nature resulted in poems and pictures (often water-colour drawings) of almost private significance. Here the artist is not concerned with fashionable portraiture; Blake preferred to paint 'The Ghost of a Flea.' He turned in on his mystical imagination and sought to express his own concept of *God creating Adam (pl. 460)* or *Satan arousing the rebel Angels (pl. 458)* with a hallucinatory intensity itself repugnant to the 'nothing too much' philosophy of many of his contemporaries.

Blake lived and died poor. He stood outside everything usually called 'society', being too honest for it and too occupied as a creator. Horace Walpole could have applied to him

457 HENRY FUSELI
Lady Macbeth seizing the daggers

458 WILLIAM BLAKE
Satan arousing the rebel Angels

459 JOHN MARTIN *Sadek in search of the waters of Oblivion*

the same terms that he gave to Fuseli. Little artistic following though he had, Blake is yet the prototype for many nineteenth-century artists, also to be ignored or rejected by their contemporaries. With him art is once again given a purpose. It is 'engaged' but not about everyday reality or space. Painting is a method, just as poetry is, of preaching the gospel—Blake's own learned, confused, but burningly sincere gospel. His revolution has its relevance for modern art, for he is one of the first artists to break the Renaissance tradition of painting an ordered world with mankind at its centre.

Equally private and removed from the everyday is the work of SAMUEL PALMER (1805-81) who at least when a young man was capable of fusing brilliantly the world of fact and his own Virgilian pastoral dreams *(pl. 461)*. There must be, he wrote, 'a mystic glimmer' behind the hills, and his best work has exactly that. The prosaic is transfigured; and Dulwich, for example, becomes 'the gate into the world of vision.' Palmer's romanticism thus has affinities with Blake and it isolates him from the rather slick mahogany world of the Regency where Sir THOMAS LAWRENCE (1769-1830) ruled. Brilliantly precocious, Lawrence had by 1789 created

460 WILLIAM BLAKE *God creating Adam*

461 SAMUEL PALMER *Cornfield by moonlight*

462 THOMAS LAWRENCE *Princess Lieven*

463 THOMAS LAWRENCE *Queen Charlotte*

in *Queen Charlotte (pl. 463)* a romantic type of portrait in which the very handling anticipates Delacroix. The paint positively sparkles and crackles on the silvery lilac dress; russet autumn trees are dashed on to the canvas; and a sweep of baroque curtain is lit fulgently aquamarine. The picture breathes the painter's assurance. Lawrence was capable of direct portraiture, as in the bird-like *Princess Lieven (pl. 462)*, only a sketch when compared with the grand style of *Mr and Mrs Angerstein (pl. 466)*, itself a demonstration of his ability in the full length. Lawrence's progress across Europe, painting the personalities who had beaten Napoleon, was the first European triumph of an English painter, himself in this case no gauche islander but as easy and as polished as his portraits.

Contemporary with Lawrence was a leading Scots painter, Sir HENRY RAEBURN (1756-1824) who, while willing to visit London, wisely remained active at Edinburgh. There his flashy handling and pseudo-virtuosity in portraiture *(pl. 465)* were doubtless welcome.

English painting was to play a strikingly direct part in the Romantic movement in 1824 when Constable's *Haywain* was shown

465 Henry Raeburn *Mrs Scott Moncrieff*

464 William Etty *Nude*

466 Thomas Lawrence
Mr and Mrs Angerstein

467 RICHARD PARKES BONINGTON *View of Normandy*

at the Paris *Salon*, impressing Delacroix. Indeed, the links between French and English artists were in general growing firmer. Géricault and his *Raft of the 'Medusa'* travelled round England. Delacroix came in 1825 with his friend RICHARD PARKES BONINGTON (1802-28) who had trained in France, and he was also in touch with WILLIAM ETTY (1787-1849). Etty's devotion to the nude *(pl. 464)* was exceptional in English art, and the attempted Venetian sensuousness of his colour made Delacroix judge him more favourably than we can who have Delacroix's own pictures.

Bonington's *plein air* effects in landscape *(pl. 467)* are more conventionally English, though touched with a prettiness that is not so much French as what the English expect of the French. The English love of landscape had already manifested itself in a complete 'School', that at Norwich, where

JOHN SELL COTMAN (1782-1842) and John Crome (1768-1821) both reveal the continued strong influence of Dutch landscapists, especially Ruisdael. Nevertheless the impetus is the local countryside itself, with its natural affinities to Holland. And the painter is now freer than ever to paint simply what he pleases and what pleases him, as in Cotman's *Seashore with boats (pl. 469)*.

A very different aura surrounded the career of JOSEPH MALLORD WILLIAM TURNER (1775-1851), London born, a Royal Academician (at twenty-seven) and a revolutionary who early had colossal fame for his romantic landscapes, and who at the end of his long life became the hero of Ruskin's 'Modern Painters.' The *Frosty morning (pl. 468)* is an early example of his sometimes Wordsworthian sensitivity to the ordinary scene. The *Frosty morning* positively tingles with cold, and its atmosphere matters much

468 JOSEPH MALLORD WILLIAM TURNER *Frosty morning*

469 JOHN SELL COTMAN *Seashore with boats*

470 Joseph Mallord William Turner *Interior at Petworth*

more than the clumsy *staffage* of people and horses. Indeed, though Turner saw everything in nature through intensely human eyes, the figures he painted are usually an embarrassment. Battling elements excited him to Wagnerian cosmic effects: and the burning in 1834 of England's Valhalla—the Houses of Parliament—inspired a gorgeous scene *(pl. 471)* where fire blazes on the water as if on oil and seems to sear the sky. One feels the fabric of the world has been set alight to make a painter's bonfire. The elements attend the last rites of the '*Téméraire*' *(pl. 472)*, a suitably muted melancholy scene where between the setting sun and the early risen moon an old ship is towed to its final berth. The sky, half molten, half cooled into glassy green, is an extraordinary achievement of European painting; it is 'truth to nature'—but nature caught at one of its most unlikely moments. Nature has largely retired, defeated, in the *Interior at Petworth* *(pl. 470)*, a picture of reckless daring to be painted in 1835. Only light and colour matter here; Petworth shimmers red and blue, and hotly white. It is a vision, painted one might say through closed eyelids. 'Imagination alone', said Constable, 'can never

471 JOSEPH MALLORD WILLIAM TURNER *Burning of the Houses of Parliament*

472 JOSEPH MALLORD WILLIAM TURNER *'The Fighting Téméraire'*

473 JOHN CONSTABLE *Haywain (sketch)*

produce works that are to stand by a comparison with realities.' JOHN CONSTABLE (1776-1837) never closed his eyes to reality; and it is easy to contrast his factual English landscapes with Turner's aerial and exotic scenes. Yet both painters acknowledged a master in Claude. Unlike Turner, Constable had no popular success, never left England and restricted his pictures chiefly to scenes where he was emotionally involved—his native Suffolk above all. The grandest effect he paints is an impending storm; and the very simplicity of his vision of, say, a country lane *(pl. 475)* was too direct for contemporary taste. In the *Brighton beach (pl. 474)* which could never have been exhibitable, there ceases almost to be a subject. The

directness of his large sketch of the *Haywain (pl. 473)* was modified in the final picture which now seems dull by comparison but needed 'finish' to be acceptable. Constable's enormous respect for facts—light flickering on foliage, heavy spirals of cumulus cloud— is in his sketches conveyed speedily and essentially. The *Haywain* is also our last view of rich pastoral England, before the coal mines cut it open and before the railways crossed it: presented as steadily and unsentimentally, and with much the same moral tone, as it appears in George Eliot's novels. A new attitude to nature was expressed in German art, by the romantic pantheism of PHILIPP OTTO RUNGE (1777-1810) and especially in the withdrawn landscapes of CASPAR

474 JOHN CONSTABLE *Brighton beach*

475 JOHN CONSTABLE *Country lane*

476 CASPAR DAVID FRIEDRICH *Man and woman gazing at the moon*

DAVID FRIEDRICH (1774-1840). The *Rest on the Flight (pl. 477)*, by Runge, is not only a prototype for the English Pre-Raphaelites, in its loving detail but is intended as a sort of symbolic homage to light. Friedrich's *Wreck of the 'Hope' (pl. 478)* is symbolic too—of despair—but is more remarkable for its imaginative depiction of an arctic scene. Nature is seen more passively than with Turner, but again mankind dwindles before it into insignificance: seeming merely a spectator of its moods *(pl. 476)*, though once more it is human mood which colours the landscape.

The painter's obsession with his own emotions—or, rather, moods—had produced a rival to late eighteenth-century classicism. The close of that century and the early years of the next were a turbulent period, conscious of its own turbulence. Napoleon, the megalomaniac romantic forcing his dreams on a most reluctant world, became the archetype man of action; and Byron, archetype of romantic poet and lover, had given the romantic movement a creed in stating that 'the great object of life is sensation.' Both Napoleon and Byron contributed to the subject matter of Turner's pictures; and the legend of the one and the poems of the other continued through the nineteenth century to supply painters with material.

French Romantic art, best reflected in the work of THÉODORE GÉRICAULT (1791-1824) and EUGÈNE DELACROIX (1798-1863), originated ironically enough in the work especially of the classical-romantic Gros *(cf. pl. 448)* whose final act was the romantic one of suicide.

What in England and Germany was chiefly a literary movement became transfigured in France by the creative genius of Delacroix. With him France established a hegemony in painting it has since always retained. Cézanne never painted that 'Apotheosis of

477 PHILIPP OTTO RUNGE *Rest on the Flight*

478 CASPAR DAVID FRIEDRICH *Wreck of the 'Hope'*

479 Théodore Géricault *Derby at Epsom*

Delacroix' which haunted him to his last years; but Delacroix's apotheosis came in the rise of Impressionism and in the homage paid to him not only by Cézanne but by van Gogh. Géricault in his brief life managed to touch on the chief things which were to be typically romantic: horses among them. With a Rubens-like vigour, he conceived them in action, chiefly in battle *(pl. 481)* or racing in a *Derby (pl. 479)* without spectators, where Epsom is a sinister blasted heath. But Géricault's 'romanticism' was intended to be real after classic insipidities; and he was inspired by Gros' example to depict contemporary life—a horrid event from which

is the *Raft of the 'Medusa' (pl. 480)*, a scandal at the Paris *Salon* of 1819. Three years before, the frigate 'Medusa' had been shipwrecked and from it was launched a raft of survivors, dwindling daily from an original hundred and forty-nine to the eventual fifteen. The ghastly scene is perhaps *the* key picture of romanticism: managing to combine on one canvas two extremes of human emotions, from the crazed father brooding over his dead son to the hysterically waving group at the other end of the raft. Death in a most dreadful manner, with human beings at the mercy of the elements, all painted with a waxen 'realism' nearly disgusting.

480 THÉODORE GÉRICAULT *Raft of the 'Medusa'*

481 THÉODORE GÉRICAULT *Artillery*

In Delacroix superb colour and vigour banish the grisly preoccupations of Géricault, even when death is the subject—as in the sumptuous *Death of Sardanapalus (pl. 482)* inspired by Byron. Barbaric and savage in subject, it is yet a beautiful picture, and dashed on to the canvas with reckless energy. Such subjects released Delacroix from his own gloom into a world of bounding horses and ferocious men. Like Rubens he admired vitality; and like Rubens again he could animate an allegory. His *Liberty on the barricades (pl. 483)*, inspired by the events of the July Revolution in 1830, is perhaps the last successful allegory to be painted, the final meeting of realism, political cartoon and 'history painting.' Political events had driven Goya to the indignation and tragedy

expressed in *3 May 1808 (cf. pl. 456)*. A moment of hope, when liberty really seemed to inspire France, helped Delacroix create this boldly painted moving document—at the time felt to be dangerously eloquent and likely to lead to riot.

Love for the exotic impelled Delacroix to visit the East, as it did Baudelaire, Rimbaud, Flaubert. The *Algerian women (pl. 484)* is less something witnessed in Algiers than a fused memory of the many scenes which impressed him. It is like the court of Sardanapalus before the massacre: withdrawn and tranquil, yet glowing with green and gold, the women relaxed but still aware, feline for all their complaisance. Delacroix's portrait of his friend *Baron Schwiter (pl. 486)*, himself a painter of sorts and a collector of

482 EUGÈNE DELACROIX *Death of Sardanapalus (sketch)*

483 Eugène Delacroix *Liberty on the barricades*

484 Eugène
Delacroix
Algerian women

485 JEAN-AUGUSTE-DOMINIQUE INGRES
Madame Rivière

486 EUGÈNE DELACROIX *Baron Schwiter*

pictures, shows the influence of Lawrence and possesses the less opulent romanticism of dandyism: both sitter and painter were still in their twenties when it was painted. Meanwhile, the oriental subjects lead on to the luxurious oriental pictures of Ingres. The enormous and comprehensive effort of imagination exhausted Delacroix (yet some of his best decorative works, like the Saint-Sulpice paintings, are among the very latest). His century was the real 'winter of the imagination'—a term so unjustifiably cast at the eighteenth century—and the images used by Delacroix, those Arabs, lions, horses, often grow insipid as does Baudelaire's imagery. Somehow, Delacroix (like Baudelaire) had to create an imaginary world in the too, too solid Paris of fact; and since Delacroix no one has succeeded in animating the jumble of images from allegory, history, literature: that particular set of theatrical props is no longer in use.

The personal rivalry which placed Delacroix in opposition to Ingres is emphasised in their pictures. Romantic but no revolutionary, JEAN-AUGUSTE-DOMINIQUE INGRES (1780–1867) pursued an ideal of beauty well expressed by Baudelaire, the champion of Delacroix and opponent of the bourgeois conservatism of Ingres: 'Je hais le mouvement qui déplace les lignes.' Ingres' subject pictures are usually absurdly posed historical tableaux, sentimental and academic in the worst sense. Only in his female nudes, often in oriental settings where he can indulge an almost cruel sensuality, did Ingres succeed in giving any satisfactory expression of his imagination. The sensuality of the *Nude from the back (pl. 489)*, a favourite view of his, is wonderfully hot-house and heavy, heavy with the languor of steamy airless rooms (hardly any windows appear in Ingres' work, only mirrors). His female portraits have the same calm voluptuousness and an air of vacuity: the life of *Madame Rivière (pl. 485)* seems to border on the vapid. She is an arrangement in white, always handled by Ingres with flawless effect. Her personality is submerged in comparison with the thundery glamour of Ingres' friend, the

487 JEAN-AUGUSTE-DOMINIQUE INGRES *Madame Moitessier*

488 JEAN-AUGUSTE-DOMINIQUE INGRES
François Marius Granet

489 JEAN-AUGUSTE-DOMINIQUE INGRES
Nude from the back

painter *Granet (pl. 488)*. Every detail of costume is caressed by Ingres: patterned shawls, high-collared shirts, above all jewellery, which snake-like coldly twines about the wrists, fingers, necks of his sitters. Indeed, *Madame Moitessier (pl. 487)* is almost a still-life of metals and upholstered fabrics. Ingres toiled many years altering, refining this image of the Second Empire, an ample and opulent goddess of mediocrity. Finished in 1856, that *annus mirabilis* of Napoleon III's unstable empire, this late flowering of Ingres' genius, where detail is subordinated to large design, is a period piece. Only Degas of the great painters who came after cared to respond to his style.

Of Ingres' direct pupils, THÉODORE CHASSÉRIAU (1819-56) alone succeeded in moving from the influence of Ingres into that of Delacroix. His *Two sisters (pl. 491)* shows his ability to create a minor masterpiece. It has much of the combination he set himself to attain: 'naïveté et grandeur'; and its melancholy candour anticipates Degas. Chassériau's later shift towards 'romanticism', out of the world of high ideals into one of reality, is significant of the shift which nineteenth-century French art was making. Free to comment on reality, even political reality, the painter could wander anywhere and comment simply on what he saw. The perfect simplicity of vision in JEAN-BAPTISTE-CAMILLE COROT (1796-1875) appears artless; but it is saved from insipidity by the truth to tone of Corot's eye and palette. His 'impressions' of Italy or France *(pl. 490)* have a wonderful clarity of vision and keen economy in execution: brushed with complete power on to the canvas, conveying baking earth, shimmering olives. This clarity Corot was in later life to exchange for a fuzzy, dimly 'classical', style of landscape with grey trees and wispy nymphs, even while his eye was capable of the old clarity and simple effect he now reserved only for portraits *(pl. 492)*, painted with enchanting directness.

Simple and generous as a person, Corot extended help to the widow of JEAN-FRANÇOIS MILLET (1814-75) and to HONORÉ DAUMIER

490 JEAN-BAPTISTE-CAMILLE COROT *Avignon*

491 THÉODORE CHASSÉRIAU *Two sisters*

492 JEAN-BAPTISTE-CAMILLE COROT *Louis
Robert as a child*

493 HONORÉ DAUMIER *Washerwoman*

(1808-79) in his blind old age. Apart from his savage political cartoons in magazines, Daumier had a Goya-like sympathy with and observation of daily life, painting usually that of the poor *(pl. 493)*. No sentimentality or blurring of objective fact occurs— only indignation and a sense of pathos aroused by life's injustice and man's cruelty, boldly painted in strong chiaroscuro, intensely dramatic *(pl. 495)*. Under Daumier's influence Millet turned to ordinary subjects, chiefly peasant scenes around Barbizon where he settled. Millet has been too hardly treated as a sentimental painter, and his *Angelus* is deplorably familiar. He had in fact a vein of forceful uncouth realism, and the *Gleaners (pl. 496)* is really a straightforward depiction of hard toil in the fields. In much the same way, CHARLES-FRANÇOIS DAUBIGNY (1817-78), influenced by the Barbizon painters, produced landscapes in which nature is observed simply for its own sake, with atmospheric effects,—typified by the *Evening landscape (pl. 494)*.

Already in France the new realism was linked to socialism and denounced. Daumier

494 CHARLES-FRANÇOIS DAUBIGNY *Evening landscape*

495 HONORÉ
DAUMIER
Drama

496 JEAN-
FRANÇOIS
MILLET
Gleaners

497 WILLIAM HOLMAN HUNT
Claudio and Isabella

was imprisoned for his satire (part of the long French tradition of shackling the Press) and one of Millet's pictures of harvesters was attacked as being socialistic. The Impressionists were to be vilified as democrats, and meanwhile in England a young group of painters, calling themselves the Pre-Raphaelite Brotherhood, banded together with the same revolutionary doctrine of 'truth to nature'—but with very different results. Haunted by romantic yearnings in the midst of prosperous Victorian London, they remained slaves of the 'history picture', illustrating Shakespeare as in *Claudio and Isabella (pl. 497)* by WILLIAM HOLMAN HUNT (1827-1910), or subjects vaguely drawn from the Bible as in the *Carpenter's shop (pl. 498)* by Sir JOHN EVERETT MILLAIS (1829-96). Truth to nature resulted in violent colour and clarity of detail, but cruelly revealed the posed studio tableaux origin of such work. Millais progressed beyond Pre-Raphaelitism to become President of that Royal Academy which at first spurned the Brotherhood. Much less competent but much more imaginative, DANTE GABRIEL ROSSETTI (1828-82) was a poet-painter incapable of truth to nature even though a Pre-Raphaelite; and his pictures frankly express the dreamworld which was his true environment *(pl. 499)*.

Victorian England was comparatively secure, but France during the same period underwent a bewildering series of upheavals, culminating in the horrors of the Franco-Prussian war. In England Tennyson found the land that 'freedom chose'; in France Victor Hugo, equally a voice of the age, was banished for his opinions. And the experiences of GUSTAVE COURBET (1819-77), a painter in revolt both artistically and politically, were no pleasanter than Hugo's. The picturesque tramp of *Bonjour, Monsieur Courbet (pl. 501)* was radical in his choice of unconventionally realistic subjects, himself included. Striding across the country in his shirt sleeves and greeted by a patron, he brings a vigorous air of fact into the academic conventions of the period—a deliberate shock of real sun and shade on the road,

498 JOHN EVERETT MILLAIS *The Carpenter's shop*

499 DANTE GABRIEL ROSSETTI
St George and the Princess

500 GUSTAVE COURBET *Stream in a ravine*

and people in ordinary clothes. Courbet's paint was applied vigorously too, a heavy impasto often laid on not with a brush but a palette knife.

In his best work, when not led into rhetoric, Courbet painted richly coloured pictures of nudes, still lives, landscapes *(pl. 500)* all with a vibrant excitement which saves them from being merely photographic. His work was bitterly criticised and officially ignored. His attempted destruction of academic standards is now more important than his destructive part in the turbulent affairs of France which resulted in his flight to Switzerland in 1873. To some extent he may appear Caravaggio born into the nineteenth century, with much more liberty to paint as he pleased but with much less influence.

Courbet's involvement in political events eventually absorbed his energies and culminated in his enforced absence from France at the very period that Impressionism was coming into existence. And whatever affinities of subject-matter he may have shared

with the new anti-academic movement, his own technique of thunderously dramatic chiaroscuro was very different. It is rather EDOUARD MANET (1832-83) who can be claimed as the real pioneer of the new school. His work was execrated even more bitterly than Courbet's, though Manet was personally no revolutionary, his pictures were quite free of social satire, and his art fits more easily into the tradition of painting represented by Velazquez, Hals and Goya, than the work of the Impressionists themselves.

More shocking perhaps to Second Empire taste than his handling of paint were the subjects Manet painted. *Déjeuner sur l'herbe (pl. 502)* was rejected at the *Salon* of 1863 and then shown the same year at the *Salon des Refusés* where it created a scandal. In fact the design is inspired by a Raphaelesque composition, and the juxtaposition of a naked woman to clothed figures—which seemed so offensive—existed already in Giorgione's *Concert champêtre (cf. pl. 218)*

501
GUSTAVE
COURBET
Bonjour,
Monsieur
Courbet

502
EDOUARD
MANET
Déjeuner sur
l'herbe

503 EDOUARD MANET *Argenteuil*

504 EDOUARD MANET *Balcony*

hanging in the Louvre. But the scandal of the *Déjeuner* stuck to Manet. 'It is my fate to be vilified', he was saying seventeen years later; but it was by no means his fate alone in the nineteenth century. The irony is that of all the painters attacked by the century he was the one it should most easily have assimilated.

It seems at first hard to understand why *La musique aux Tuileries (pl. 505)*, which was exhibited earlier in 1863, should have seemed outrageous. But its light high tone and free handling, and its neglect of conventional composition and subject made it a daub in academic eyes. Its open-air depiction of an ordinary scene makes it more revolutionary than *Déjeuner sur l'herbe*, for it anticipates the *plein air* snapshot effect for which the Impressionists were to strive. The public disliked the realism of the *Déjeuner*, which is perhaps closer to Courbet than anything else by Manet, and were equally repelled by the frank realism of the *Olympia (pl. 506)* which was shown in the *Salon* of 1865.

The 'realism' which Manet was pursuing was not so much connected with what is depicted as how it is painted. Drawing gives way to painting, and Manet juxtaposes direct lights and shadows in paint with suppression of half-tones. Such an innovation in an academic milieu ruled by the aged Ingres was bound to be treated as heresy or insanity. After *Madame Moitessier (cf. pl. 487)* where drawing meticulously defines the relationship of each object to the other, Manet's *Balcony (pl. 504)* is recklessly direct in recording what is seen rather than what is known to be there. Looked at closely the picture seems unfinished—is unfinished in contrast to the glazed cold surface of *Madame Moitessier*; but it has all the atmospheric brightness and impact of real life. Manet went further; and in the *Argenteuil (pl. 503)*, of 1874, strong sunlight fractures the forms into patches of bright paint and makes the striped clothes of the two figures shimmer like the expanse of river behind.

In the year Manet painted this, the group of Impressionists, as they were derisively labelled, organised their first exhibition.

505 EDOUARD MANET *La musique aux Tuileries*

506 EDOUARD MANET *Olympia*

Ruskin had spoken of an 'impression' by Turner; Gautier had criticised pictures by the landscapist Daubigny as merely 'impressions'. Now a picture by CLAUDE MONET (1840-1926) entitled *An impression* gave its name to the movement of which he was the leader. Most closely associated with him were CAMILLE PISSARRO (1831-1903), whom he met in 1859 when both were desperately poor, and ALFRED SISLEY (1839-99) who was perhaps the purest and certainly the simplest Impressionist of them all. Visual impressions are conveyed onto canvas in his pictures with incredible truth to tone *(pl. 509)* and with instant response to atmosphere. He painted almost exclusively landscapes, where the weather is evoked with physical effect: a cloudy sky reflected in chill water, or a stretch of dusty road blazing hot in sunlight. And his best pictures have the vivid heightened effect of landscapes momentarily glimpsed from train windows.

Pissarro too was almost entirely a landscape painter *(pl. 508)*. Strictly Impressionist at first, he painted in the open air but with a much firmer sense than Sisley of the scaffolding underlying what he saw. Without losing any freshness, he managed to compose his pictures in a way satisfying and yet natural: not for nothing was he the pupil of Corot. Forced by the Franco-Prussian war to leave France, Pissarro, with Monet, took refuge in England in 1870; on his return to France he concentrated on atmospheric effects, but the interest in structure he had already shown led him later to follow the mathematical-scientific efforts of Seurat in what was really rejection of Impressionist doctrines. In the end he turned back again to Impressionism, about the time that Monet was evolving out of it a highly personal style.

Monet's early pictures have a clarity which is almost naive. The *Women in a garden (pl. 511)*, painted about 1866, is direct and bright, yet hardly atmospheric. And as Manet was to come under Impressionist influence and paint his *Argenteuil*, so Monet at first came under Manet's influence. *Madame Gaudibert (pl. 507)* wife of Monet's only

507 CLAUDE MONET *Madame Gaudibert*

508 CAMILLE PISSARRO *View from Louveciennes*

509 ALFRED SISLEY *Flood at Port Marly*

510 CLAUDE MONET *Rouen cathedral*

511 CLAUDE MONET *Women in a garden*

patron at the time it was painted, in 1868, might almost be by Manet. There is not much portraiture; the sitter's face is turned away, and interest is concentrated on her dress and rich shawl.

Monet's achievements came in the following decade. After the Franco-Prussian war, he rented a house on the banks of the Seine at Argenteuil, on the outskirts of Paris. Here in the open air he painted not simply views of Argenteuil but the atmosphere, the sensation of the view *(pl. 512)*: with sunlight filtered through the leaves, dancing on the water, and captured on canvas by myriad dots and strokes and flecks which are like light itself. Light is the screen through which everything is seen, and detail breaks up under its impact.

But light is always varying in intensity and an object varies its appearance under such fluctuation. So Monet, in his passion for truth to what is seen, was led to paint series of pictures in which a haystack—or a cathedral—is seen at different times of day, with varying light effects. *Rouen cathedral (pl. 510)* is only one of a whole series showing the cathedral; and by this time—1892—the object painted hardly matters. It merely serves as something for light to play around, and in the grey stone Monet's eye detects prismatic colours, a shimmering restless surface which makes the picture a kaleidoscope of brilliance, reminiscent of Turner's *Petworth (cf. pl. 470)*. The colours are like those that pulse behind closed eyelids or when sight is strained too far. And in many ways Monet's pursuit of exactly what the eye sees culminated in pictures in which nothing is seen—at least, nothing is distinguished.

While living at Argenteuil Monet had often had working with him his friend PIERRE-AUGUSTE RENOIR (1841-1919), whose pictures temporarily came close in style to his. Renoir in fact was a very different kind of painter, with a much greater range of subject matter and a wider response to things seen. Renoir's response included delight in attractive girls and pretty clothes, and in eighteenth-century paintings by Watteau,

512 CLAUDE MONET *Regatta*

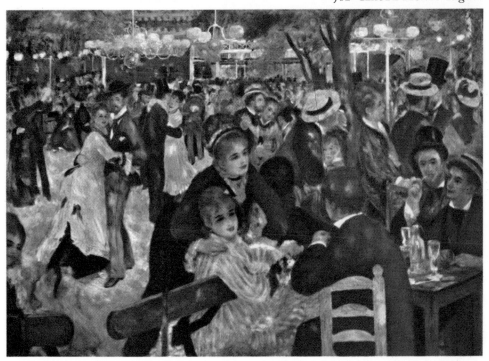

513 PIERRE-AUGUSTE RENOIR *Moulin de la Galette*

291

514 PIERRE-AUGUSTE RENOIR *Nude*

515 PIERRE-AUGUSTE RENOIR
La première sortie

Boucher and Tiepolo (whose work he discovered in Venice in 1881), all masters of frank enjoyment in the senses.

The ravishing feathery touch which Renoir gave to his Impressionist pictures is also eighteenth century, as is his charm. This has perhaps militated against him in puritan critical eyes. The effortless beauty of his rainbow effects in the seventies is now usually set aside, and his later more classical pictures preferred, presumably because of Cézanne's pervasive influence. The *Moulin de la Galette (pl. 513)*, of 1876, shows one use Renoir made of Impressionist doctrine for his own ends: to paint contemporary life, seen at its most attractive in this picture of Renoir's friends dancing gaily in the sunshine. The *Nude (pl. 514)* of about the same date combines joy in the flickering caressing light with instant sensuous response of flesh; and Renoir was later to create much hotter-coloured, heavier female nudes.

The *Madame Charpentier and her children (pl. 517)* still remains enchanting, even if it was successfully received at the *Salon* of 1879 and even if it contained all the elements of popular success. Renoir's feeling for children had already been demonstrated, at its most charming in *La première sortie (pl. 515)* which dodges sentimentality in its sense of breathless eagerness. *Madame Charpentier* is more grand and contrived, less spontaneous in its brushwork; while the porcelain freshness of *La première sortie* is not only a reminder that Renoir had originally been apprenticed to a china painter but manages to convey, through the flickering lightness of the paint, a psychological account of the child's own unspoilt excitement at the shimmering scene.

By the beginning of the eighties Renoir apparently felt that Impressionism could go no further. *Les parapluies (pl. 516)* shows the emergence of a new feeling for classical form, possibly under the influence of Cézanne. The little girl with her hoop at the right is still in Renoir's feathery, rainbow Impressionist manner; but the grisette at the left is much more firmly modelled. The background of umbrellas makes a definite

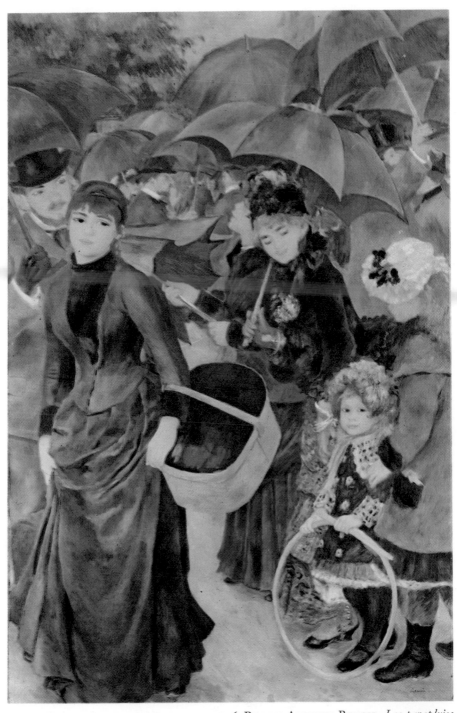

516 Pierre-Auguste Renoir *Les parapluies*

pattern of solids which light has shaped. Muted brightness replaces—only temporarily—the radiance Renoir loved; and in this dull atmosphere the forms are not dissolved but painted with a new sense of volume. In a letter of 1882 Renoir speaks of hoping to acquire the 'simplicity and grandeur' of the old masters. Monet had little interest in museum art, and Renoir's attitude was much closer to that of EDGAR DEGAS (1834-1917), different as was his art.

Degas met Manet while copying as a young man in the Louvre, yet he remained throughout his life aloof not only from the Impressionists personally, even while taking part in the group's exhibitions, but from most human contacts. This detachment only sharpened his formidable powers of observa-

tion and his incisive ability to convey a movement or a whole scene with a few lines. His emphasis upon linear effects derived from Ingres, and at first no more than Ingres did he turn his penetrating gaze on contemporary life. But already in the *Bellelli family (pl. 518)*, begun in 1859, there is an unconventional and natural air in the portrait group—an almost snapshot sense of improvisation.

Degas was influenced to some extent by the new science of photography and even more by Japanese colour prints with their unexpected angles of vision, off-centre compositions and use of blank space, and their deceptive sense of being unplanned. These prints, suddenly available on Japan's new contact with the West, were appreciated in

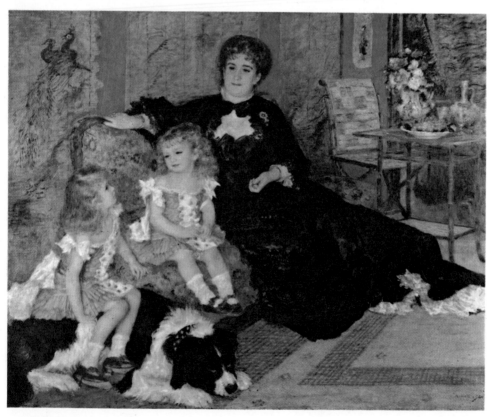

517 PIERRE-AUGUSTE RENOIR *Madame Charpentier and her children*

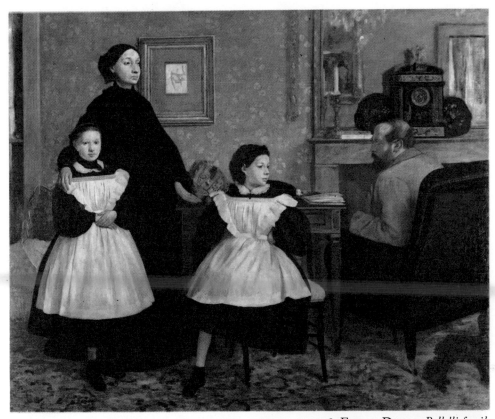

518 EDGAR DEGAS *Bellelli family*

519 EDGAR DEGAS *Diego Martelli*

520 EDGAR DEGAS *Rehearsal in the foyer of the Opera*

Manet's circle and by Monet. They helped Degas towards that summing up of life 'in its essential gestures' which is his own definition of art. His wonderfully controlled and economical technique was equally at home in oil, pastel, watercolour and etching—though this by no means exhausts the list of his media. But everything comes back to his superb draughtsmanship and acid pitiless observation. In the portrait of *Diego Martelli (pl. 519)*, of 1879, the surprising viewpoint results in a witty view of the plump sitter, very different in mood from the earlier also unexpected composition of *Madame René De Gas (pl. 523)*, his cousin and sister-in-law, painted in New Orleans about 1872 during Degas' visit to America. For once candour is combined with at least a mitigation of dispassion; and the blind woman, then pregnant, is huddled and isolated in the space of canvas even with a sort of tenderness.

But it was not portraiture which really fascinated Degas. His obsession with observing ordinary life resulted in the biting reality of *L'absinthe (pl. 522)* in which abrupt slices of table top lead the eye to the drooping woman and her glass; and in the animated *Café-concert (pl. 521)* which brilliantly suggests the crowd, the heat, the noise, and seizes on the singer's action at a particular moment—one of those 'essential gestures' he spoke of. The races and the ballet provided him with enormous and similar material: trained movement, rigorously controlled. For all their sense of actuality such scenes, like the *Rehearsal (pl. 520)*, are not painted on the spot but fused out of isolated studies and composed with less regard to the truth of the scene than to Degas' own interests. Reality is subjected to stringent refining—not to 'improve' it, but for it to yield its essence. The inessential dropped away in the strong

521 EDGAR DEGAS *Café-concert* 522 EDGAR DEGAS *L'absinthe*

523
EDGAR DEGAS
*Madame René
De Gas*

524 GEORGES SEURAT *Circus*

525 HENRI FANTIN-LATOUR
Flowers and fruit

solution of Degas' mind, leaving only images of incisive clarity.

The result was not Impressionism, being at once too ordered and too intellectual. An intellectualised type of Impressionism was created by GEORGES SEURAT (1859-91) in whose mathematically exact and timeless scenes order reigns. *Une baignade (pl. 526)* and *La Grande Jatte (pl. 527)* are lifted out of their contemporary Parisian settings, and a heat haze in both pictures blurs detail and gives static quality to the people, the water, the clouds suspended in the summer sky. Seurat's technique, which he called division-ism, was based on scientific colour theories as a result of which he laid on the paint in tiny dots of pure colour, leaving them to be mixed by the spectator's eye. His sketches for compositions, like that for *La Grande Jatte*, were less rigorous and more freely handled; afterwards in the studio he elaborated his method on the large canvas. The results in open air scenes justify the technique, but not only did it become tiresome in Seurat's followers but in such pictures as the *Circus (pl. 524)* it seems arbitrary and over-cerebral.

The crisis of vision which Impressionism had accentuated rather than solved remained to harass painters and divide them against each other, even when they were united in rejecting conventional painting. Degas was not impressed by *La Grande Jatte*. Monet and Renoir found it better not to paint together any more; and Manet had well before hinted to Monet that Renoir should give up painting altogether.

A number of other artists, besides, grew into possession of their own highly personal styles, and it is probably impossible for any group of truly talented painters to remain for long an organised group. Even the Pre-Raphaelites, somewhat low-powered in talent, could not preserve coherence as a brotherhood. Friendly with Manet but quite uninfluenced by him was HENRI FANTIN-LATOUR (1836-1904) who developed a romantic passion for Wagner but was also capable of the steady almost 'Dutch' manner of *Flowers and fruit (pl. 525)* and

526 GEORGES SEURAT *Une baignade*

527 GEORGES SEURAT *La Grande Jatte*

528 BERTHE MORISOT *Cradle*

529 JAMES ABBOT McNEILL WHISTLER
Little white girl

remains best known for this style of picture. Much further apart artistically from his contemporaries, PIERRE-PUVIS DE CHAVANNES (1824-98) worked in a pale decorative style with simple linear effects, removed from actuality and often somewhat anaemic. The *Poor fisherman (pl. 531)*, of 1881, has an unexpected poignancy in its simplicity, and though attacked when exhibited is much more effective and successful than Puvis' allegorical friezes. Both the Impressionists and the aesthetes admired his work and he, though he could not stomach Cézanne, took an interest in the young Matisse.

Manet's style was most directly reflected in the work of his pupil and sister-in-law, BERTHE MORISOT (1841-95), herself exhibiting with the Impressionists and bringing Manet partly under their influence. Her own unambitious but professional, as well as charming, pictures kept within her experience, often scenes unsentimental and intimate of family life like the *Cradle (pl. 528)* of 1873. 'Mere scrawls', was how Rossetti in 1864 described Manet's pictures; but Rossetti's friend the American JAMES ABBOT McNEILL WHISTLER (1834-1903) had exhibited with Manet the year before at the *Salon des Refusés* and was influenced by him as well as, like Degas, by Japanese art. No more than Degas was he an Impressionist; the *Nocturne in blue and gold (pl. 530)*, one of his views of Battersea Bridge, is a patterned night-piece in the Japanese manner rather than an impression of real darkness. The *Little white girl (pl. 529)* is an 'arrangement' too, decoration more than a portrait. And Whistler's preoccupations with pattern and his relative lack of interest in light, along with his dilletante attitude, unite him to the new aesthetic movement.

Bitterly as the bourgeoisie rejected it, Impressionism was a bourgeois movement: robust, unanguished and, though saddled with a theory, unintellectual. Indeed, the theory itself was merely a more precise application of the neutralism dear to the bourgeois. It moved confidently to seize the actual, commonplace appearance of

530 JAMES ABBOT MCNEILL WHISTLER
 Nocturne in blue and gold

531 PIERRE PUVIS DE CHAVANNES
 Poor fisherman

things, and concerned itself hardly at all with the artist's emotions or his comments.

By the nineties, this robust impetus was spent, and the battle against philistinism was taken up by artists who, in pointed contrast to the Impressionists, welcomed and gloried in their alienation from society. Whistler had bouncily propounded his view of the artist as a privileged jester-prince; and now the aesthetes floated languidly through society conspicuously absorbed in their own beautifully pallid dreams. Such dreams were expressed in Paris by the oil paintings and pastels of ODILON REDON (1840-1916), himself from a suitably exotic-decadent background, since he was the delicate child of an American Frenchman and a Creole. In a manner at once pretty and morbid, Redon mistily depicted fine, unhealthy faces, with a suggestion about them of the drowned Ophelia *(pl. 533)*, and flowers which might have been held in the pale, plump hand of Oscar Wilde himself. If Redon painted what might have been the content of Wilde's mauve aesthetic fictions, HENRI DE TOULOUSE-LAUTREC (1864-1901) depicted the sordid background of Wilde's life (and in an imaginative drawing done from memory after meeting him in London, he captured the cheesy decay of Wilde's face). A personality who might have been invented by Baudelaire, an aristocrat crippled at the age of two and forever stunted, Lautrec, after a competent beginning in a sub-Impressionist manner *(pl. 532)*, found his own stark and emphatic style by pursuing the theatrical subjects which had been painted by Degas into the underworld locales of music-hall *(pl. 534)*, cabaret and bar: disreputable milieux which, in an age of social rigidity, were the only places where the classes mixed, raddled prostitute and client, drinker and dancer. Of these sad figures, Lautrec gives us a dwarf's-eye view; the black-stockinged, feline legs of his dancers wave above our heads; and out of this loveless mingling of bodies relentlessly observed, and massed in incisive, satirical patterns, he creates a fin-de-siècle inferno lit by gaslight.

532 HENRI DE TOULOUSE-LAUTREC
Artist's mother

533 ODILON REDON
Violette Heyman

534 HENRI DE
TOULOUSE-LAUTREC
At the Moulin Rouge

535 PIERRE BONNARD *Woman and dog*

In 1892 the name of Les Nabis, from the Hebrew for 'prophet', was attached to a group which was to make a more purely painterly protest against bourgeois standards. Prophetic, however, they were not. Indeed, after a flirtation or at least a sympathy with aestheticism, the two finest painters among them turned back to Impressionism and demonstrated that, in one vein at least—the domestic interior—it was not worked out. PIERRE BONNARD (1867-1947) and EDOUARD VUILLARD (1865-1940) have received the name 'intimist' for their candid yet friendly close-ups of bourgeois life. Bonnard the more versatile in style and subject *(pl. 535)*, Vuillard specialising in portraiture and conversation-pieces which display the sitter not merely in but by means of, the furnishings he has collected about him *(pl. 536)*. Occasionally Vuillard's manner verged on the banality of the cluttered interiors themselves, but at his best he is a poet of upholstery and bric-à-brac, weaving muted but firm decorative effects from that most anomalous result of European imperialism, the oriental richness and intricacy of the patterns on suburban carpets, wallpapers and loose covers.

Before developing their neo-Impressionist style, Bonnard, Vuillard and the other Nabis, together with other more or less aesthetic painters, were much influenced by the 'symbolist' work of PAUL GAUGUIN (1848-1903). Gauguin had been a business man who took an interest in art, patron of the Impressionists and an amateur painter himself—until, at the age of thirty-five, he resigned from his firm and became a professional painter. This was not, however, the instantaneous and carefree escape from family and business which popular legend represents. Gauguin was still trying to support his family—by painting; and when that failed, he sought, usually in vain, other kinds of work. He was by turns Impressionist, Expressionist-religious (at the period of his friendship with van Gogh) and symbolist-poetic.

Like many artists whose genius was really for powerful effects, Gauguin was at first imprisoned in an over-delicate manner. Not

536 EDOUARD VUILLARD *Mantelpiece*

537 PAUL GAUGUIN *Riders on the beach*

305

until 1891 did he make his definitive escape to Tahiti and discover in himself the style which was to become, after his death, a corner-stone of modern painting. Apart from one sojourn in Paris, he remained in the South Seas, at first in Tahiti and then in the Marquesas, poor, and at the last agonisingly ill with syphilis.

Gauguin's South-Sea exoticism has not broken its links with the exoticism of the decadents, but the climate and light of Tahiti has liberated the artist's senses. The tight calligraphic whorls have opened into exotic blooms. The flora of the islands, and the native women, seen as beings as natural and unreflective as gentle animals, become motifs which Gauguin weaves into a decorative trellis of his own imagining. His method remained literary and symbolist. These poetic scenes pose philosophical problems about the purpose of existence— questions Gauguin even inscribed on the canvas, as though to emphasize that he was not seeking a representational illusion; and he underlines their enigmatic quality by giving them native titles *(pl. 539)*. Colour has been liberated from its naturalistic duties. The brown women *(pl. 538)* are brown less as a description of their skin than as an account of Gauguin's delight in their uncivilised un-European simplicity; sands become pink *(pl. 537)* to convey Gauguin's sense of an unlimited, sunny expanse.

With Gauguin the subject-matter is all important, inasmuch as his spirit could not come to expression until it had possessed itself of a vehicle in the form of suitably exotic subjects. With van Gogh the voracious demon is internal; subjects are sucked in to the artist until they have no existence except in his vivid consciousness.

VINCENT VAN GOGH (1853-90), son of a Dutch pastor, was a picture-dealer, a schoolmaster, a theological student and an evangelist preacher in a Belgian mining district, before he became a painter. His early work was heavy, dark and even clumsy with social seriousness: scenes, for the most part of peasants working, which underscore the

538 PAUL GAUGUIN *Tahitian women*

IA ORANA MARIA

539 Paul Gauguin *Ia Orana Maria*

540 VINCENT VAN GOGH *Sunflowers*

541 VINCENT VAN GOGH *Chair and pipe*

bitter toil and poverty which had—rather too much for the authorities' liking—provoked his sympathy in his mission days. In 1886, the missionary was himself converted. He joined his younger brother Théo, who worked for a dealer in Paris; and there he encountered Impressionism. He was, however, ill. Two years later he moved to the southern climate of Arles, where Gauguin, whom he had met in Paris, came to live with him. But van Gogh was already a mental cripple. In one of his fits of insanity he attacked Gauguin, and thus drove him away; in another, he cut off his own ear. Restored to himself, he was utterly dependent on his brother's devotion; mad again, he was removed in turn to the hospital at Arles, the asylum at Saint-Rémy, and finally to Auvers, where he shot himself. His brother died six months later.

For subject matter van Gogh drew on the props of a life as pitifully bare as a lunatic's cell: a vase of sunflowers *(pl. 540)*; a chair *(pl. 541)*; the countryside round Arles *(pl. 542)*—often in views obtainable from the room where he was shut up; the son of the local postman *(pl. 544)*; his own face *(pl. 543)*, the one model that was always available, even though, as the bandaged portraits show, he might mutilate it.

These themes van Gogh fell on with passionate intensity, as though he could absorb into his own being the assured, unchanging, sane there-ness of the chair, as though he could merge his own intermittent periods of light with the immutable continuity of the seasons. If Gauguin's work liberated colour, van Gogh's liberates coloured paint; the bright pigments themselves writhe, as though matter were on the point of taking life. The world esteemed his pictures so little that not one was sold in his lifetime; only now, when the world, in its lucid periods, has come to recognise its own intermittent insanity and to share van Gogh's desperate fight against the gathering dark, is he recognised as one of the universal saints. The nineteenth century would have been surprised to know that two of its most influential bequests to the twentieth were

542 VINCENT VAN GOGH *Cornfield and cypress trees*

543 VINCENT VAN GOGH *Self portrait*

544 VINCENT VAN GOGH *Armand Roulin*

545 PAUL CÉZANNE *Self portrait*

546 PAUL CÉZANNE *La Vieille au chapelet*

the isolated, ignored and tormented figures of Vincent van Gogh and Søren Kierkegaard, posthumously canonised as the heroes of the age of anxiety.

If van Gogh is a patron saint of modern art, PAUL CÉZANNE (1839-1906) is its Old Testament patriarch—or rather its forerunner. The facts of his life are undramatic. His father was a rich Provençal, and Cézanne was never poor. Of the older painters whom he knew, only the gentle and generous Pissarro seems to have been interested in him. His peasant-stubborn secretive nature made him detest theorising talk; and his own efforts to overcome an inherent clumsiness and to force himself on in pursuit of the significant made him largely indifferent to the work of other painters. Van Gogh's pictures seemed to him the product of a madman—as he told van Gogh. Cézanne's early work was Impressionistic, but in fact he had been born to destroy Impressionism. His increasing lucidity before nature, before scenery like the *Mont Sainte-Victoire (pl. 547)* near his native Aix, led him away from atmospheric effects into an apprehension of the forms underlying this familiar scene. Cézanne assaults nature frontally: part of the tremendous impact of his work comes from this head-on assault. All the planes interlock in the *Card players (pl. 548)* where the table is almost pushed at the spectator, and yet without any dramatic disturbance of the absorbed and absorbing scene. Time seems banished in Cézanne's passionate contemplation of the reality before him: whether it is a landscape or one of those still lives *(pl. 549)* in which the essence of objects, the 'appleness' of apples and so on, is fixed forever. Cézanne himself mentioned his wish to 'do Poussin again, from nature', and one can add Chardin too.

In this way he intended to make something durable of Impressionism, even while he was making something quite different. He set out to record what he saw, just as the Impressionists set out; but his reality was much deeper and went on deepening the longer he looked. Corot had spoken of

547 Paul Cézanne *Mont Sainte-Victoire*

548
Paul Cézanne
Card players

549 PAUL CÉZANNE *Still life with basket of apples*

throwing himself on nature, but Cézanne was really stalking nature as an elusive prey which did not always manifest itself. It was the same with his portraits, where he captures his own sharp glance *(pl. 545)*, or subjects the sitter to unwearying scrutiny to perpetuate not so much a 'likeness' as the relation to each other of forms and patterns. The *Vieille au chapelet (pl. 546)* bears all the marks of Cézanne's struggle, his positive wrestling with the medium of paint to fix his image, his sensation in front of what he sees. Not surprisingly, Flaubert was often named by Cézanne; and the novelist's struggle with words was paralleled by the painter's agonising struggle to express. Both men died in the midst of the struggle. Cézanne had broken finally with conventional ways of seeing and recording what is seen. Before his death the appreciation of younger artists had managed to soften even his reserve and distrust. And early in the new century he wrote to a youthful admirer words deliberately prophetic and yet more profound than he could realise: 'Une ère d'art nouveau se prépare...' It was the era of modern art which he himself had prepared.

LIST OF ILLUSTRATIONS

Measurements are given for the whole picture not details
Centimetres precede inches and height precedes width